To Uncle Vic

Merry Christmas 2014

With love from

Glenn + Sue

x x x

Impressionists
by the Sea

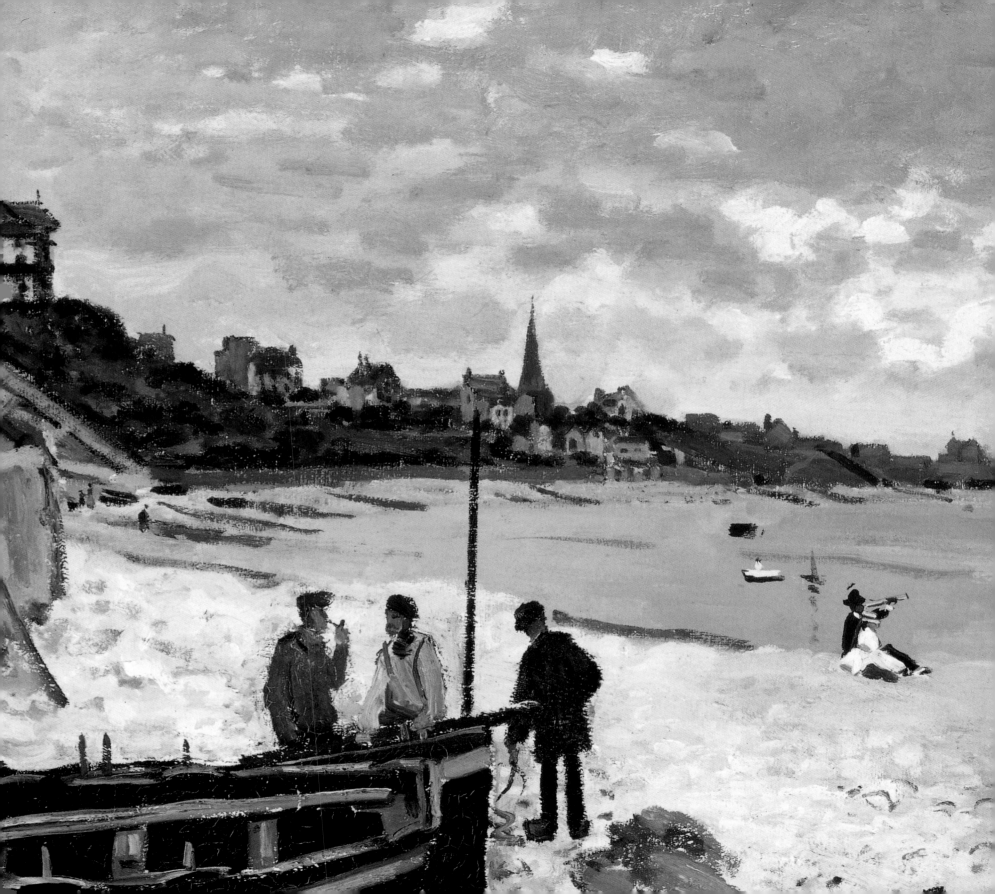

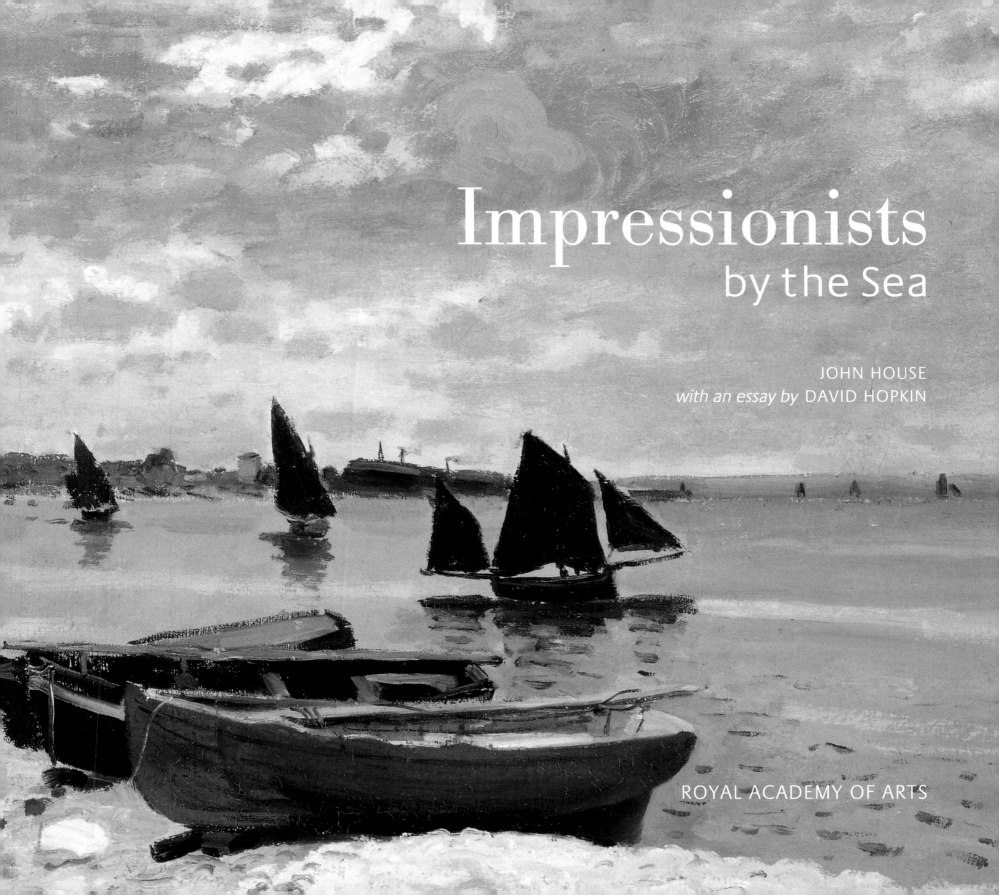

Impressionists
by the Sea

JOHN HOUSE
with an essay by DAVID HOPKIN

ROYAL ACADEMY OF ARTS

First published on the occasion of the exhibition
'Impressionists by the Sea'

Royal Academy of Arts, London
7 July – 30 September 2007

The Phillips Collection, Washington DC
20 October 2007 – 13 January 2008

Wadsworth Atheneum Museum of Art, Hartford
9 February – 11 May 2008

Sponsored by

Manufacturers of Traditional Papers and Paint

The Royal Academy of Arts is grateful to Her Majesty's Government
for agreeing to indemnify this exhibition under the National Heritage
Act 1980, and to Resource, The Council for Museums, Archives and
Libraries, for its help in arranging the indemnity.

EXHIBITION CURATORS
John House
Eliza Rathbone, The Phillips Collection
MaryAnne Stevens, Royal Academy of Arts
Eric Zafran, Wadsworth Atheneum Museum of Art

EXHIBITION ORGANISATION
Mary Herbert-Busick and Adria Patterson,
 Wadsworth Atheneum Museum of Art
Lucy Hunt, Royal Academy of Arts
Christopher Ketcham, The Phillips Collection

PHOTOGRAPHIC AND COPYRIGHT CO-ORDINATION
Andreja Brulc, Royal Academy of Arts

CATALOGUE
Royal Academy Publications
David Breuer
Harry Burden
Claire Callow
Carola Krueger
Peter Sawbridge
Nick Tite

Copy-editing and proofreading: Caroline Ellerby
Design: Maggi Smith
Picture research: Sara Ayad
Colour origination: DawkinsColour
Printed in Italy by Graphicom

British Library Cataloguing-in-Publication Data
A catalogue record for this book is available from the British Library

ISBN 978-1-903973-89-9 (paperback)
ISBN 978-1-903973-88-2 (hardback)

Distributed outside the United States and Canada
by Thames & Hudson Ltd, London

Distributed in the United States and Canada
by Harry N. Abrams, Inc., New York

EDITORS' NOTE
All measurements are given in centimetres, height before width.

Frontispiece: CLAUDE MONET, detail of cat. 32
Pages 38–39: EUGÈNE LOUIS BOUDIN, detail of cat. 17
Pages 62–63: GUSTAVE COURBET, detail of cat. 21
Pages 120–21: CLAUDE MONET, detail of cat. 57

Contents

Foreword

Economic and social changes in France in the second half of the nineteenth century brought about a transformation of the seaside. Newly accessible through transport improvements, notably the coming of the railways, the Normandy coast saw fishing villages developed into seaside resorts, complete with new villas, grand hotels and casinos, and its local population pressed into the service of the crowds of city dwellers who descended upon such locations as Trouville, Deauville, Etretat and Honfleur.

Impressionists by the Sea charts these changes, from earlier picturesque views of storm-tossed beaches and fisherfolk plying their trade, to the celebration of light, atmosphere and modernity in the works of Courbet, Boudin, Jongkind and Monet. A prime contributor to the evolution of artists' appreciation of the seaside, Monet moves from depictions of populated beaches in the 1860s to a dismissal of the impact of modernity on his return to the coast in the first half of the 1880s, in paintings in which he turns his back on the shore and focuses on the enormity of the natural scene, with seas whipped up beneath stormy clouds, and cliffs and deserted beaches under luminous marine skies.

This exhibition was initially conceived by Peter Sutton when he was Director of the Wadsworth Atheneum Museum of Art. Like so many of his brilliant shows from that period, it was based on key works in the museum's collection – in this case the views of the beach at Trouville by Monet and Boudin. Dr Sutton invited the distinguished art historian John House, Walter H. Annenberg Professor at the Courtauld Institute of Art, London, to provide the scholarship necessary to turn the concept into a viable enterprise. He also approached The Phillips Collection, Washington DC, to be a partner in the venture. Some years later, the exhibition has now been realised as a collaboration between these two American institutions and the Royal Academy of Arts, London.

Nearly seventy paintings have been assembled to reveal the range of artists' responses to the seaside, a task in which John House has been assisted by the staffs of all three museums, most notably Eliza Rathbone, Chief Curator at The Phillips Collection, MaryAnne Stevens, Acting Secretary and Senior Curator at the Royal Academy of Arts, and Eric Zafran, Susan Morse Hilles Curator of European Art at the Wadsworth Atheneum Museum of Art. The catalogue has been written by John House, with an important contribution from David Hopkin, Lecturer in Modern European History at Oxford University and a Fellow of Hertford College, Oxford, and edited under the direction of Peter Sawbridge, Managing Editor at the Royal Academy of Arts. The exhibition has been organised by Lucy Hunt and Cayetana Castillo at the Royal Academy of Arts.

To achieve so comprehensive and compelling a review of the subject, we are deeply indebted to our lenders, both public and private. Their generosity in making their masterpieces available has ensured that this important subject can be presented to our visitors.

Support for *Impressionists by the Sea* when it is presented in London comes from Farrow & Ball, which returns to the Royal Academy of Arts for its second exhibition sponsorship. The Royal Academy expresses its deep thanks for this continued support.

It would appear that exhibitions involving Impressionism have proliferated in recent years. By addressing issues of social, economic and artistic change over a crucial period of the nineteenth century, however, *Impressionists by the Sea* opens a new chapter in our appreciation of artists' responses to the peculiar qualities of the marine landscape and man's impact upon it.

Sir Nicholas Grimshaw CBE
President, Royal Academy of Arts

Coleman H. Casey
President of the Board of Trustees,
Wadsworth Atheneum Museum of Art

Jay Gates
Director, The Phillips Collection

Sponsor's Preface

Farrow & Ball is delighted to sponsor *Impressionists by the Sea* at the Royal Academy of Arts; a collaborative exhibition featuring the truly inspirational works of pre-eminent artists from the Impressionist movement.

At Farrow & Ball we have an abiding passion for colour and texture, a keen interest in the visual arts and a commitment to preserving historical designs and methods. Our colour palette relates strongly to the colours featured in this exhibition, and so we felt it fitting to support the Royal Academy and to celebrate the work of some of the greatest Impressionist artists of the nineteenth century.

We are thrilled to be associated with this exhibition which is sure to delight and inspire.

Acknowledgements

The curators at all three participating institutions are most grateful to John House for his devotion to this project and his brilliant scholarship, and to his fellow catalogue author David Hopkin. We much appreciate the generosity of all our lenders, both public and private, and would also like to thank the following colleagues and individuals for their kind assistance: Graham W. J. Beal, Sarah Cash, Cayetana Castillo, Lucinda Ciano, Philip Conisbee, Emmanuel di Donna, Anna Drumm, Sarah Faunce, Alice Frankel, Judy Greenberg, Gloria Groom, Torsten Gunnarson, Jefferson Harrison, Mary Herbert-Busick, Erica Hirshler, Joseph Holbach, Lucy Hunt, William R. Johnston, Kimberley Jones, Larry Kantor, Christopher Ketcham, Annette Bourrut Lacouture, Suzanne Glover Lindsay, Nancy Rose Marshall, Renee Maurer, Mitchell Merling, Patrick Noone, David Norman, Lynn Orr, Adria Patterson, Katia Pisvin, Richard Rand, Catherine Regnault, Jock Reynolds, Aileen Ribeiro, Christopher Riopelle, Shannon Schuler, George Shackelford, Jae Shannon, Lewis Sharp, Patterson Sims, Guillermo Solana, Timothy Standring, David Steele, Elizabeth Steele, Nigel Thorp, Gary Tinterow, Ernst Vegelin, Alice Wheelihan, Juliet Wilson-Bareau, and John Zarabell.

John House would like to thank MaryAnne Stevens, Lucy Hunt and Peter Sawbridge at the Royal Academy of Arts, Eliza Rathbone at The Phillips Collection, Eric Zafran at the Wadsworth Atheneum, Caroline Ellerby for her attentive and non-interventionist editing, and David Hopkin for his essay, which gives the catalogue a vital dimension it would otherwise have lacked.

Opposite: 'France, 1', from *Lett's Popular Atlas*, Lett's, Son & Co. Ltd, London, 1883

Overleaf: EDOUARD MANET, detail of cat. 42

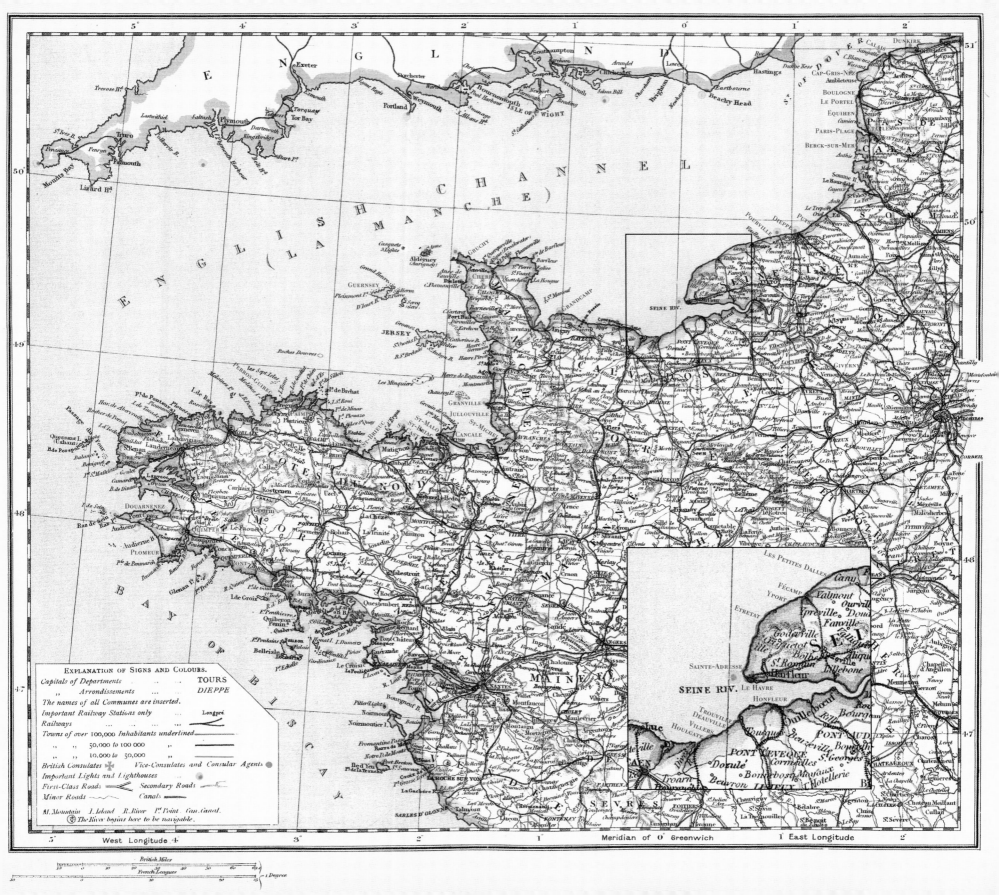

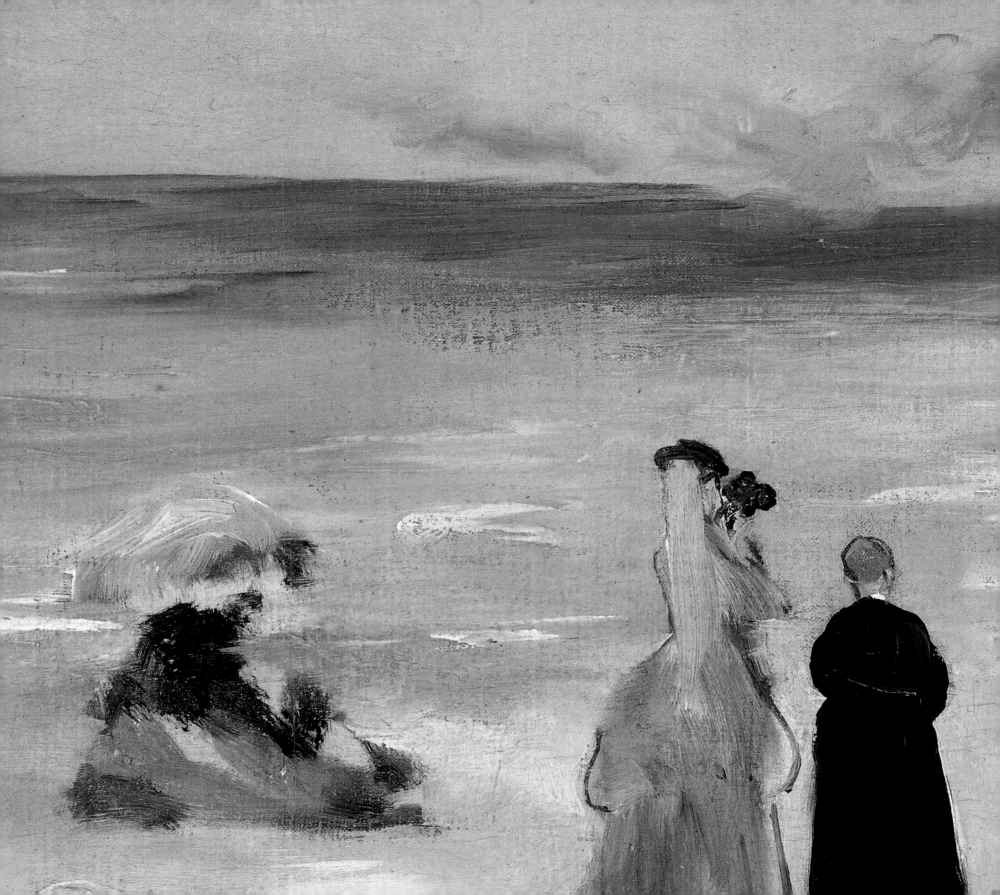

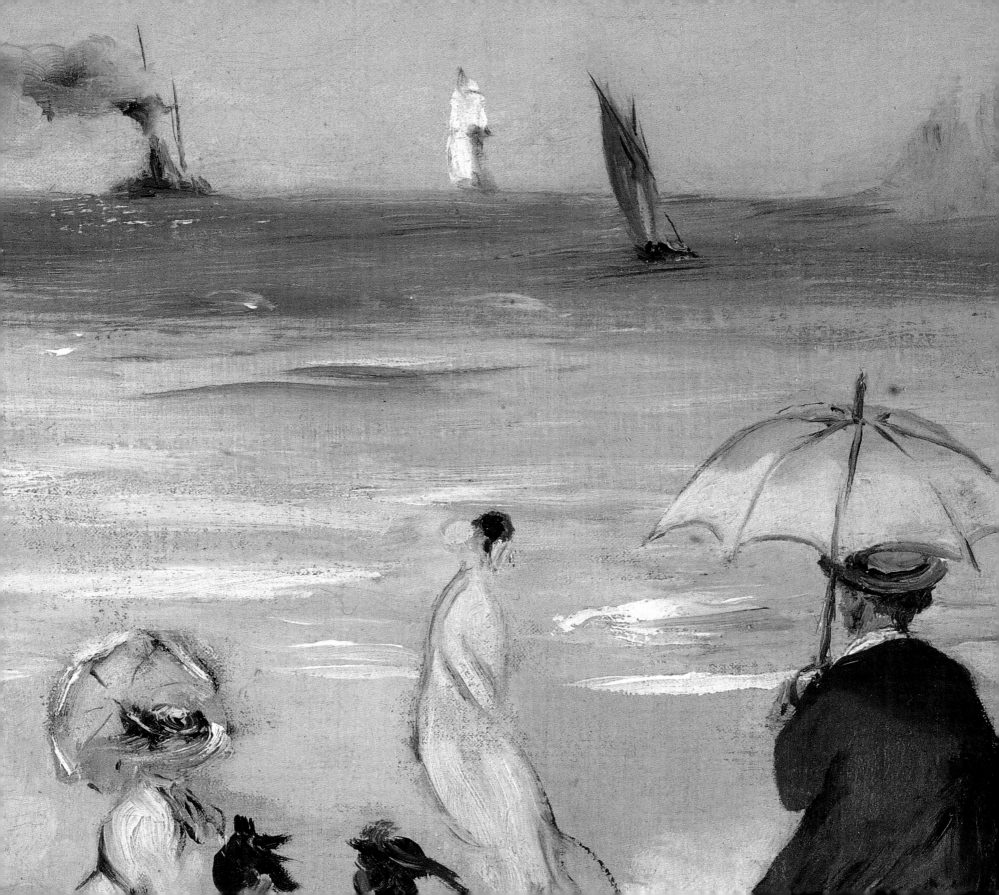

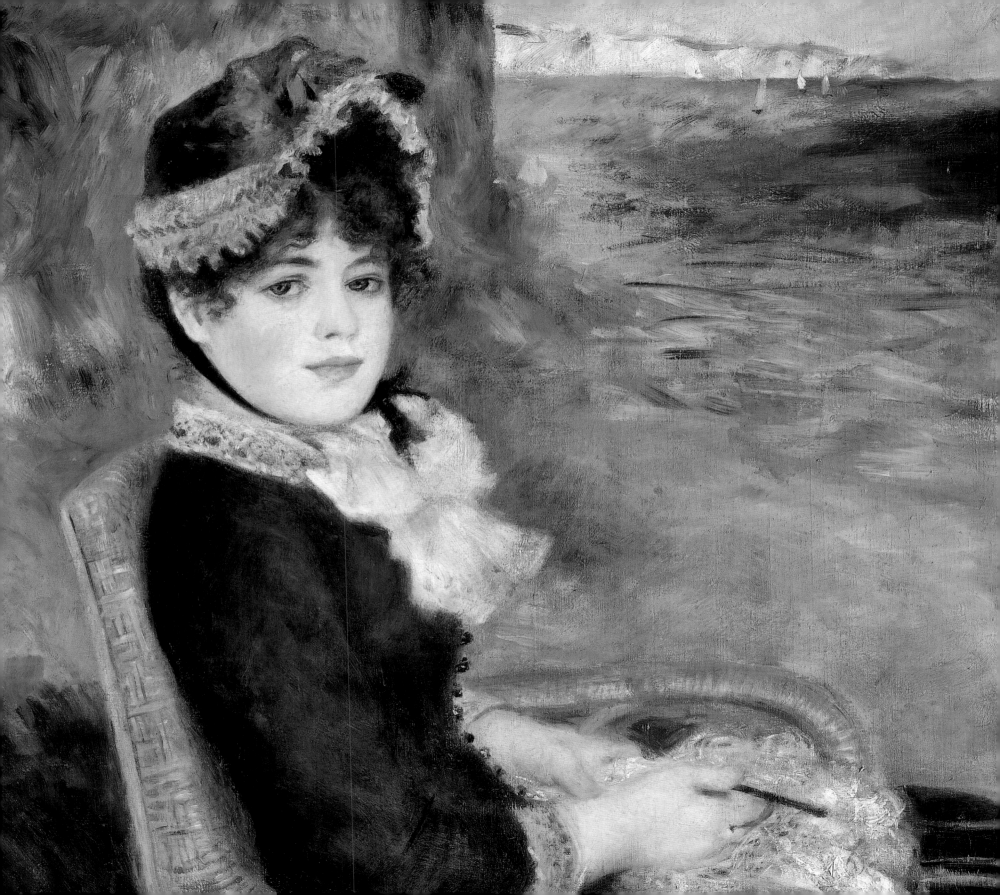

Preface

JOHN HOUSE

During the nineteenth century, the northern coast of France was transformed. At its start, the beaches were the preserve of the local people who sought to make a living from them – from the fish and seafood they could gather. But by the end of the century the holidaymaker had taken over the coast of northern France, at least in the summer, and the beaches had become, as contemporaries put it, 'the summer boulevard of Paris'. The rapid growth of the rail network made these changes possible; however, the central factor was the development of the idea of the holiday away from home as a form of organised leisure.

From the 1820s onwards, too, the coast played an important role in painting in France. In some ways this developed in tandem with the social changes. Initially, painters focused on the force of the waves on the shore and on the local fishermen: only in the early 1860s did fashionable holidaymakers on the beach become a regular subject in painting, at the moment when the resorts of Trouville and Deauville were coming into vogue. However, the more traditional themes did not disappear; the imagery of the forces of the elements and their impact on those who worked on the coast remained popular in painting throughout the century.

Impressionists by the Sea explores the painting of the northern French coast between the 1850s and the 1890s. Its central theme is the development of the beach scene in the art of the Impressionists, but their work is set within a broader context through the inclusion of canvases by their immediate predecessors, notably Eugène Boudin, Gustave Courbet and Johan Barthold Jongkind, and by comparison with a group of paintings characteristic of the coastal scenes exhibited in these years at the Paris Salon. Such comparisons highlight the distinctive qualities of the Impressionists' treatment of the subject, and at the same time reveal the range and diversity of approaches to the coastal theme.

In the 1860s and early 1870s, Boudin, soon followed by Claude Monet and Edouard Manet, pioneered the theme of the fashionable holidaymaker on the beach, creating an explicitly modern form of beach scene. However, both Monet and Boudin in their later work turned their backs on the holidaymakers and used their novel technique to capture the effects of weather and light on the coastline, emphasising the forces of the elements. The exhibition and its catalogue explore the factors that led to this change, and examine the varied viewpoints the painters adopted towards their chosen subjects: did they present themselves as part of the new leisure industry, or assume a position that emphasised the distinctiveness and uniqueness of the artist's vision?

The exhibition focuses on the coast of Normandy, since this was the focus of the painters, and it was there that the new resorts first developed; a number of scenes of Brittany are also included. However, paintings of the Mediterranean do not feature, since France's southern coast was not a destination for summer holidaymakers in these years, and only became a popular subject for painters late in the century. It also concentrates on paintings that show the beach itself – the meeting point of land and sea – as it is this that reveals most clearly the painters' approaches to the theme, both to the uses of the beach, for work and pleasure, and to the natural forces that shaped the coastline.

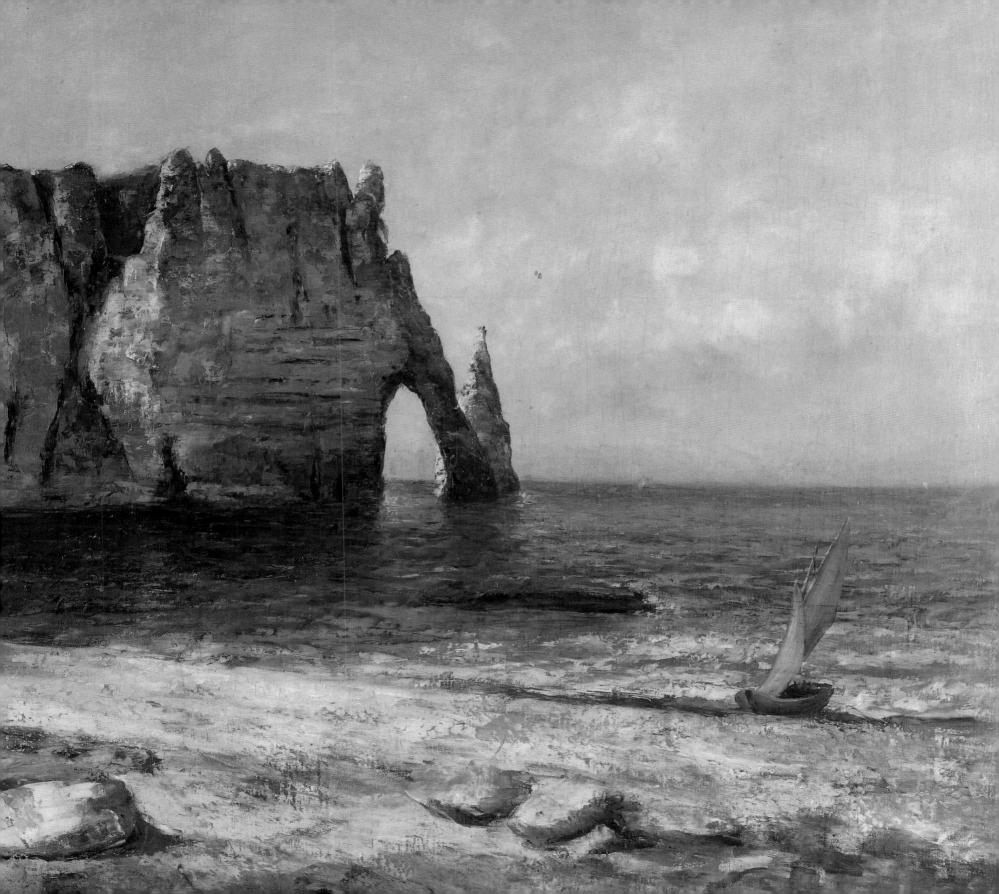

Representing the Beach: The View from Paris

JOHN HOUSE

SEA: Has no bottom. Symbol of infinity. Gives rise to deep thoughts.

Beside the sea, one should always have a telescope.

When contemplating it, always say: 'What a lot of water, what a lot of water.'

(Gustave Flaubert, *Dictionnaire des idées reçues*, sv. MER)

Two distinct histories are involved in exploring the representation of the beach in France in the nineteenth century: the dramatic physical changes that took place on the coast itself, with the rise of the seaside resort, and the evolving representation of the coast in paint. However, as we shall see, the two did not always run on a parallel course.

Bald statistics can give some idea of the scale of the physical transformation of the northern French coastline. Around 1830, Trouville was a fishing village with fewer than 2,000 inhabitants;[1] in 1866 its population was 5,200, but augmented by around 20,000 visitors every summer.[2] However, such data provide only the bare bones of the story, and give no sense of the significance of the changes – of how the coast was perceived and why people visited it. Flaubert's parodic 'received ideas' about the sea remind us that the image of the sea and its coasts was forged out of a whole set of cultural assumptions: it was the representations of the beach that provided the impetus for the physical changes.

These representations took many forms, both verbal and visual, ranging from literature and fine art painting[3] at one end of the spectrum, to satirical journalism, guidebooks and popular engravings at the other. The 'received ideas' about the coast were generated by the sum of all of these, and resulted in people deciding to spend time on the coast themselves as well as influencing their choice of resort. The physical transformation of the coastline was itself the outcome of the ways in which the coast was represented, and the primary context here was Paris. The French capital was where the books and magazines were published and the pictures exhibited, whether in the Salon[4] or in the windows of dealers' shops, and statistics show that the majority of visitors whose demands led to the development of the coastline came from the Paris.[5]

Writing the Beach

From the Old Testament onwards, the sea represented potential danger and destruction. A long-standing literary and visual lineage presented its forces as a constant threat to those who tried to tame it or to exploit the riches it contained. A further threat came from the figure of the wrecker, who lured ships into danger, and the looter who pillaged the ensuing wrecks.[6] Alain Corbin has pinpointed a gradual shift, in the first half of the nineteenth century, to narratives of heroism and rescue,[7] but the sea retained its destructive powers in the collective imagination throughout the century, as expressed in immensely successful novels such as Victor Hugo's *Les Travailleurs de la mer* (1866) and Pierre Loti's *Pêcheur d'Islande* (1886), stories of the fate of fishermen set, respectively, on the Channel island of Guernsey and in Brittany.

A different view of the coast began to emerge in the second quarter of the nineteenth century, focused especially on the Normandy coastline along the English Channel to the northwest of Paris. A key text here is Alphonse Karr's *Le Chemin le plus court*, published in 1836. This popular and much-reprinted novel narrates the personal and emotional history of Hugues, a young painter from Le Havre, who visits Etretat, then a remote and little-known seaside village, where he falls in love with Thérèse, a young peasant girl. However, after his success at the Paris Salon with his paintings of Etretat, he abandons her and marries Louise, a wealthy woman whom he does not love. Realising his mistake too

late, he returns to Etretat to find that Thérèse has married Vilhem, a local man, who has saved her from attempted suicide.[8]

Two aspects of Karr's book are central to the arguments of this essay. First, Karr was one of the group of writers and artists whose explorations brought the Normandy coast to the attention of the Parisian public, and his book played a significant role in popularising the beauties of Etretat, with its evocative descriptions of the remarkable rock arches that flank its bay. Second, the book's narrative evolves in terms of the stock opposition of the countryside, and specifically the coast, as representing innocence and purity in contrast to the moral and financial corruption of the city – a chain of associations very different from the traditional association of the sea with danger and the unknown. A similar structural opposition appears half a century later in Guy de Maupassant's *Une Vie* of 1883, in which Jeanne's seaside house at Yport represents innocence and happiness in contrast to the inland residence to which she is forced to move due to financial ruin.[9]

Normandy's seaside resorts developed gradually. Of all its coastal locations, only Dieppe was established as a resort before 1830. It had been visited by fashionable holidaymakers since early in the century, and after the end of the Napoleonic Wars in 1815 became a favourite destination for English visitors who saw it as a second Brighton and brought with them the English vogue for sea bathing.[10] The visits of the Duchesse de Berry during the 1820s put Dieppe firmly on the map.[11] For all the other sites along the Normandy coast, from Fécamp westwards, we find a recurrent pattern of discovery or, rather, recurrent and endlessly repeated narratives of discovery.[12] Places were usually first explored by a painter and brought to wider public attention by a writer or, on occasion, by a writer and then a painter. The property developer and the fashionable visitor followed, whereupon the artistic elite moved on to less populated locations.[13] Repeatedly these pioneers were compared to Robinson Crusoe, Christopher Columbus or Captain Cook, as if their explorations had transformed humankind's knowledge of the globe.[14]

Etretat, we learn, was 'discovered' in the 1820s by the painter Eugène Isabey, who was soon followed by fellow painters Eugène Le Poittevin and Charles Mozin; Karr's texts, among them *Le Chemin le plus court*, brought it to public attention.[15] Sainte-Adresse was also popularised by Karr's writing before Johan

Barthold Jongkind and Claude Monet went there to paint. Villerville was pioneered by the painters Duval Le Camus and Jules David, followed by Charles François Daubigny, and was written about by Charles Deslys.[16] Trouville – the most spectacular of the transformation stories – was 'discovered' by Mozin in 1825, who was followed by Isabey and Paul Huet, and then, in 1829, by Jean Baptiste Camille Corot and Alexandre Dumas, whose descriptions of the place set it on the highroad to celebrity.[17]

The books and articles that repeat these accounts take various forms, ranging from discursive personal travel narratives to formal travel guidebooks, but a central theme of all of them is the shock of discovery, the surprise at finding a new and striking site; at the same time, the pioneering artists and writers are named, as if to validate the credentials of the place. The texts often quote each other, and even formal guidebooks such as those in the Guides-Joanne series include extended passages from literary texts alongside the 'hard' data about hotels and casinos.[18]

In the years after 1850 the guidebooks had a standard structure according to the routes visitors were expected to travel; for access to the principal towns, this was via the railway. The construction of train links from Paris was the single most significant factor in opening up the coast to the holidaymaker. The line to Le Havre was completed in 1847, to Dieppe in 1848, to Lisieux and Caen in 1855, and then to Cherbourg in 1858, to Fécamp in 1856 and, finally, to Granville in 1870. The branch line from Lisieux to Trouville opened in 1863, and later in the century many of the smaller coastal towns were linked to the rail network.[19]

The main characters in accounts of the coast in such guides and travel books are, first, the artists and writers, followed by the fashionable Parisians (often identified by name) who built their villas in these coastal resorts, and then by the anonymous throng of holidaymakers who followed in their footsteps. Although the guidebooks followed the common tracks of the tourist, the majority of visitors to the coast cannot strictly be described as tourists, for their normal pattern was to leave Paris in order to spend an extended holiday in a single place, rather than 'touring' from site to site.[20] As we shall see, the position of the artists fitted neither category – their viewpoint was neither that of the holidaymaker nor that of the tourist.

There was, of course, another group of people involved: the local inhabitants of the villages before their 'discovery', who mostly

Fig. 1
Bertall,
engraving from *La Vie hors de chez soi*, 1876

Fig. 2
'A Toiler of the Sea',
engraving from Henry Blackburn,
Normandy Picturesque, 1869

earned their living from the sea. They make their appearance in novels like Karr's and in the paintings, but clearly their lives were changed by the influx of visitors. Bertall's caricature (fig. 1), made for a Parisian audience, plays on the local fisherman's incomprehension of the vogue for sea bathing: 'Life must be really filthy in Paris, to make them come here so much to wash themselves, mustn't it, Pulchérie?' In practice, however, the local population found many ways to take advantage of the arrival of the newcomers. There are accounts of them renting rooms to holidaymakers, showing them how to fish on the local rocks, taking them out to sea (though a guide advised women against this, since they were 'sometimes too affected by their emotions'),[21] and servicing their needs in numerous other ways.[22] Alongside this they continued to fish, and their activities, together with the local fish markets, became spectacles for visitors. At the end of the 'season' they were able to reclaim their familiar territory.[23]

In some accounts of life on the coast, subtexts claim that the influx of wealthy Parisians encouraged local inhabitants to dream of migrating to Paris in the hope of bettering their lot. Henry Blackburn highlighted this in his account of the local fisherwomen at Granville who, as he and many other writers noted, were renowned for their beauty (see fig. 2). He imagined his reply if one of them were to ask his advice about such a move: 'Could we draw a tempting picture of life in cities, could we … draw a favourable

contrast between *her* life, as we see it, and the lives of girls of her own age who live in towns, who never see the breaking of a spring morning, or know the beauty of a summer's night? … could she but see the veil that hangs over London … on the brightest morning that ever dawned on their sleeping inhabitants, she might well be reconciled to her present life!'[24]

The contrast between the local population and the visitors emerges vividly in relation to the building of houses. The local inhabitants' cottages were constructed with their windows turned away from the sea, and they were bemused that the new arrivals insisted on windows facing the water.[25] Seeing the ocean framed by a window was to see it as 'landscape';[26] the whole business of conceiving it as something to be viewed aesthetically made no sense to the locals, who saw it in practical terms as the source of their livelihood and a harbinger of danger.

So what did a visit to the coast mean for the holidaymaker? The contrasts between Paris and the coast play on city versus country, illness versus health, work versus rest.[27] Certainly the main argument proposed by supporters of the seaside holiday was the rhetoric of physical and mental well-being,[28] and the ostensible purpose of sea bathing, in particular, was primarily therapeutic.[29] At the same time, as Flaubert's 'received ideas' tell us, the sea was meant to encourage 'deep thoughts' – thoughts articulated, in a non-parodic vein, by the painter Ernest Hareux: 'Think that this beautiful water, these graceful waves, hide in their depths the most dreadful dramas, and enormous riches torn from man by their indomitable force; reflect upon the thousands that are each year engulfed, and you will commence to understand what this sea is.'[30]

However, the texts make it clear that therapy and moralising were by no means the whole story; in a number of ways this simplistic picture was compromised, even contradicted, by the reality of resort life. The most problematic issue was pleasure. Though the prescriptive texts present sea bathing as something that had to be endured for the good of the patient, they often hint that it might also be enjoyable,[31] and the engravings that accompany the Conty guidebooks of the 1870s – less serious-minded than the Guides-Joanne – repeatedly show the sea as an arena for play and flirtation, especially in resorts where bathers were not segregated by sex (see figs 3 and 4).

This imagery reminds us that the mythic history of the sea was twofold; it was not only an agent of destruction, as in the biblical

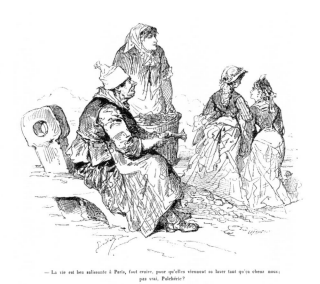

— La vie est ben salissante à Paris, faut croire, pour qu'elles viennent se laver tant qu'ça chenz nous; pas vrai, Pulchérie?

A TOILER OF THE SEA.

UNE CORDE SENSIBLE.

Mais je vous dis que les règlements s'y opposent.

Défiez-vous, Mesdames, des zéphyrs de Trouville.

Figs 3 and 4
Engravings from H. A. de Conty,
Guide Conty: Les Côtes de Normandie,
1876, section on Trouville

narrative of the Flood, but also the birthplace of the goddess Venus, who was born from the waves. The imagery of the birth of Venus plays a startling role in Jules Michelet's *La Mer* of 1861. The final section, devoted to 'La Renaissance par la mer' (rebirth through the sea) begins with a celebration of the benevolence and generosity of the sea, particularly towards suffering beings: 'The sea, which is a woman, delights in setting them on their feet again.' He continues: 'Venus, who was once born from the sea, is born again from it every day – not the enervated, tearful melancholic Venus, but the true victorious Venus, in all the triumphal power of her fecundity and desire.'[32] This passage is the prelude to his discussion of sea bathing and women coming to the coast to restore their health and spirits. Flaubert, too, picked up on this imagery in his account of his boyhood visit to Trouville in 1836, in which he recounts an encounter with a married woman with whom he imagined himself to be in love; in his text, she becomes a modern Venus as she emerges from the waves.[33]

The question of pleasure raises the broader issue of the nature of life in the seaside resorts. Paradoxically, the holidaymakers, especially at Trouville, sought to replicate the social rituals of their existence in Paris. Indeed, in 1855 a guidebook declared that Trouville was rapidly becoming a suburb of Paris,[34] and by

the 1860s it was commonplace to refer to it as the 'boulevard des Italiens of the Normandy beaches',[35] and to describe the elaborate rituals of the daily life of fashionable female visitors during the season. Etretat, where the bathing was less tightly regulated, was described as the Asnières of the seaside resorts,[36] comparing it with the Paris suburb noted as a playground of the Parisian demi-monde.

Commentators could not agree whether this new world should be viewed positively or negatively. Trouville was the prime focus of this debate. As early as 1844 a magazine article on sea bathing at Trouville urged readers to see the place before it became as populous as Paris or London: 'The picturesque is disappearing, and, when one encounters it, one should not let it slip from one's grasp. Well! Trouville is still picturesque, and its mixed population [of fisherfolk and holidaymakers] gives it a very distinctive appearance.'[37]

For Eugène Chapus in 1855 it was 'a nonchalant town, a sort of chaise-longue where one can voluptuously stretch out in order to dream in front of a deep horizon, to the sound of the waves, the splashing of the bathing women, and the harmonies of the winds that blow against the cliff-face'; the 'marvellous metamorphosis' of the town was partly the achievement of its 'intelligent administration', helped by the exceptional natural beauties of the site.[38] However, the 1856 edition of J. B. Richard's guide to France sounded a note

of warning. With its charming new villas and ravishing setting, Trouville still offered the visitor 'that deep silence that encourages the spirit to contemplation, that solemn peace that acts on the heart and brings serenity to the soul'. He warned, though, that this 'fury of construction' meant that this 'delicious place' would soon lose its original character.[39]

During the 1860s there were growing concerns about the state of Trouville. In 1862 Morlent could still celebrate the crowd on the beach: 'The guests at Trouville are that floating, parasitic mass of people who come in the summer in search of health or pleasure. Nothing is more colourful than this elegant crowd, whether healthy or sick. The pretensions of class disappear in face of the splendour and grandeur of the Ocean.'[40] However, in 1866 Adolphe Joanne presented a thoroughly jaundiced view of the place: 'It is the meeting-place of the sick who are perfectly healthy, it is Paris transported for two or three months to the sea coast, with its qualities, its absurdities and its vices. … It is sad to say that most of the women go there only to parade a senseless luxury.'[41] By contrast, in 1867 the American writer Moncure D. Conway felt that it had not yet lost its charm: 'I cannot promise any reader that he will ever see the marvellous place with all the tints which it wears now. The boulevard-world is coming, and may scare away all the elves that now dance openly in the coverts and on the yellow sands.'[42] Henry Blackburn's verdict in 1869 was more equivocal:

> Of the fashion and extravagance at Trouville a moralist might be inclined to say much; but we are here for a summer holiday, and we *must* be gay, both in manner and attire. It is our business to be delighted with the varied scene of summer costume, and with all the bizarre combinations of colour that the beautiful Parisians present to us; but it is impossible altogether to ignore the aspect of anxiety which the majority of people bring with them from Paris. They come 'possessed'; … they bring their burden of extravagance with them, they take it down to the beach, they plunge into the water with it, and come up burdened as before. *Dress* is the one thing needful at Trouville, in the water or on the sands.[43]

After the fall of Napoleon III's Second Empire in 1870, Frederic Marshall saw the paraded artifice and luxury of Trouville life in the 1860s as a metaphor for the imminent decline and fall of Napoleon's empire.[44] However, in 1874 Katharine Macquoid could

still enjoy the place: 'The first impression of Trouville is very gay and charming. … There is not so much as a beggar to destroy the illusion. Truly Trouville would have seemed a paradise to that Eastern philosopher who wandered about in search of happiness; and the paradise would last – perhaps till he was called on to pay his hotel bill.'[45] The Conty guide of 1877 could celebrate the fashionable parade on Trouville Beach without resorting to didactic moralising.[46]

A central theme in the debates about life on the beach was the issue of viewing and voyeurism. Fashionably dressed women evidently paraded on the beach in order to be seen, something that was widely interpreted as an expression of the shallowness of their values. But beyond this, women bathers exposed themselves to male viewers. Michelet was deeply concerned about the exposure of young women after their first therapeutic bathe: 'It is a cruel exhibition in front of a critical audience, in front of rivals who take pleasure in considering her ugly, in front of frivolous men, who laugh mindlessly and pitilessly, who observe, with their lorgnette in their hands, the unfortunate accidents in the dress of a poor humiliated woman.'[47] One wonders if this type of viewing was one of the reasons why Flaubert saw a telescope as a necessity beside the sea. From other standpoints, though, watching the bathers was just another part of the daily ritual of life on the beach; for example, the Conty guide described how at certain times of day the male bathers gathered on the beach at Etretat, where mixed bathing was permitted: 'Some come to bathe, others to admire the rise and fall of the waves, where, at high tide, elegant and gracious sirens are swimming.'[48] Many of the illustrations in the guide also play lightheartedly on such viewing (e.g. figs 3 and 4). The local fisherwomen, too, might be the objects of scrutiny. In 1867 Conway described how they walked through the streets, demurely dressed, 'but when they get down to the shore shoes and stockings are thrown aside, an upper skirt flies off, and they are transformed into corps de ballet, which might drive a manager mad'.[49]

Painting the Beach

The painters, too, visited the coast in order to view and, like the texts, their canvases found their audiences in Paris. They painted most of the sites that feature so largely in the guides and travel writing, but their responses to the transformation of the coastline were by no means straightforward. As we have seen, the writing ascribes a crucial, formative role to the painters, as explorers and

'discoverers' of the beauties of the coast in the first half of the century, and much of the later painting of the coast can be viewed as an attempt to sustain that position, by emphasising a fresh, solitary vision, rather than engaging directly with the 'new' coast. But this is not the whole story.

Landscape painting in the nineteenth century was viewed within two distinct contexts – not only in relation to the sites depicted and their associations, but also in the context of the art of the past, which established a whole set of terms of reference and criteria by which new paintings were judged. The two standard points of comparison were with the coastal paintings of seventeenth-century Holland and with the very different French coastal scenes by Claude Lorrain and, in the eighteenth century, Claude Joseph Vernet.[50] The sun-bathed imaginary port scenes of Claude Lorrain and Vernet had little legacy in the nineteenth century. By contrast, Vernet's series of panoramic views of the ports of France of the 1750s and 1760s were the starting point for many nineteenth-century port scenes, but these do not come within the remit of the present exhibition. Of most direct relevance for nineteenth-century painters of the sea and the beach were the scenes of stormy seas by the Dutch painters and by Vernet (fig. 5), and the Dutch coastal scenes that focused on everyday life on the beaches and beside the sea (fig. 6).

The long-standing association of the coast with danger and shipwrecks had acquired a new momentum in the 1830s with the 'romantic' coastal paintings of Isabey and Huet. Isabey's fascination with stormy seas continued into the 1860s (see cats 1 and 4), while Huet, in canvases such as *Equinoctial High Tide near Honfleur*, shown at the 1861 Salon (Louvre, Paris), dramatised the confrontation of sea and land without any human content. For the following Salon in 1863, Huet pursued his ambition 'to add expressive figures to the dramatic expression of the landscape'[51] in his monumental canvas *The Cliffs of Houlgate* (fig. 7) by combining a distinctive topographical site, the 'Vaches noires' cliffs, with the elemental drama of a drowned corpse being carried up the beach during a storm. However, the critical responses to this painting reveal divergent views about the desirable relationship between man and nature in scenes such as this. Jules Castagnary succinctly summed up the picture: 'Storms of the heart and storms of the Ocean go well together.'[52] For Ernest Chesneau, though, the 'human drama' in the foreground distracted from and trivialised 'the emotion that this savage site inspires'.[53]

The connection between the holiday industry and the imagery of peril and shipwreck is made clear in Eugène Chapus's guide to the region, first published in 1855. Alongside an extended

Fig. 5
Claude Joseph Vernet,
A Shipwreck in Stormy Seas, 1773.
Oil on canvas, 114.5 x 163.5 cm.
National Gallery, London (NG 6601)

Fig. 6
Jacob van Ruisdael,
The Shore at Egmond-aan-See, c. 1675.
Oil on canvas, 53.7 x 66.2 cm.
National Gallery, London (NG 1390)

20

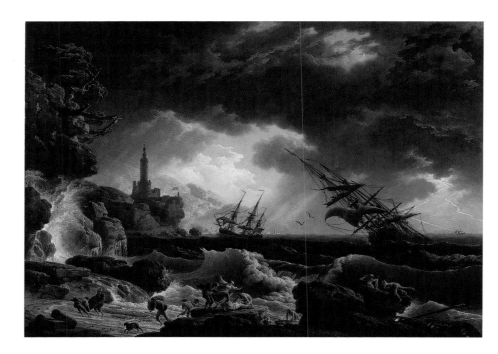

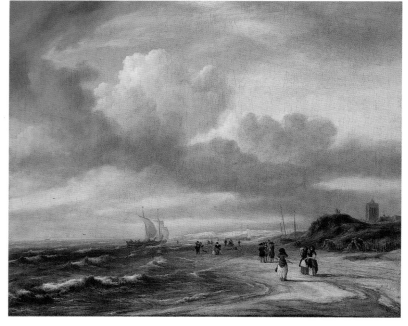

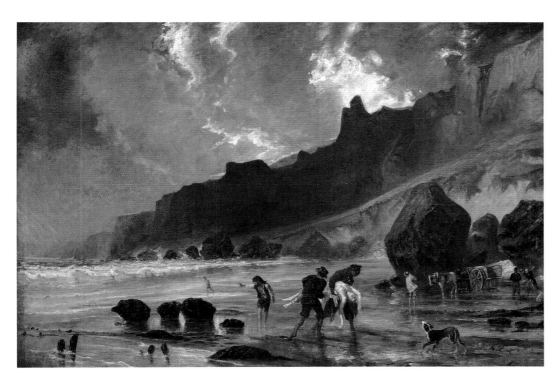

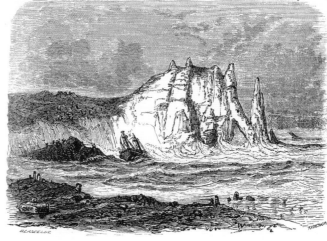

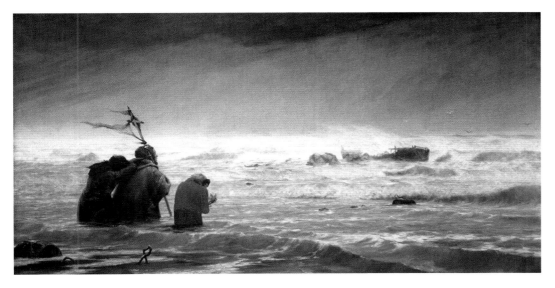

description of the recent development of Etretat, the guide includes a highly dramatised and topographically inaccurate engraving of the beach battered by a storm, with a sailing boat wrecked on the far rocks (fig. 8).[51]

As in literature, the theme of the dangers of the sea continued in painting throughout the nineteenth century. There was a religious dimension to the theme, since one of the intercessionary titles of the Virgin Mary was Stella Maris (Star of the Sea). Thomas Couture depicted this theme in terms of a shipwrecked family on a seashore in his mural decorations of 1852–56 in the church of Saint-Eustache in Paris. And at the 1883 Salon, Francis Tattegrain exhibited a gigantic canvas titled *The Mourners of Etaples* (fig. 9), depicting a priest, a woman and a child praying as they stand waist-deep in stormy surf, gazing at a shipwreck out to sea; no sign here of help from the Virgin Mary.

The lasting relevance of the imagery of the peril of the ocean appears in an unexpected context in the decorations of the Hôtel de Ville in Paris. In the Salle Georges Bertrand, whose decor, executed during the 1890s, represents rural France offering its

21

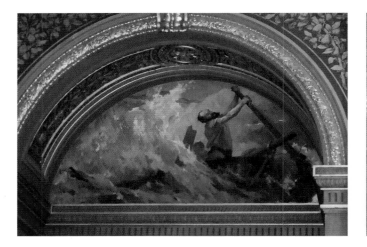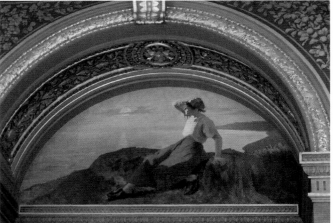

wealth to the city of Paris, Alexandre Falguière's allegorical statue of *Fishing* is accompanied by two lunettes painted by Bertrand, one representing a young woman anxiously waiting on a cliff top, the other a desperate fisherman whose boat is about to disintegrate in a storm (figs 10 and 11). The mortal dangers of the sea are here foregrounded even in the context of a celebration of nature's bounty.

However, the very different imagery of the sea, as the locus of female sexuality and male heterosexual desire, also had a long-lasting currency in painting. Michelet's image in *La Mer* (1861) of the 'victorious Venus' reborn from the sea was rapidly followed by a cluster of paintings of the birth of Venus at the Salon,[55] and these, in turn, were parodied by Gustave Courbet in his ambitious but unfinished canvas of a celebrated bather at Trouville, *Woman on a Podoscaphe*, of 1865 (private collection), described by Thoré in terms of a modern birth of Venus.[56] The role of the sea as feminine temptress is vividly expressed in Léon Belly's *The Sirens* (fig. 12), shown at the 1864 Salon. Here, the Neoclassical rigidity of the figure of Ulysses, clinging to the mast of his vessel, is set off against the Rubensian voluptuousness of the sirens in the sea in the foreground, whose writhing bodies seem to re-create the movements of the sea itself.

In the 'discovery' of the Normandy coast before 1850, the paintings of the pioneer artists played a significant role, but they interpreted the theme in various ways. Corot's *Trouville: The Mouth of the Touques* (fig. 13), probably painted in the early 1830s during

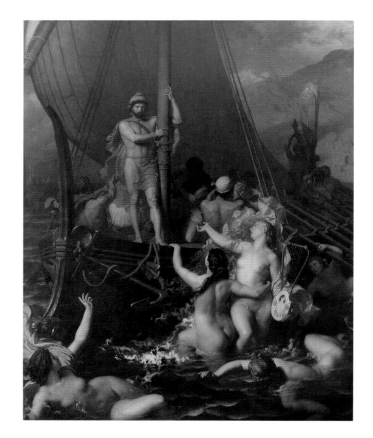

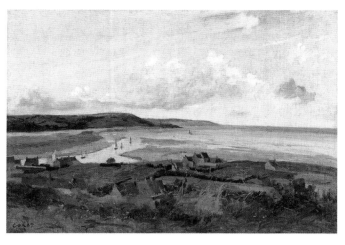

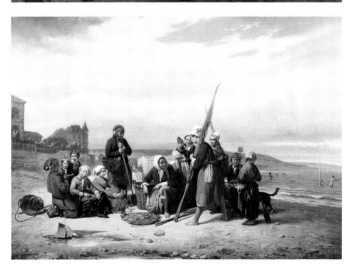

one of his first visits there, lays out the topography of the place, with the bay and the future site of Deauville stretching out beyond the modest cottages of Trouville and the estuary of the River Touques. The viewpoint, from the cliff above the village, vividly evokes the sense of discovery, as the wide panorama opens out in front of the viewer, and the little community, seemingly untouched by the outside world, nestles beneath the sheltering hillside. In contrast, other canvases present stereotypical views of the local inhabitants and their cottages, treated as if they were 'primitive' and uncultured; Isabey's *Low Tide* (Louvre, Paris) shown at the 1833 Salon, and Mozin's *Winnowers' Cottage beside the Sea* (fig. 14), also from the 1830s, make little of the setting and surroundings of their scenes in favour of the local colour of the buildings and their occupants.

The local inhabitants of the coast remained a popular theme throughout the century. French nineteenth-century depictions of peasant figures can loosely be divided into two groups: those that play on their coarseness and roughness, and those that idealise and ennoble them. The figures in Mozin's *Winnowers' Cottage beside the Sea* belong to the first category, and Bertall's 1876 caricature of fishermen on the beach (fig. 1) demonstrates the survival of this stereotype in the popular imagination. However, most of the images of fisherfolk on the beaches present the figures – generally female – as dignified, even statuesque. Jules Breton's *A Spring by the Sea* (cat. 3), set on the bay of Douarnenez in Brittany, is a particularly striking example of this mode, treating the women in the foreground with a quasi-processional solemnity; although more concerned with effects of light and atmosphere, John Singer Sargent gave his *Oyster Gatherers of Cancale* (cat. 46) a comparable dignity. The figures in Jules Héreau's *The Return from Shrimping* (cat. 30) strike a mean between the two modes with their more informal poses and the inclusion of young and old, together with a male figure.

Pierre Duval le Camus's *Sea-Bathing at Trouville* (fig. 15), painted around 1850,[57] is the earliest traced canvas in which the two worlds, of work and recreation, are juxtaposed: a group of local women and children stand and sit around a basket of fish in the foreground, but beyond them the sea is peopled by bathers and the skyline is interrupted by an elaborate turreted villa. A similar contrast informs Monet's pair of canvases of the beach at Sainte-Adresse of 1867 (cats 32 and 33), one dominated by fishermen, one by holidaymakers, but each containing references to the other

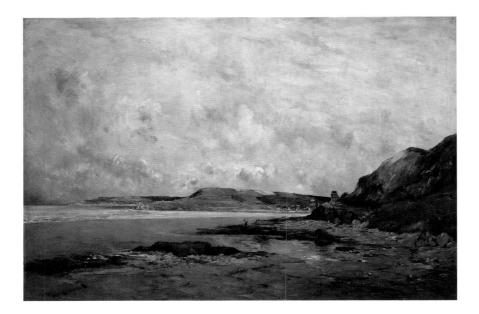

world. Ten years later, Jean Baptiste Antoine Guillemet included the casino and a villa in a panoramic view of the bay of Villers (fig. 16), whose human content is otherwise restricted to humble cottages and local figures on the beach. However, such juxtapositions, which would have been part of the everyday experience of visitors, are relatively unusual in the painting of the period. The majority of pictures include references to one world or the other, or present the landscape with little or no trace of any human presence.

The earliest fine art paintings that focus exclusively on the holidaymakers and the physical transformations they generated seem to date from around 1860. Mozin, who died in 1862, can probably claim priority. His *Trouville, The Beach, High Tide, in a High Wind* (fig. 17) pits the holidaymaker against the elements, as the bathing facilities are washed away by an exceptionally high tide (the villa is clearly the same as that in Duval le Camus's canvas). However, the force of the waves here has none of the tragic dimension of Huet's *Cliffs of Houlgate* (fig. 7); it is, rather, treated as a picturesque interruption to the pleasures of the beach.

Eugène Louis Boudin's many canvases of fashionable figures on Trouville beach have become the archetypal painted images of holiday life in the nineteenth century, although he concentrated on this theme only for a relatively short phase in his long career, from

around 1862 to 1869 (see cats 5 and 13–17). In the more ambitious of his later beach scenes (see cats 48 and 49), the figures are generally local fisherfolk and contribute less to the overall effect of the picture. In most of the Trouville canvases, the sea is relegated to the background; weather effects sometimes play an active part in the composition (e.g. cat. 15), but the primary focus is on the interrelationships between the clusters of fashionably dressed figures on the wide expanses of the sands. Their scattered, informal groupings mark the transfer of a particular vision of urban modernity to the 'summer boulevard' of Trouville beach. They are viewed with a detached and dispassionate gaze that notes their clothing and posture, but at the same time makes no attempt to probe their personalities or to hint at sentimental anecdotes. This way of seeing belonged to a particular notion of the Parisian flâneur, as an observant viewer who could register the nuances of clothing and deportment, but recognised that ultimately the public face of fashionable, modern society was a facade that denied access to inner feelings and experiences.[58]

The illegibility of the social interchanges that Boudin depicts makes an interesting contrast with *Sea-Bathing at Honfleur*, the canvas his friend Louis Alexandre Dubourg exhibited at the 1869 Salon (fig. 18), in which the gestures and body language of the figures are far more precisely and literally depicted. Still more

Fig. 16
Jean Baptiste Antoine Guillemet,
The Beach of Villers (Calvados), 1878.
Oil on canvas, 130.5 x 196.5 cm.
Musée des Beaux-Arts, Rouen

Fig. 17
Charles Mozin,
*Trouville, The Beach, High Tide,
in a High Wind*, c. 1860?.
Oil on panel, 27.5 x 40.5.
Musée de Trouville

24

anecdotal is Le Poittevin's *Sea-Bathing at Etretat* (fig. 19), exhibited at the 1866 Salon, in which we see both men and women bathing, together with bathing instructors, including, on the diving board, a figure who must be identified as the celebrated Zephyr whose prowess and exploits were described in many texts.[59]

By the late 1860s Boudin had carved out a distinctive reputation for his fashionable beach scenes, primarily through the canvases he exhibited at the Salon (see cat. 5). In 1869, Castagnary hailed him as the inventor of this distinctive genre of marine painting.[60] Indeed, in their art-world novel *Manette*

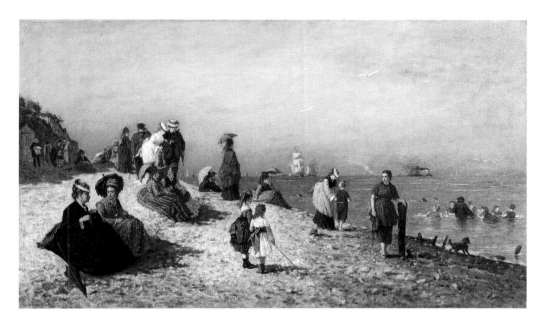

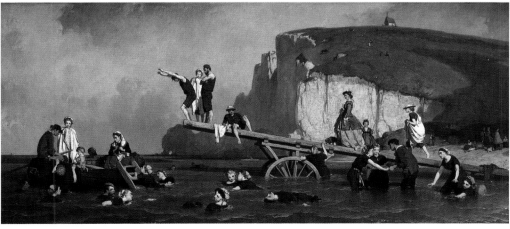

Salomon, published in 1867, the Goncourt brothers included a long and complex description of a painting of Trouville by the novel's chief character, Coriolis, that is clearly based on Boudin's canvases.[61]

In 1867 Ernest Chesneau gave a particularly perceptive account of the way in which he treated this theme:

> Nobody apart from M. Boudin has seen or painted the joyous intermixing of colours of these elegant costumes, the rustling of the fabrics in the breezes from the sea, the contrast, so specific to our own time, of what is most mobile and inconstant with the eternally grandiose spectacle of the Ocean. Is this a contrast, or a reconciliation? … In either case, M. Boudin's canvases contain an indication of our customs that is well worth preserving. In truth, no-one previously has ever paraded their love of nature so extravagantly. Spending the summer season by the sea is a wholly new craze. … M. Boudin is the first to have captured and preserved for us this piquant aspect of modern life, and he has done it artistically, without being distracted by small details.[62]

By asking whether Boudin's canvases suggest a contrast or a reconciliation between figures and sea, Chesneau's text raises the issue of his attitude to the parade of high fashion on the beach. Boudin himself justified his treatment of beach scenes in a letter in 1868:

> [I have been congratulated] for daring to include the things and people of our own time in my pictures, for having found a way of making acceptable men in overcoats and women in waterproofs. … This attempt is not new, for the Italians and the Flemish painted the people of their own times. … The peasants have their favourite painters. … But don't the bourgeois, who stroll on the jetty towards the sunset, have the right to be fixed on canvas, to be brought to the light? Between ourselves, they are often resting from hard toil, these men who emerge from their offices and their studies. If there are some parasites among them, there are also men who have fulfilled their tasks.[63]

Even this manifesto letter, in its mention of 'parasites', hints at the shallowness and sham nature of beach society that so concerned other commentators. The previous year, after an extended stay in

the very different surroundings of western Brittany, Boudin had written to the same friend describing the beach in very different terms:

> We ended our expedition with a trip to Plougastel where we stayed for a week. We saw the most marvellous *pardons* [religious festivals] imaginable. Must I admit it? This beach at Trouville that until recently so delighted me, now, on my return, seems merely a ghastly masquerade. … When one has spent a month in the midst of those races devoted to the harsh labour of the fields, to black bread and water, and one comes back to this band of gilded parasites who look so triumphant, one pities them a little, and also feels a certain shame in painting their idle laziness.[64]

These two texts should not be used to accuse Boudin of insincerity; rather, we should see them as illustrating the complex and conflicted attitude of 'city' to 'country'. At one moment, the country is viewed as the repository of authenticity and morality; at the next it is seen as passive and inert, alongside the dynamic of progressive urban bourgeois modernity.

In the coastal scenes of Edouard Manet, Monet and Berthe Morisot in the years around 1870, the 'modern' beach plays the central role (see Section 3, pp. 75–87), and in the early 1880s Gustave Caillebotte concentrated his attention on the transformation of the coast (cat. 50). However, taken as a whole the Impressionists' coastal scenes of the 1880s do not pursue the theme of the modernity of the coastline (see Section 5, pp. 99–119). Pierre Auguste Renoir's vision of the beach became increasingly idyllic, but it was Monet who broke most decisively with the aesthetics of modernity that had underpinned his work over the previous decade or more. In his Normandy coastal scenes of 1880–86 there is virtually no sign of the new villas or hotels, and very few of his canvases include fashionable figures (but see cat. 54); it is as if the whole redevelopment of the coast had never happened. In terms of their subject matter, these canvases bring Monet far closer to the stock imagery of contemporary Salon painting (see Section 4, pp. 89–97).

How should we explain this change of direction? It belongs to a wider shift in the art of the Impressionists in the early 1880s, away from explicitly contemporary subjects to forms of art that paraded the distinctive personality and style of each artist. This coincided with radical changes in the arts policy of the government of the Third Republic, as the state began to espouse the modern urban subject matter that had previously been the province of the Impressionists.[65] In this context, Monet's virtuoso technique – his seeming capacity to find a pictorial equivalent for the most extreme effects of nature – was a marker of his unique vision (see e.g. cats 51 and 60).

However, the Impressionists' virtual abandonment of the imagery of the modern beach should also be viewed in a wider historical frame. As we have seen, the landscape painter played the crucial role of pioneer in the 'discovery' of the Normandy coast in the years before 1850. This role was by definition a solitary one; the painter stood alone surveying a hitherto undiscovered land or, rather, a landscape whose potential as a subject for painting had not previously been appreciated and appropriated by other painters.

The idea of solitary viewing also became a part of the rhetoric of the travel guide; Eugène d'Auriac articulated this clearly in 1866:

> When one wants to go sea bathing, one needs a calm site, a free choice of dress, a deserted beach; one needs to stay in one of those houses that overlooks the Ocean with its immensity in front of one, and needs to hear only the sound of the sea, almost always agitated, and not to sense a busy commercial town near to one's lodging.[66]

It was appeals such as this, of course, that made this dream impossible for the holidaymaker to realise, as more and more refugees from the city combed the coast seeking solitude.

This is part of the broader paradox of tourism. Many people travel in search of the distinctive, personal experience. Yet guidebooks and word of mouth lead travellers down the beaten track – whether, as in the nineteenth century, that track led them to sights within easy reach of the railway or, as in France today, leads them to the starred locations and viewpoints in the Michelin Green Guides. In this situation one may seek the private experience, either by trying to get off the beaten track, or by claiming to cultivate a mental distance that authenticates one's own responses even if one is surrounded by fellow tourists. Yet however far one cultivates the position of 'anti-tourist', one's points of reference remain those established by the infrastructures of transportation, information and practical resources.[67]

The position of the artist, and of landscape painting, however, was different. In practical terms, landscape painters were able to spend extended periods in their chosen locations and to explore their pictorial potential thoroughly. But beyond this there is a crucial distinction between the experience of a site and the experience of a painting. However closely the forms of the painting follow those of the natural site, it cannot be seen as a straightforward record of the site. The framed, two-dimensional image on the canvas creates a reality of its own. In part this is because the painter's personal experience has been translated into the physical medium of paint, and bears the visible signs of his or her personal mark-making.[68] But the experience of the viewer is crucially involved here too; a landscape painting presents a wholly self-contained world that the viewer is invited to visit, to inhabit, to penetrate in his or her imagination, and this experience is categorically different from the experience of visiting the site itself.

Two critics in the early 1860s articulated the reasons for excluding figures from landscape paintings, in both cases writing as if the experience of viewing the painting was a passport into the world depicted. For Maxime du Camp, the presence of a peasant figure or a sailor destroyed the charm of the picture: 'What one loves in the forests, on the meadows or beside the sea, is the absolute solitude that allows one to enter into direct communion with nature.'[69] Ernest Chesneau was more explicit about the role of the viewer in explaining how the young school of landscapists could inspire elevated feelings despite the absence of any human presence in their canvases:

> The human figure that the artist suppresses in the landscape is restored to it by the viewer; he places him in a central position, and it is himself, the viewer, who lives and thinks in the midst of the site, who enters into communication with all the forces placed before his eyes, and animates them with his own existence added to theirs.[70]

Viewed in this context, Monet's coastal scenes of the 1880s set up a special position for the viewer. We are invited to share with him the sense of discovery and excitement that he has experienced on the coast, turning his back on the new world of organised leisure, and exposing himself to the dangerous forces of the elements as he seeks out unexpected vistas, dramatic viewpoints, startling juxtapositions of forms, and extreme effects of weather — natural

beauties that he alone has seen, and whose pictorial potential he alone has appreciated.[71] The coastline may have been colonised by the holidaymaker, but it still offers novel and exhilarating experiences for the artist, as it does for those viewers who buy into his unique vision.

For Monet, in the 1880s, there was perhaps a further, more personal dimension to his voyages of discovery on the cliffs and the seashore: he was re-enacting his fondest memories of his childhood spent at Le Havre. As he recalled in an interview in 1900: 'School always felt like a prison to me, and I couldn't reconcile myself to spending even four hours a day there, when the sun was inviting and the sea beautiful, and when it felt so good to run on the cliffs, under the open sky, or to paddle in the water.'[72]

Viewed in these terms, Monet's coastal scenes of the 1880s are more comparable to Jean François Millet's views of the coast near his birthplace, Gruchy, the hamlet on the extreme northwestern tip of the Cotentin peninsula in western Normandy (see cat. 31). Millet explicitly saw his paintings of this rugged coastline as an attempt to evoke the vision of a young child brought up in this remote corner of France — a far cry from the coastline further to the east so effectively colonised by the summer holidaymaker.

In a sense we have come full circle in the story of the pictorial representation of the coast. The phase during which painters focused on the new resort culture and the presence of the holidaymaker on the beach was relatively brief, through the 1860s and the early 1870s. In the 1880s, in Monet's work, and also in the coastal scenes exhibited at the Salon (e.g. cat. 47), we are taken back to the visual world of the explorer, the pioneer. But of course there was a fundamental difference. Unlike the paintings of the actual pioneers of the years before 1850 — artists such as Mozin, Huet, Corot and Isabey — the painters who worked on the coast in the 1880s were living and working within the culture of the bourgeois summer holiday. As they explored the cliffs and beaches, the villas and hotels of the resorts lay just behind them. Moreover, their canvases, on display in Paris, offered the fantasy of escape from the fellow holidaymaker to viewers who themselves belonged to that culture. The pristine natural world the paintings created gained its meanings through its difference from the world that painters and viewers alike inhabited.

ACKNOWLEDGEMENT

For the broader ideas in this essay, I am particularly indebted to Rouillard 1984, Corbin 1995 and Urbain 2003, beyond the specific references to these texts in the notes. I am most grateful to David Hopkin, Suzanne Glover Lindsay and Nancy Rose Marshall for their valuable comments on drafts of the essay.

NOTES

All translations from the French are the author's own.

1 Glasgow 1992, pp. 49–50.
2 Joanne 1866, pp. 390–1.
3 By 'fine art painting' I mean works designed to be displayed and sold within the institutional frameworks of the art world – at the Salon or in other fine art exhibitions, or through art dealers.
4 The Salon was the vast art exhibition in Paris, mounted annually through most of the period covered by the present exhibition, and organised by the state until 1880.
5 See Désert 1983, pp. 119–23.
6 See Cabantous 1993, who emphasises that the ransacking of shipwrecks was in fact a less common practice than it was made out to be.
7 Corbin 1995, pp. 225–9.
8 Karr 1845.
9 Maupassant 1883.
10 See Pakenham 1967, pp. 17–34.
11 See Corbin 1995, pp. 273–5.
12 On this, see especially Rouillard 1984, Chapter 2, 'Image de la formation ou genèse imaginaire'.
13 On this pattern, see Morlent 1862, Bertall 1880 and Humphreys 1884. See also Rouillard 1984, pp. 52–4.
14 For Robinson Crusoe, see e.g. Joanne 1866 (quoting Auguste Villemot, discussing Houlgate). For Columbus, see e.g. Chapus 1855, 1862 edition, p. 250 (discussing Etretat); Joanne 1866, p. 397 (quoting Charles Deslys, discussing Villerville); Conway 1867, p. 26 (discussing Mozin's discovery of Trouville). For Cook, see e.g. Dumas 1989, 2, p. 515 (discussing his own discovery of Trouville). On this pattern, with special reference to the image of Robinson Crusoe, see Urbain 2003, especially pp. 14–26, and Rouillard 1984, p. 63.
15 See e.g. Joanne 1866, pp. 116–9, and Auriac 1866, pp. 173–7 (quoting Karr's own account of the 'discovery'). On Etretat's history and reputation, see Herbert 1994, pp. 61–9.
16 Joanne 1866, pp. 396–7.
17 See Joanne 1866, pp. 390–1; Morlent 1862, pp. 285–6; Chapus 1855, 1862 edition, pp. 274–7; Huet 1911, pp. 106–7 (where it is emphasised that Huet visited the place a year before Dumas).

18 See e.g. Joanne 1866; on the range of types of writing, see Rouillard 1984, pp. 45–9 and 341.
19 See the map in Désert 1983, pp. 28–9.
20 On this distinction, see Herbert 1994, pp. 2–4, and especially Urbain 2003, the same contrast is drawn in Conty 1876, p. 11, between excursionnistes and baigneurs.
21 Conty 1876, p. 162.
22 See Urbain 2003, pp. 37–66 and David Hopkin's essay in the present catalogue.
23 See e.g. Blackburn 1869, pp. 279–80, on Etretat, and Macquoid 1874, pp. 316–7, on Trouville.
24 Blackburn 1869, pp. 129–32, quotation from p. 132, engraving opposite p. 132.
25 See e.g. Morlent 1862, p. 282, discussing Villerville; Bertall 1876, pp. 569ff; Bertall 1880, 'Etretat', pp. 3–4.
26 On the idea of 'landscape' as implying a distinctive way of seeing, see London 1995, pp. 12–14.
27 See especially Rouillard 1984, pp. 107–42.
28 See e.g. Le Roy 1865, pp. 8–10, who emphasises the visible good health of the local population on the coast.
29 See also James 1869, pp. 334ff.
30 Hareux 1891–93, pp. 48–9.
31 See e.g. Morlent 1862, pp. 113–15; Blackburn 1869, p. 271.
32 Michelet 1983, pp. 277–8.
33 Flaubert 1910, 1, p. 507.
34 Chapus 1855, 1862 edition, p. 277.
35 See e.g. Auriac 1866, p. 216.
36 See e.g. Chapus 1855, 1862 edition, p. 260.
37 L'Illustration 1844, p. 4.
38 Chapus 1855, 1862 edition, pp. 273 and 276.
39 Richard 1856, p. 344.
40 Morlent 1862, p. 289
41 Joanne 1866, p. 391.
42 Conway 1867, p. 27. For another very positive account of Trouville from the mid-1860s, see Auriac 1866, pp. 216–17.
43 Blackburn 1869, pp. 267–8.
44 [Marshall] 1871, pp. 481–3.
45 Macquoid 1874, p. 317.
46 Conty 1876, p. 163.
47 Michelet 1983, p. 309
48 Conty 1876, p. 107.

49 Conway 1867, p. 27.
50 See e.g. Castagnary 1861, p. 61; Merson 1861, pp. 357–8.
51 Letter from Huet to Auguste Petit, April 1863, in Huet 1911, pp. 339–40.
52 Castagnary 1892, 1, p. 139.
53 Chesneau 1864, pp. 167–8.
54 Chapus 1862, pp. 250–61. As Robert Herbert has shown (Herbert 1994, pp. 64–5), the engraving is closely based on an engraving of the 1830s after the English artist Clarkson Stanfield.
55 On these, see Shaw 1991.
56 Thoré 1870, 2, pp. 281–2; on this see House 2003, pp. 11–13.
57 The painting was acquired by the museum in nearby Lisieux in 1851.
58 This notion of the flâneur may be linked with the ideas presented in Charles Baudelaire's essay 'Le peintre de la vie moderne', and stands in contrast to the notion of the flâneur as analogous to the detective; for further discussion of this distinction, see House 2004, pp. 37–8.
59 See e.g. Bertall 1880, 'Etretat', pp. 5–6
60 Castagnary 1892, 1, p. 374.
61 Goncourt 1867, 2, pp. 166–74. The Goncourts recorded their impressions of Trouville in their Journal for July 1864 (Goncourt 1989, 1, pp. 1,086–9).
62 Chesneau 1868, p. 334.
63 Letter from Boudin to Ferdinand Martin, 3 September 1868, in Jean-Aubry 1922, pp. 70–1.
64 Letter from Boudin to Ferdinand Martin, 25 August 1867, in Jean-Aubry 1922, p. 65.
65 See House 2004, Chapter 6.
66 Auriac 1866, p. 183.
67 For further discussion of these issues, see Buzard 1993, Culler 1988 and Herbert 1994.
68 The Impressionists' choice of the term 'sensation' to characterise the experiences they were trying to translate into paint made it clear that they viewed these experiences as subjective, uniquely personal to each artist (see Shiff 1984).
69 Du Camp 1861, pp. 145–6.
70 Chesneau 1864, pp. 207–8.
71 For further discussion, see House 1986, pp. 140–6; Herbert 1994, pp. 108–112.
72 Thiébault-Sisson 1998, p. 9.

CLAUDE MONET, detail of cat. 51

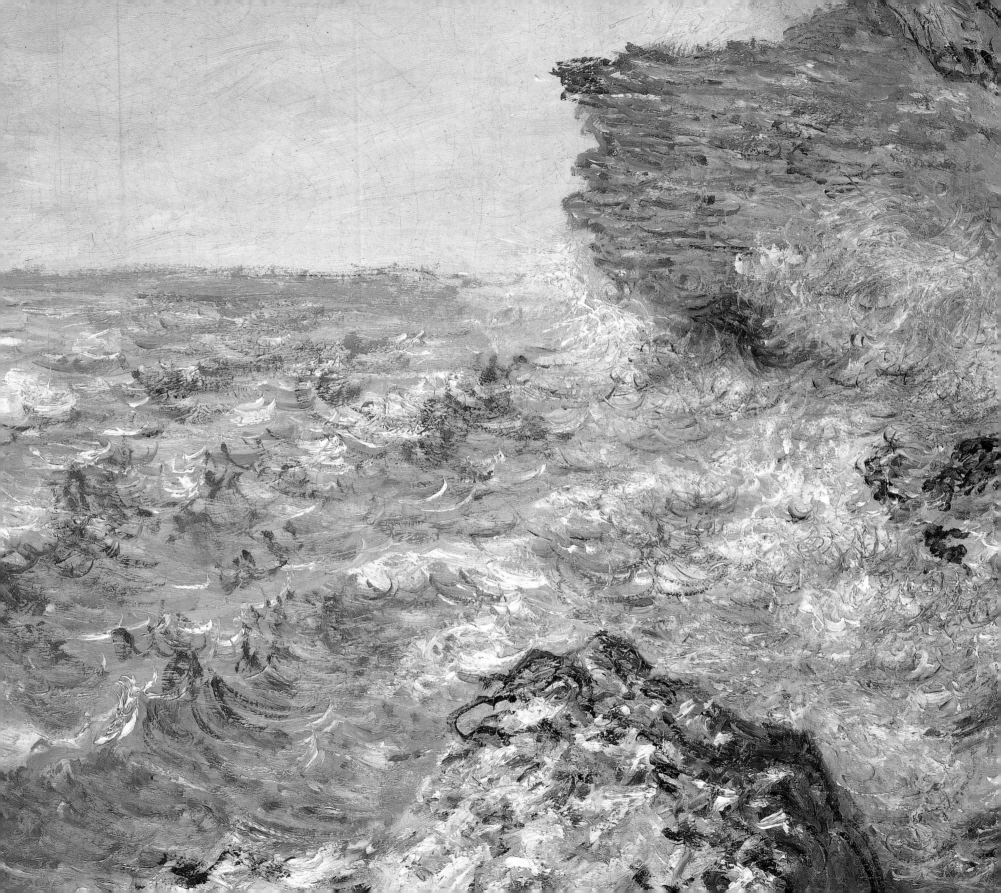

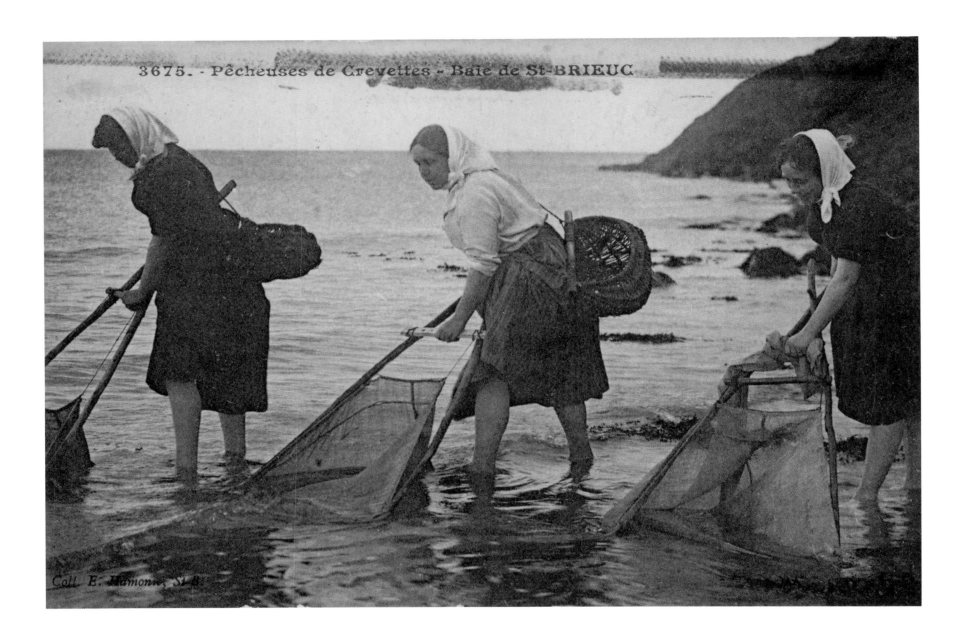

Fig. 20
'Pêcheuses de crevettes, Baie de St Brieuc'
(Shrimp fisherwomen, St Brieuc Bay),
c. 1900. Postcard.

This was just one of many ways in which
women made a living from the beach.

Fishermen, Tourists and Artists in the Nineteenth Century: The View from the Beach

DAVID HOPKIN

The Channel beaches were not, in the nineteenth century, spaces entirely devoted to leisure; they were, still, places of work for numerous fishing communities. Each low tide revealed an expansive terrain for laborious exploitation. The artists and writers who were early 'explorers' and 'discoverers' of future tourist resorts took an almost anthropological interest in the aborigines of the littoral. The romantics and realists foregrounded their dress and customs, while writers such as Gustave Flaubert presented them as a 'race apart'. 'Nothing could be more barbarous,' wrote François Coppée in 1893 about the women of Plomeur in Brittany: 'It makes one think of Iceland and Lappland.'[1] These were the noble or not so noble savages of France's domestic empire. As John House discusses in his essay in this catalogue, the later Impressionists were less interested in fishermen's picturesque qualities than in 'natural' motifs, and so removed the locals from the landscape.[2] According to the French sociologist of the beach holiday, Jean Didier Urbain, this was the precursor to their actual exclusion. The beach became 'virgin land' through its presentation by artists, available for development by tourist entrepreneurs and their paying customers.[3] In an echo of contemporary events in the New World, the internal colonisation of France required the extinction of its ethnically separate populations, culturally if not physically. And yet, as is demonstrated here, there remained traces of their presence.

In art as in life, women were the more obvious exploiters of the productive potential of the beaches. We see them at their laundry (utilising freshwater streams rather than seawater) (cat. 3), or going with their baskets to harvest mussels, razor clams and other shellfish, or armed with triangular nets to fish for shrimps (cats 30 and 47, and fig. 20). Occasionally they are pictured tending flocks on cliff-top pastures; few families relied entirely on the produce of the sea, but with the men away agricultural tasks devolved to women and children. And so we also see them gathering and burning seaweed on the beach for fertiliser. The Cancalaises and Granvillaises are shown tending their oyster parks which, like other landed property, passed down in the female line (cat. 46).

The products of the beach were not primarily for domestic consumption. If they were not destined, like lugworms and sea snails, to provide bait for the fishermen, then they were carried to market in nearby towns. Women were *mareyeuses*, brokers between the fishing fleet and the urban food market. And so we see them unloading, gutting, salting, hawking and 'crying' (auctioning) the fishermen's capture. For some this created entrepreneurial opportunities in the retail trade, but for most women this combination of activities was simply what they needed to do just to survive in what historians term 'an economy of makeshifts'.[4] As the century wore on and fishing became more industrialised, and more processed, women would become the proletarian workforce of the canning factories. But here they were less visible to artists and tourists.

Control of property and direct involvement in the market meant fisherwomen had more economic power than many other women of the labouring classes. Indeed, the men's wages, or a substantial part of them, were often passed directly from shipowners to the wives. In addition to controlling the purse strings, women occupied most of the social spaces of the village, including the beach. Men ashore were out of place. Banished from the house, they loafed

around the quayside where they were available to become that stock character of travel literature and tourist encounters occasionally also encountered in art, the yarning sailor. Storytelling, an activity usually associated with women, became a male prerogative on the coast, just one sign of the reversal of gender roles in fishing communities that so fascinated visitors (fig. 21). Fisherwomen were depicted as raucous, foul-mouthed and even physically aggressive, utterly at odds with the norms of feminine behaviour of the urban middle-classes that were on display in the neighbouring hotels and tea rooms. The stereotype is overstated, but it is not entirely without foundation, as the police court reports of any maritime conglomeration will attest. However, the term 'matriarchy' sometimes deployed by nineteenth-century writers is more contestable.[5] Unlike other work communities, in which a gendered division of labour produced a sexual hierarchy with men on top, fishermen and their wives were more equal partners in a joint undertaking. But the women still defined themselves around the men's occupations; her numerous economic activities were arranged to support his. In any case, to assess their relationship in terms of a distribution of authority is to miss that both were subject to a much more powerful agent – the sea. The saying 'Here it's the fish that give the orders' was commonplace.[6]

Fishermen are less visible in paintings of the shore. More than 10,000 men from the Norman and Breton littoral were employed as *terre-neuvas* (Newfoundlanders) fishing for cod on the Grand Banks of Newfoundland. They left the ports of Fécamp, Granville, Cancale and Saint-Malo in early April and did not return till October.[7] From adolescence to old age (should they live to see it) they never experienced what holidaymakers had come to enjoy – summer in their own land. Several thousand more undertook a similar journey from Dunkirk or Paimpol for the fjords of Iceland.[8] Accounts left by the few visitors to this floating world, usually naval doctors, present pictures of unrelenting toil and misery in a context of ever-present danger. Exhausted sailors relieved their frustrations through drink and violence, often directed against younger crew members. It is to be hoped that the worst ships, sometimes witnesses to murder or suicide, were not typical, but even in the annals of the nineteenth-century labouring poor the Grand Banks were a harsh environment.[9] Six to seven months of this labour would, if the catch were good, net an established crew member somewhere between 500 and 700 francs – less than the cost of a

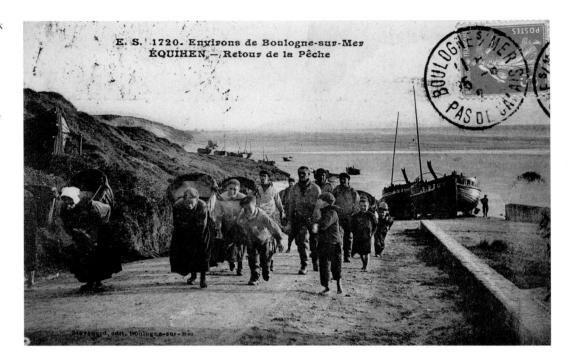

E. S. 1720. Environs de Boulogne-sur-Mer
ÉQUIHEN. — Retour de la Pêche

Stevenard, édit. Boulogne-sur-Mer

Fig. 21
'Equihen – Retour de la Pêche'
(Bringing home the catch at Equihen),
c. 1898. Postcard.

The reversal of expected gender roles
in fishing communities fascinated visitors.

fortnight's stay in one of the more fashionable Normandy resorts.[10] After a poor voyage he might actually come back in debt to the shipowner, because the men were not waged but, rather, took shares in the catch, with bonuses for individual performance. As a result everyone on board was a potential rival, exacerbating tensions in the cramped and insalubrious cabins, and encouraging risk taking so that ships left port too early or waited too late to return and were caught in equinoctial storms (fig. 22).

Men were also absent in that many of them were dead. At the turn of the century, mortality on the deep-sea fishing fleet per 'campaign' ran at about 4 per cent per annum. Men fell from the rigging or got lost in their dories (small skiffs used to make the actual catch and which operated up to 6 kilometres out from the mother ship); wounds from hooks and gutting knives festered and led to blood poisoning. Ships were run down in the fog by transatlantic liners or, old and worm-eaten, simply went to pieces in high seas. If we are to believe doctors' reports, accidents were often associated with massive alcohol consumption. The loss of a ship *en ressac*, carrying home the hundreds of fishermen who had crewed the fleet of yachts operating out of the tiny French colony of Saint-Pierre et Miquelon, could decimate a village.

Fig. 22
André Petitjean, 'Iceland Fishermen:
the Crew of the yacht *La Glaneuse*',
8 May 1893. Photograph.

The North Atlantic fishing grounds were tough
working environments and there can be little
doubt, looking at images such as this, that they
bred hard men.

Those men not engaged in high-seas enterprises, which in many areas meant principally the young, the old and the infirm, were employed on the inshore fishing fleet. Inshore vessels and their crews are more visible in this exhibition, though the motif of sails at sea has become so much a part of the art accompanying the leisure economy it is difficult to remember that, in nineteenth-century paintings, almost every one of these represented a working boat (cats 67 and 68). Aspects of boat design captured by artists can help maritime experts identify either their port of origin or the kind of labour they were involved in: such as trawling for herring, line fishing for flatfish or laying lobster pots.

However, one can overplay the degree of specialism: a boat that one day raced to put a pilot aboard a cross-Channel steamer might on the next serve as a lifeboat, and the next as coastal freighter, with a cargo of rocks collected on the beach sold as ballast for larger ships, and the next fishing for mackerel. When not at sea such vessels were often pulled up on the strand itself, as we see them in Claude Monet's views of Etretat, because the French Channel coast was desperately short of decent harbours (cat. 63). And so the

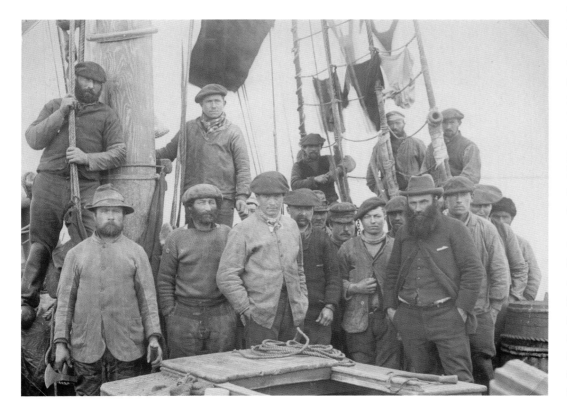

beach, once again, became a scene of labour as wives winched the loaded boats slowly up the incline. Once the catch was landed it might be cried there and then for the benefit of tourist customers.

Inshore fishing was considered safer than its deep-sea counterpart, but freak weather and the absence of harbours could likewise rob a community of its menfolk. As not all fishermen could swim, silly accidents in calm weather and in sight of land could still lead to disaster. Even in an age when workplace accidents were a major component of mortality figures, the sea was undoubtedly the most hazardous environment in which to work (as it still is, of course). Given this high mortality, it is ironic that sea bathing was promoted by lauding fishermen's supposedly healthy lifestyle.

Summer visitors were not entirely unaware of the risks run by their hosts and neighbours. Indeed, there was even what might be termed a tourism of fishermen's misfortunes. Pierre Loti's novel *Pêcheur d'Islande* about the hard life and premature death of a Paimpol sailor initiated a whole genre of fictionalised maritime misery.[11] There are at least half a dozen children's books from the turn of the century that take as their subject the vicissitudes of a cabin boy employed on the Grand Banks.[12] One could also listen to music-hall songs, read articles in *Le Petit Journal*, and send postcards featuring 'the martyred cabin boy' – sadly not an entirely invented trope. There is, perhaps, something distasteful about this vicarious enjoyment of others' sufferings. However, one must also acknowledge the benefits such public attention brought. Loti himself was active in raising money for the widows and children of shipwrecked sailors, and other visitors supported philanthropic efforts to organise hospital ships, fishermen's hostels, lifeboats and other services.[13] Newspaper campaigns also helped tighten the legislative framework surrounding the employment of children at sea.

Fishing was often dangerous, and always chancy. Fishermen were dependent on tides, winds and other variables that were impossible to control. A harvest on which whole communities depended, such as the herring, might for reasons unknown desert the coast for years at a stretch. These factors explain another aspect of fishermen's 'exoticism' that so fascinated visitors – their relationship with the supernatural. Artists and travel writers created an image of picturesque piety: of sailors carrying model ships to offer before statues of Notre-Dame Stella Maris, while their wives prayed before cliff-edge calvaries for the safe return

of their menfolk. Tourists loved to witness the blessing of new boats, or fishermen singing hymns aboard their ships as they passed seaside shrines such as that at Berck, or making barefoot pilgrimages to chapels. The influence on artist-visitors of the painted ex-votos that decorated such sites, given in performance of a vow made in extremis and which depicted the direct intercession of the saints in the lives of mariners, is yet to be explored, but may be detected in the work of Paul Gauguin at Pont-Aven, for example.

In reality the religiosity of maritime populations, as measured in more orthodox terms such as the taking of the sacraments and willingness to follow the political line laid down by the Church, was extremely variable. Some were judged 'good' by their priests, others combined popular piety with virulent anticlericalism, while yet others were considered essentially pagan. As the development of mass tourism coincided with a ferocious battle between Church and state in the early Third Republic, the Catholic hierarchy worried that tourists' urbane attitudes of secularism and materialism would rub off on those fisherfolk still deemed dependable. In fact visitors may have had an opposite influence, as the performance of colourful Catholic rites, such as the *Pardon des terre-neuvas* in Saint-Malo, at least in part put on for tourists, actually generated a sense of occupational piety.[14]

Did fisherfolk object to this observation of their observances? Did they resent the intrusion of holidaymakers into their places of work and worship? Did the erection of boardwalks, cabins, deckchairs, bathing platforms and other impedimenta lead to quarrels between natives and incomers? Did they battle the claims of seaside entrepreneurs, with local officials in their pocket, to the exclusive control of the beach? The answer to all these questions is yes, but perhaps not quite to the extent one might have expected.[15] One reason for this is that conflict about who owned and who used the beach was nothing new. It was not as if the juggernaut of mass tourism simply crushed a traditional way of life – fishermen had always had to compromise with other claimants.

Before the Revolution, various secular and ecclesiastical lords had professed the privileged right to erect fish farms and fish traps, or to tax the produce of the foreshore. Their claims were contested from below by littoral communities, and from above by the state. In 1681 Louis XIV's minister Colbert had asserted the king's authority over this territory, although almost immediately this example of

'absolutism' was diluted with individual grants and widespread derelictions. The king wanted control in order to make the coast a firmer boundary of his kingdom, part of fortress France as designed by his chief military architect Vauban. In the seventeenth and eighteenth centuries the coast was a potential battleground in the long series of wars for maritime supremacy between France and Britain; sizeable British forces were landed at Cherbourg, Cancale and Saint-Briac in 1758 alone.[16] And then there was the even longer guerrilla war against smugglers and wreckers, the former a major industry in the eighteenth and early nineteenth centuries.[17] Tall tales of their exploits were, of course, part of the attraction of the coast for holidaymakers who visited the caves used as hideouts and sat astride old cannons to have their photographs taken. However, although customs officials were still part of the everyday life of fishing communities, this battle was more or less won by the 1830s, well before the large-scale development of bathing resorts. Its physical legacy is nonetheless apparent in these paintings: militia watch-posts and customs lookout points either feature as motifs, or artists borrowed them to establish their own 'views' (cat. 53 and fig. 23).

Other battles with the state were not over. In 1853 the Minister of Marine Affairs issued a decree requiring all forms of fishing

Fig. 23
'Le Portel. Vue de la Plage, prise du Parapet'
(Le Portel: View of the beach taken from the parapet), c. 1900. Postcard.

Fishermen watch the antics of holidaymakers. Men on shore were out of place, and banished from home they took up position on the quayside or, as here, adapted the geography of the militarised coast to their own social needs.

E. S. 733. Environs de Boulogne-sur-Mer LE PORTEL
Vue de la Plage prise du Parapet

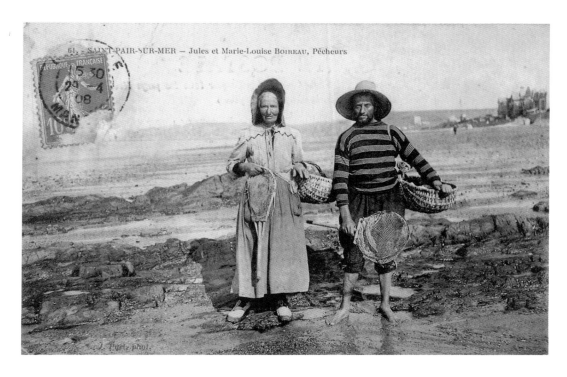

61. SAINT-PAIR-SUR-MER — Jules et Marie-Louise BOIREAU, Pêcheurs

Fig. 24
'Saint-Pair-sur-Mer. Jules et Marie-Louise Boireau, Pêcheurs'
(Saint-Pair-sur-Mer. Jules and Marie-Louise Boireau, fisherfolk), 1908. Postcard.

During the summer, Jules Boireau worked as a swimming instructor, but here we see him equipped to harvest the beach, illustrating how local populations combined traditional practices with seasonal service provision as part of their 'economy of makeshifts'.

'on foot', including shrimps, oysters and mussels, to seek prior authorisation. Some communities, particularly in Normandy and the bay of Saint-Michel, fought regulation for more than 30 years. The issue was less about clearing the ground for touristic exploitation than about preserving stocks, but the long-term effect was to empty the beach of competing users.[18] If fishing populations finally submitted, as they had previously to the customs regime and the military organisation of the coast, it was because the state did not just impose itself with a stick, it also dangled a carrot. All governments, from Louis XIV onwards, had maintained a genuine interest in fishermen because they were the primary providers of manpower to the navy. In 1668 the same Colbert had instituted a system of conscription affecting only *gens-de-mer* (seafolk) through which a few years' naval service was rewarded by a lifetime monopoly on all maritime activities and a pension at the end of 30 years. Along the whole coast syndics were established to ensure both that mariners abided by the rules and that no one trespassed on their prerogatives. A peasant could not just get into a boat and catch some fish: he had to be 'inscribed' first. What welfare services fishermen received, at sea as on land, were largely under the auspices of the state. In consequence of this long-standing

relationship, fishermen could be surprisingly pliant in the face of governmental authority.

The other reason why fishermen readily established a modus vivendi with visitors is that they quickly learned that they were a valuable source of extra income. Selling one's catch to customers locally was preferable to making the arduous and potentially dangerous trip around the headland to the nearest major town. The seasonal arrivals and departures of holidaymakers fitted neatly into the existing 'economy of makeshifts'. A fisherman could transform himself into a swimming instructor for the season, before returning to his boat in the autumn (fig. 24). A woman whose *terre-neuva* father or sons were on campaign on the Grand Banks could rent their rooms out. There was a whole range of services that locals provided to tourists in return for money: they took in washing, sold donkey rides, became bathing-cabin attendants and lifeguards, offered boat trips around the bay, guided the curious to beauty spots and carried the easels of artists. Even sitting as a model probably involved a small financial transaction. No wonder fishermen were prepared to share their space, or divide it as at Etretat where the eastern half of the beach was reserved for fishing and the western half for leisure. Where no such arrangement was possible, money raised through municipal taxes on tourists paid for the building of jetties and harbours. Although this has been portrayed as a ghettoisation of the natives, fishermen themselves were active campaigners for such developments, because they improved their daily lives.

As John House demonstrates in this catalogue, artists were often the outriders for the tourist industry. In addition to splendid landscapes and genre subjects, the seaside provided cheap living. However, having made a place fashionable the artists were forced out by the purchasing power of the leisured classes and moved further and further west into the rougher and more 'foreign' territory of Brittany until some, like Gauguin, fell off the continent altogether. More canny artists turned their 'exploration' to financial advantage. The watercolourist Alfred Marinier, on a painting trip to Saint-Cast, recognised that its long white beaches were ideal resort material and bought up the undeveloped dunes, turned them into plots for villas, and constructed the large hotel Ar Vro whose dining rooms he decorated with seaside motifs (fig. 25). His son-in-law, Edouard Alix, a prolific author of guidebooks sold at railway kiosks, promoted the new resort in his publications.[19]

Artists like Marinier turned the coast into a series of views packaged and sold to an urban audience, creating a desire to experience the seaside. The problem was that visitors therefore came with established notions about what the shore should look like. They wanted to see what the artists had shown them: the fishing fleet setting sail, the unloading of the catch, the women waiting on the headland. Association with the 'toilers of the sea', whose lives were judged somehow more rooted, more authentic than those lived in cities, was part of the seaside experience. Yet their very presence made fishing a less attractive means to make a living compared with the new service industries. Fisherfolk were becoming, to use the jargon, 'acculturated'. In truth fishing communities had never been quite the isolated tribes of the romantic imagination. The sea was, after all, a highway of communication. However, cultural transmission was greatly speeded up by the seasonal conjunction of visitors and locals. Tourists *en pension* left their magazines and books in the homes of their hosts. Fisherwomen saw the new Parisian styles paraded on the boardwalk. As Paul Sébillot, a landscape painter turned anthropologist of the coast, noted in the 1880s, local women were beginning to emulate not only urban fashions, but the notions of proper feminine behaviour that had shaped them.[20] The exoticism of the gender relations of fisherfolk was being eroded.

For purveyors of the picturesque this was bad news: their audience came wanting to experience cultural difference. And so the promoters of tourism went to considerable lengths to ensure that customs were preserved or, as in the case of the *Pardon des terre-neuvas*, invented. Women were encouraged to wear their lace headdresses, which became increasingly elaborate as they became 'heritage'. Fishermen were paid to land their catch on the beach, even if this fish had only come from the wholesale market and not direct from the sea. Rather than living a traditional life, fishermen were performing it for the benefit of tourists. They had become part of the heritage industry.[21]

Fig. 25
Alfred Marinier,
The Sunken Paths of Saint-Cast, c. 1885
Oil on wood, 160 x 70 cm.
The Ar Vro building (formerly the Grand-Hôtel de la Plage), Saint-Cast

Fig. 26
'Paris-Plage – La Pêche à la Crevette'
(Paris-Plage: fishing for shrimp), c. 1900.
Postcard.

Holidaymakers mimicked the actions of fisherfolk.

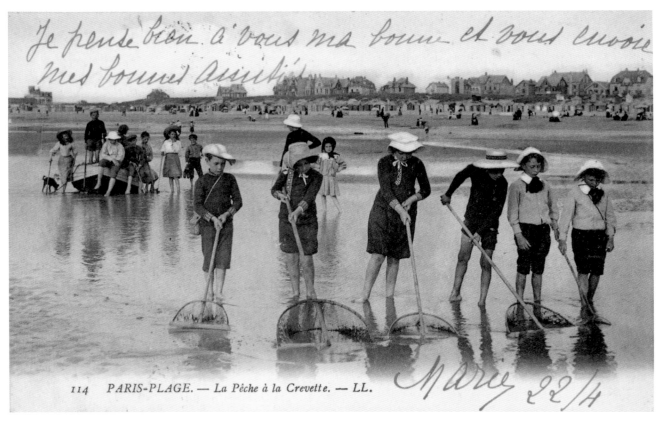

Je pense bien à vous ma bonne et vous envoie mes bonnes amitiés

114 PARIS-PLAGE. — La Pêche à la Crevette. — LL.

Fig. 27
Paul Sébillot,
Mouth of the River Trieux, Roche-Hir, 1879.
Oil on canvas, 168 x 232 cm.
Musée de Saint-Brieuc

NOTES

All translations from the French
are the author's own.

1 Duigou 1985, p. 7.
2 See also Herbert 1994, pp. 104 and 129.
3 Urbain 2003, p. 40.
4 See Le Bouëdec 2004.
5 Guichard-Claudic 1998.
6 Deldrève 2004.
7 Grossetête 1988.
8 Chappé 1990.
9 Cuny 1904.
10 Lognone 1985.
11 Loti 1886.
12 See, for example, Giron 1887.
13 Darrieus 1990.
14 Cabantous and Hildesheimer 1987.
15 There is a recent, excellent study of
 this process in the Gascogne resort
 of Arcachon; see Garner 2005.
16 Middleton 1993.
17 Cabantous 1993.
18 Sinsoilliez 1994.
19 Toulier 1998.
20 Sébillot 1997.
21 Garner 2005, pp. 175–194.
 For comparison see Nadel-Klein 2003.
22 Urbain 2003, pp. 40 and 51.
23 Sébillot 1998–2000.
24 Letellier 1999.
25 Hopkin 2005.

For Urbain this 'submersion of the local culture by leisure' was 'nothing less than the social falsification of the site and the disintegration of its inhabitants' daily lives.'[22] But such a negative judgement overlooks that visitors were involved not just in cultural imposition, but in a cultural exchange. Fishermen became more like Parisians, but Parisians also became a bit more like fishermen. One of the early Romantic explorers of the coast, Alphonse Karr, went native and wore a seaman's cap and boots, starting a fashion for maritime bohemianism that is still very much with us today. Visitors imitated the working lives of fisherfolk, taking off their shoes and pulling up their petticoats to gather shellfish or shrimp in the shallows (fig. 26). And while this was play, it may have taught bourgeois ladies something of the physical and verbal freedom of fisherwomen, and thus contributed to the creation of the late nineteenth-century 'new woman'.

To lament the destruction of the 'authentic' lives of fishermen would also ignore the degree to which these had always been performances. Operating in an oral culture with little use for the written word, fishing communities' own understandings of their world seldom made their way into the archives used by historians. So the personal testimonies collected in the 1870s and 1880s by Paul Sébillot in the fishing hamlet of Saint-Cast offer a rare insight.[23] Although these were presented as folktales, that is as fictions, it is not difficult to connect the situations depicted with the life stories of their tellers, nor to hear in them the expression of personal hopes and fears, particularly in those told by the young men and boys who were his most forthcoming informants. This group were preparing for their first voyage on the deep-sea fishing fleet, and their anxieties about what to expect on the Grand Banks are all too apparent. We can see them learning through performance the attitudes and outlook of 'an old sea-wolf', the epitome of maritime masculinity and the character they needed to adopt if they were to survive in this harsh environment. But this performance required a constant exertion of will, a never-ending 'mastery of self' as one cabin boy turned autobiographer put it, which was exhausting for those who could manage it, and potentially fatal for those who could not.[24] It is unsurprising, then, that many took the opportunity offered by the tourist influx to escape the sea. Sébillot himself provided one such route out of fishing. Politically well connected, he acted as patron to his young informants, finding them jobs in the customs service, on the railways and other less demanding, and often better rewarded, occupations.[25]

Like the paintings on display here, these tales were brought back by a visitor to the coast, Sébillot, as a souvenir of a brief, vicarious experience (fig. 27). They are proof that the transmission of culture was not a one-way process. But they offer a very different, insiders' vision of the sea and those who made their living from it than that purveyed by artists and writers. This is not to suggest that all fishermen saw when they looked out from the beach was fish stocks and fate. They too had their own 'romance of the sea', but one based on a personal struggle for social success that could only be achieved at immense physical, and perhaps emotional, cost. As Sébillot knew, the decline of a tradition was not always experienced as a loss.

Catalogue plates

with section introductions by JOHN HOUSE

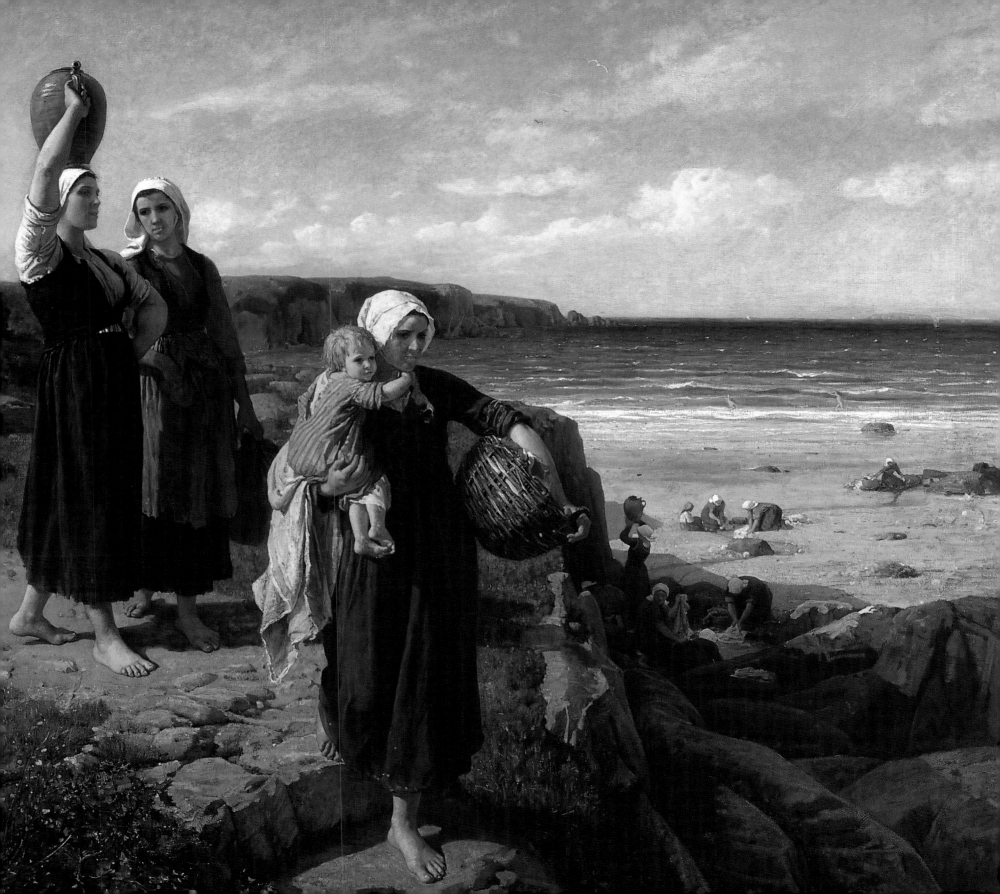

1 The Public Face of the Coast

In the years around 1860, marine painting was widely believed to be in deep decline. Only a few pictures of stormy seas and shipwrecks, together with canvases of naval military engagements, appeared at the exhibitions of the Paris Salon. The most celebrated painter of coastal scenes was Eugène Isabey, who was especially noted for his paintings of storms on the seashore, seen here in *Low Tide* (cat. 1), a romantic vision of the coast that dramatises the struggles of coastal fishermen against the forces of the elements.

Local peasant women were a very popular subject in French painting in these years; in paintings of the coast they were generally depicted working, either seeking shellfish on the beach or going about their daily business on the shore. These canvases focused on the regions of France that were noted for their distinctive regional costume, and especially on Brittany. Jules Breton's canvas *A Spring by the Sea* (cat. 3) emphasises the dignity and homogeneity of the peasant community on the Breton coast as they go to collect water from a freshwater spring on the beach; by contrast, James Abbott McNeill Whistler's solitary figure in *Alone with the Tide* (cat. 2) is still and inactive, her isolation heightened by the wide expanses of beach and sea.

A few painters during the 1860s took up the subject of fashionable holidaymakers on the beaches of the rapidly developing coastal resorts of Normandy. Most notable of these was Eugène Louis Boudin, who exhibited a sequence of paintings of the beach at Trouville at the Salon, including cat. 5, in which the groups of figures perform their social rituals apparently wholly uninterested in their natural surroundings. Isabey's canvas (cat. 4) representing women bathing at Granville, on the rocky western coast of Normandy, is exceptional in his oeuvre, and brings together the theme of holidaymakers with his interests in effects of stormy weather.

The sombre colours and tonal contrasts of Isabey's canvases emphasise the drama of the elements, while Boudin adopted a luminous, blonde tonality that conveys the distinctive qualities of light and atmosphere on the Normandy coast.

1

EUGÈNE ISABEY
Low Tide, 1861
Oil on canvas, 84 x 124 cm
Musée Malraux, Le Havre.
Dépot du Musée du Louvre, 1961

43

2

JAMES ABBOTT McNEILL WHISTLER
Alone with the Tide, 1861
Oil on canvas, 87.2 x 116.7 cm
Wadsworth Atheneum Museum of Art, Hartford, CT.
In memory of William Arnold Healy, given by his daughter, Susie Healy Camp

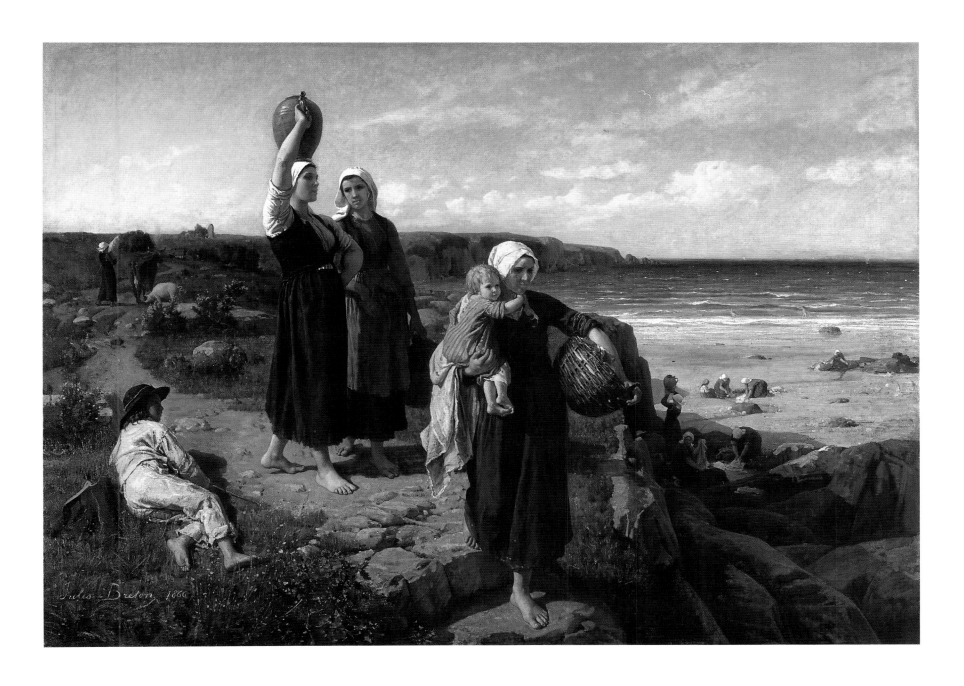

3

JULES BRETON
A Spring by the Sea, 1866
Oil on canvas, 110 x 155 cm
Private collection

45

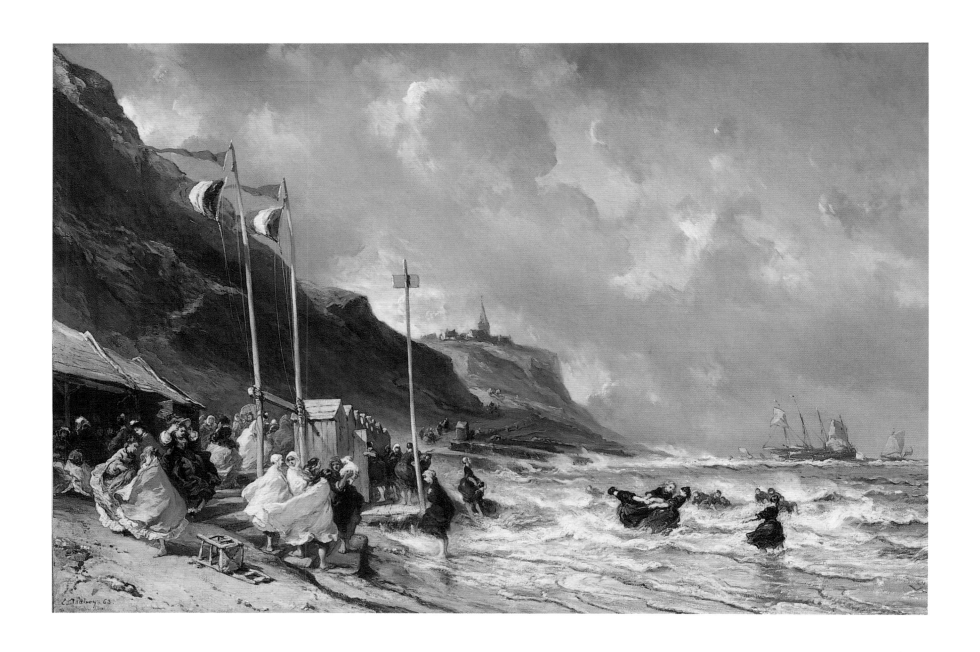

4

EUGÈNE ISABEY

The Beach at Granville, 1863

Oil on canvas, 83 x 124 cm

Musée du Vieux-Château, Laval

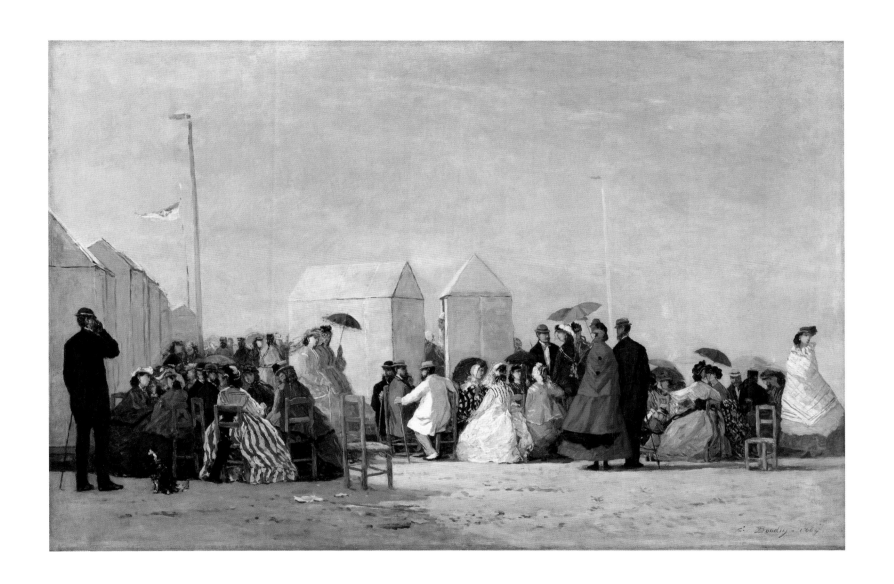

EUGÈNE LOUIS BOUDIN
The Beach at Trouville, 1864
Oil on canvas, 67.5 x 104 cm
Collection Art Gallery of Ontario, Toronto. Anonymous gift, 1991

2 Before Impressionism

Open-air sketching in oils had been common among landscapists working on the northern French coast since the 1820s, pioneered by painters such as Jean Baptiste Camille Corot, Paul Huet and the Englishman Richard Parkes Bonington. By the 1850s smaller, more informal canvases of the coast were finding a market through art dealers – canvases suitable for private collectors, but not for the crowded walls of the Paris Salon. The beaches of Normandy were the most popular site among painters, but their subjects ranged along the entire northern French coast.

Dramatic effects of stormy seas remained a popular theme, as seen in Jules Dupré's *Marine Landscape (The Cape and Dunes of Saint-Quentin)* (cat. 27); Gustave Courbet, in his canvases of breaking waves, took up this theme, heightening the impact of the scene by directly facing the sea (cat. 26). Working at Trouville and Deauville, Courbet also pioneered the view out to sea that focused on the play of light and colour over wide sands and calm water, often depicting rain showers or vivid sunsets (cats 18–21); working alongside Courbet, James Abbott McNeill Whistler created atmospheric effects of particular finesse (cats 23 and 24).

When painting the coastline, most artists sought sites that were untouched by the developments of seaside resorts along the coast; the canvases by Corot, Johan Barthold Jongkind and Charles François Daubigny (cats 7, 9, 10, 28 and 29), together with Claude Monet's first views of Sainte-Adresse of 1864 (cats 11 and 12), follow this convention; the only signs of human activity are supplied by the local fishermen, their equipment and their boats, at sea or on the beach. In Jules Héreau's canvas (cat. 30), the fisherfolk are the main focus. In all of these canvases, though, the painters also show their interest in the effects of light and weather on the coast.

In contrast to these local figures, Eugène Louis Boudin popularised the theme of the fashionable holidaymaker on the beach in his long sequence of canvases of the seashores at Trouville and Deauville, begun in 1862, in which he focused on the social rituals on the beaches during the summer season, framed on one side by the sea, on the other by the hotels, villas and casinos along the shore (cats 13–17). By the late 1860s, these small canvases had gained considerable success with private collectors.

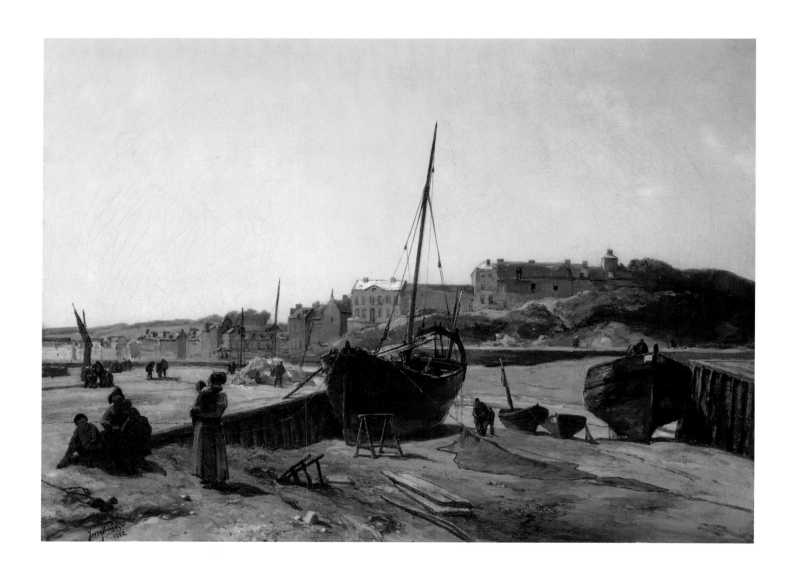

6

JOHAN BARTHOLD JONGKIND

Fécamp, 1852

Oil on canvas, 43.2 x 57.5 cm

Wadsworth Atheneum Museum of Art, Hartford, CT.

The Ella Gallup Sumner and Mary Catlin Sumner Collection Fund

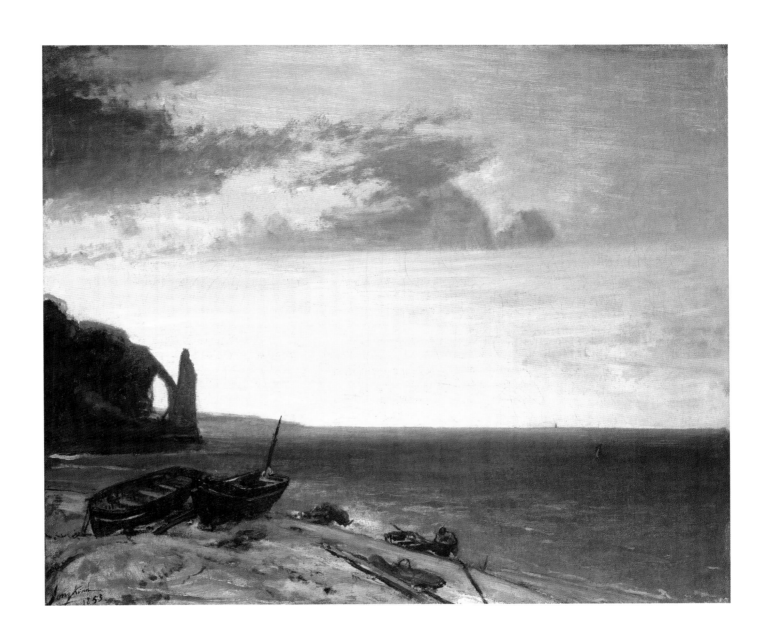

JOHAN BARTHOLD JONGKIND
The Sea at Etretat, 1853
Oil on canvas, 53.3 x 63.5 cm
Birmingham Museums and Art Gallery

8

CONSTANT TROYON

The Coast near Villers, c. 1860

Oil on canvas, 67.4 x 95.7 cm

The Walters Art Museum, Baltimore, 37.993

JOHAN BARTHOLD JONGKIND
The Beach at Sainte-Adresse, 1862
Oil on canvas, 33 x 46 cm
Courtesy of the Ivo Bouwman Gallery, The Hague

JOHAN BARTHOLD JONGKIND
On the Beach at Sainte-Adresse, 1862
Oil on canvas, 27 x 41 cm
Collection of Phoenix Art Museum.
Mrs Oliver B. James Bequest

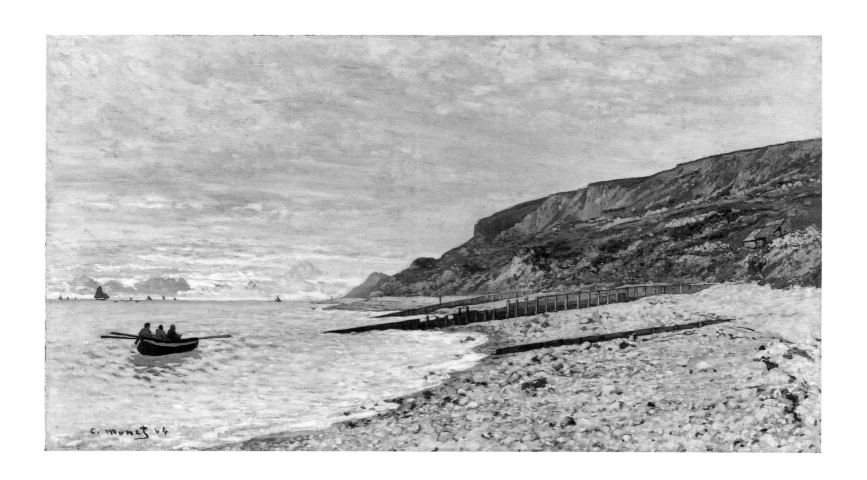

11

CLAUDE MONET
The Pointe de la Hève, 1864
Oil on canvas, 41 x 73 cm
The National Gallery, London

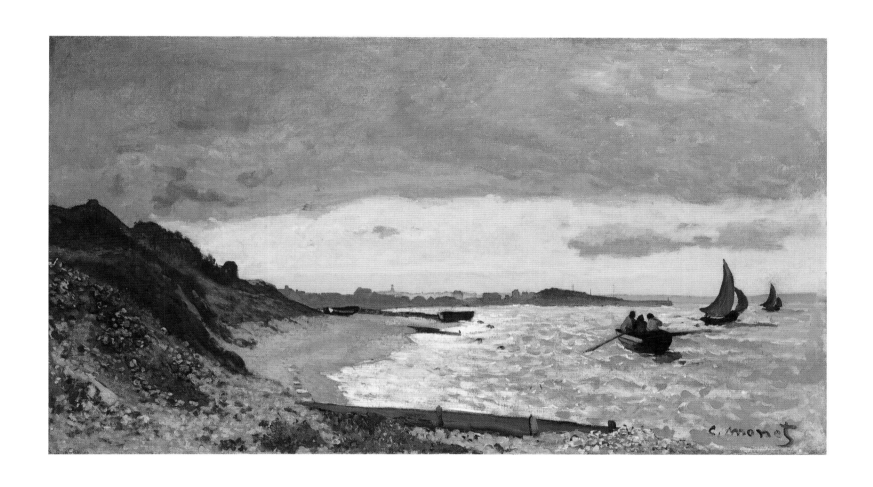

12

CLAUDE MONET
The Coast at Sainte-Adresse, 1864
Oil on canvas, 40 x 73 cm
Minneapolis Institute of Arts. Gift of Mr and Mrs Theodore Bennett

13
EUGÈNE LOUIS BOUDIN
The Beach at Trouville, 1863
Oil on canvas, 25.4 x 46.4 cm
Wadsworth Atheneum Museum of Art, Hartford, CT.
The Ella Gallup Sumner and Mary Catlin Sumner Collection Fund

14
EUGÈNE LOUIS BOUDIN
The Beach at Trouville, 1863
Oil on panel, 18.4 x 34.9 cm
The Phillips Collection, Washington DC

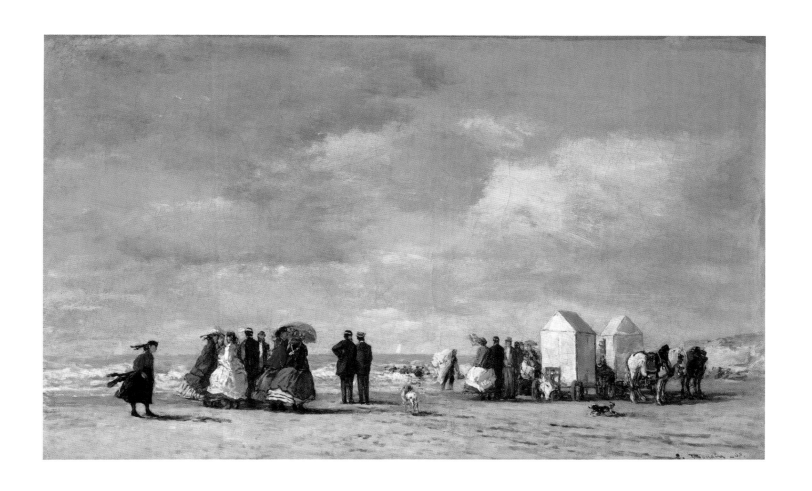

EUGÈNE LOUIS BOUDIN
The Beach at Trouville, 1865
Oil on canvas, 38 x 62.8 cm
Princeton University Art Museum.
Gift of the Estate of Laurence Hutton (50-65)

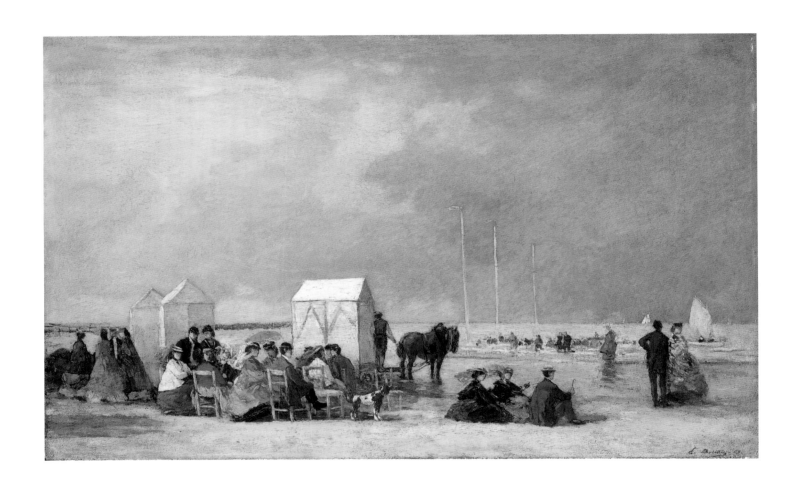

16
EUGÈNE LOUIS BOUDIN
Bathing Time at Deauville, 1865
Oil on panel, 34.5 x 58 cm
National Gallery of Art, Washington.
Collection of Mr and Mrs Paul Mellon, 1983.1.8

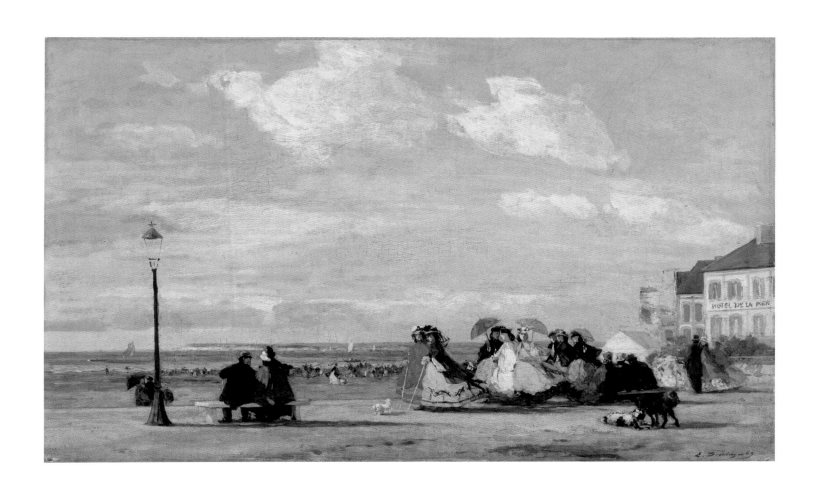

EUGÈNE LOUIS BOUDIN
The Empress Eugénie on the Beach at Trouville, 1863
Oil on panel, 34.3 x 57.8 cm
Glasgow City Council (Museums)

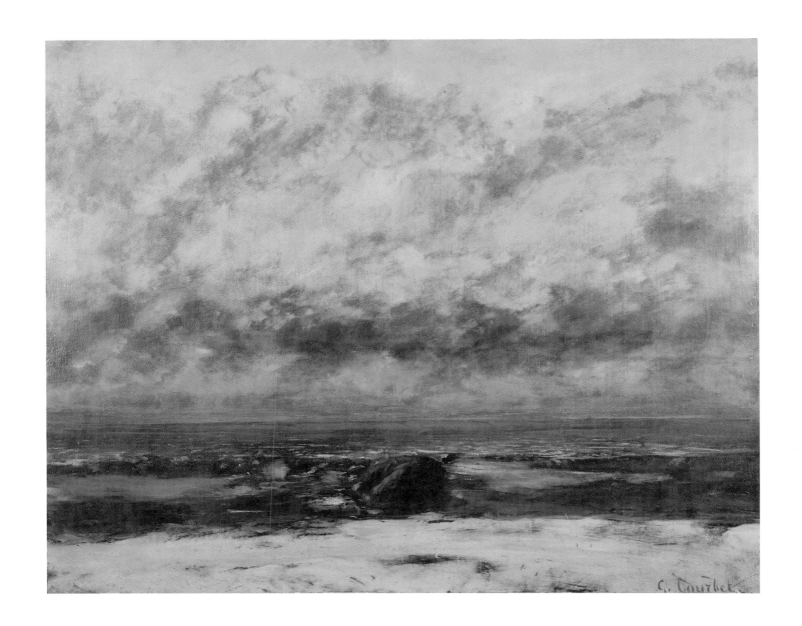

18

GUSTAVE COURBET
Marine Landscape ('Eternity'), c. 1865
Oil on canvas, 64.7 x 79.3 cm
Bristol's Museums, Galleries and Archives

60

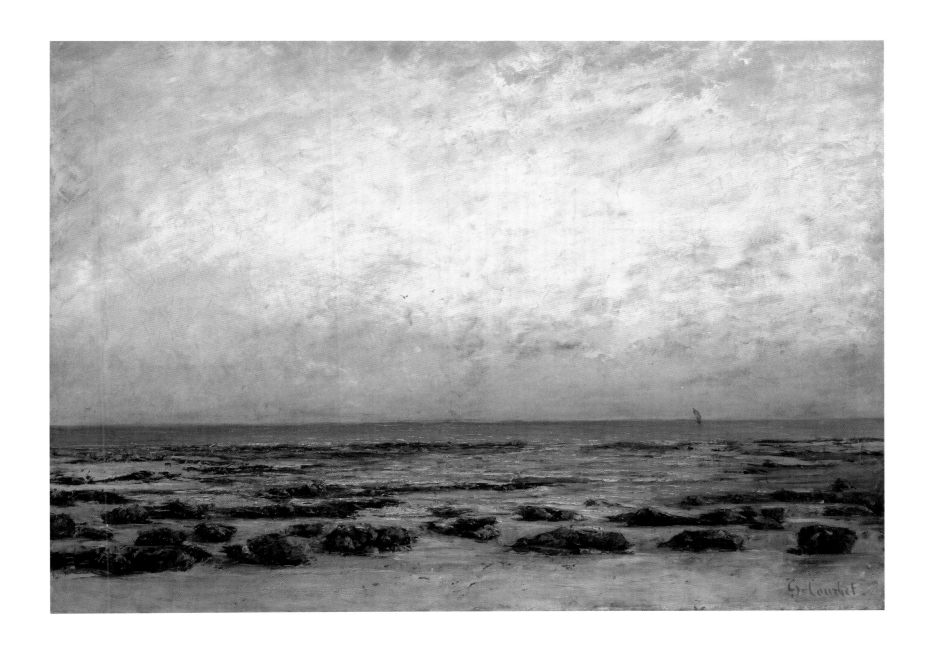

19

GUSTAVE COURBET
The Shore at Trouville: Sunset Effect, c. 1865/69
Oil on canvas, 71.4 x 102.2 cm
Wadsworth Atheneum Museum of Art, Hartford, CT.
The Ella Gallup Sumner and Mary Catlin Sumner Collection Fund

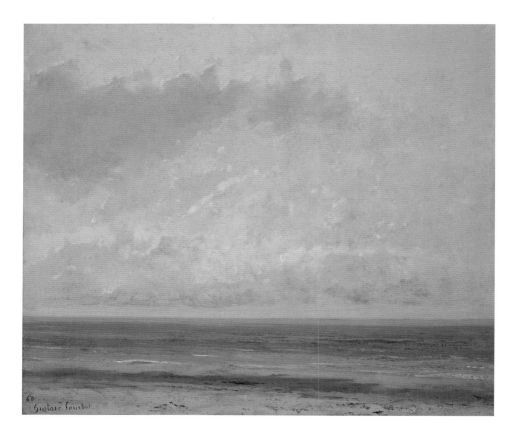

20

GUSTAVE COURBET

Calm Sea, 1866

Oil on canvas, 54.1 x 63.9 cm

National Gallery of Art, Washington. Collection of Mr and Mrs Paul Mellon 1985.64.10

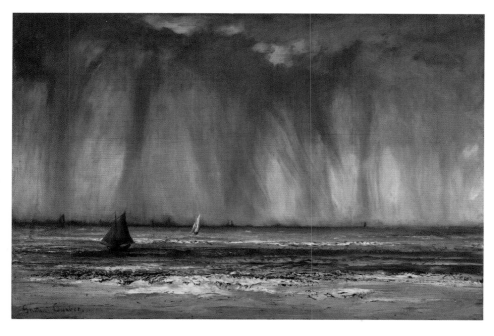

21

GUSTAVE COURBET

The Waterspout, c. 1866

Oil on canvas on gypsum board, 43.2 x 65.7 cm

Lent by the Philadelphia Museum of Art. John G. Johnson Collection, 1917

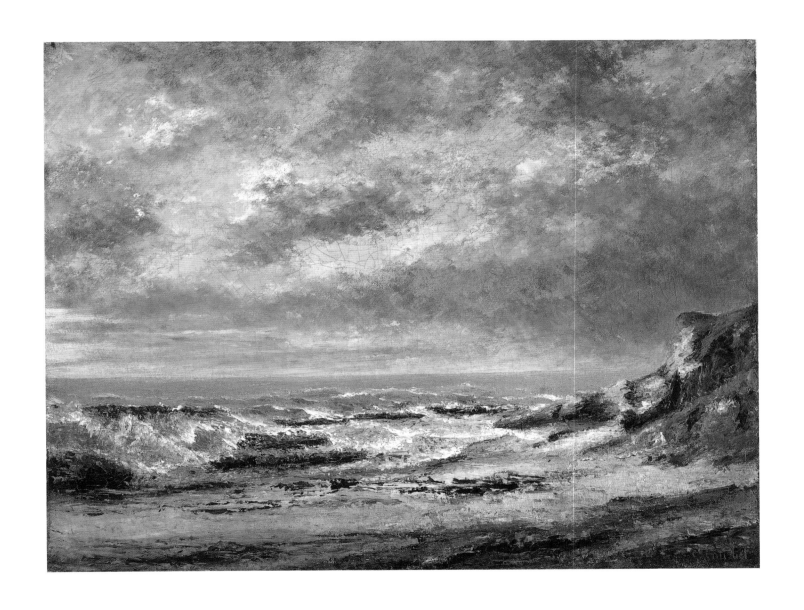

22

GUSTAVE COURBET
Rough Sea near a Cliff, c. 1865/66
Oil on canvas, 61 x 81 cm
The Matthiesen Gallery, London

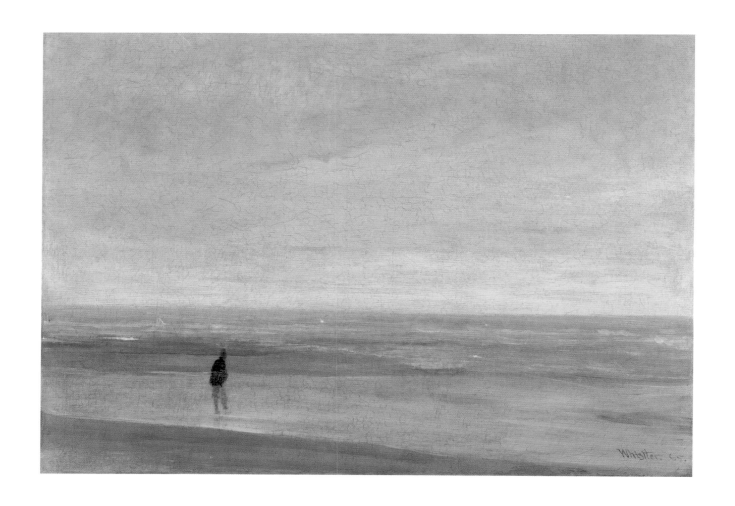

23

JAMES ABBOTT MᶜNEILL WHISTLER
Sea and Rain, 1865
Oil on canvas, 51 x 73.4 cm
University of Michigan Museum of Art, Ann Arbor.
Bequest of Margaret Watson Parker

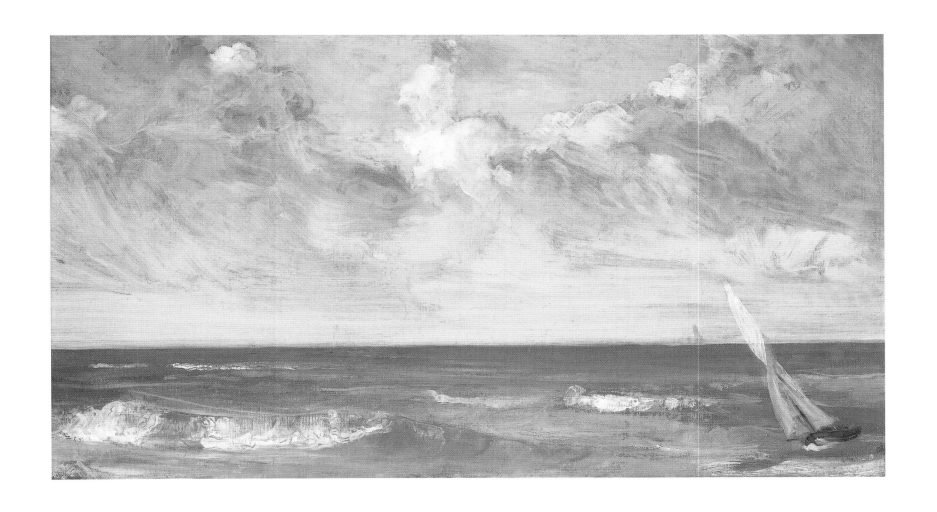

JAMES ABBOTT McNEILL WHISTLER
The Sea, c. 1865
Oil on canvas, 52.7 x 95.9 cr
Montclair Art Museum, New Jersey. Museum Purchase; Acquisition

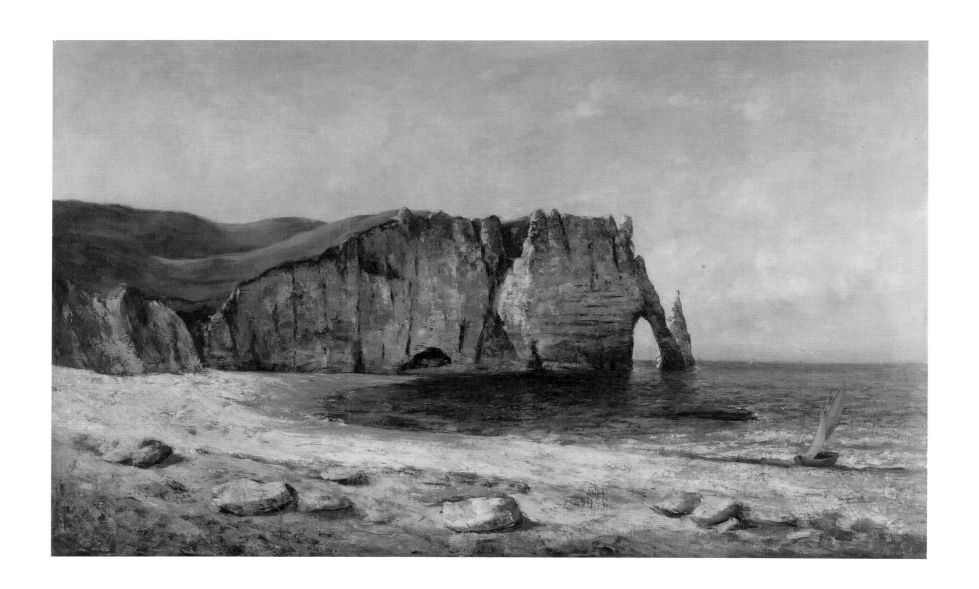

25
GUSTAVE COURBET
The Porte d'Aval at Etretat, 1869
Oil on canvas, 79 x 128 cm
The Trustees of the Barber Institute of Fine Arts, The University of Birmingham

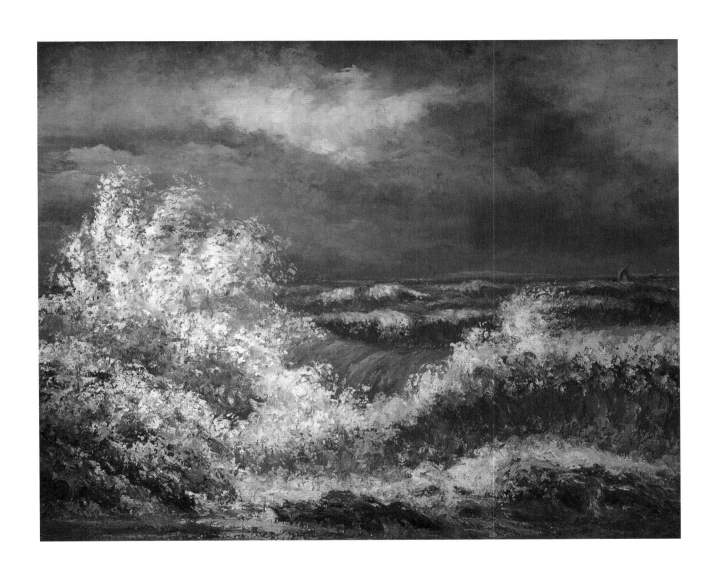

GUSTAVE COURBET
The Wave, 1869
Oil on canvas, 58.4 x 78.7 cm
Fine Art Museums of San Francisco.
Museum Purchase, Grover A. Magnin Bequest Fund
and Roscoe and Margaret Oakes Income Fund, 2006

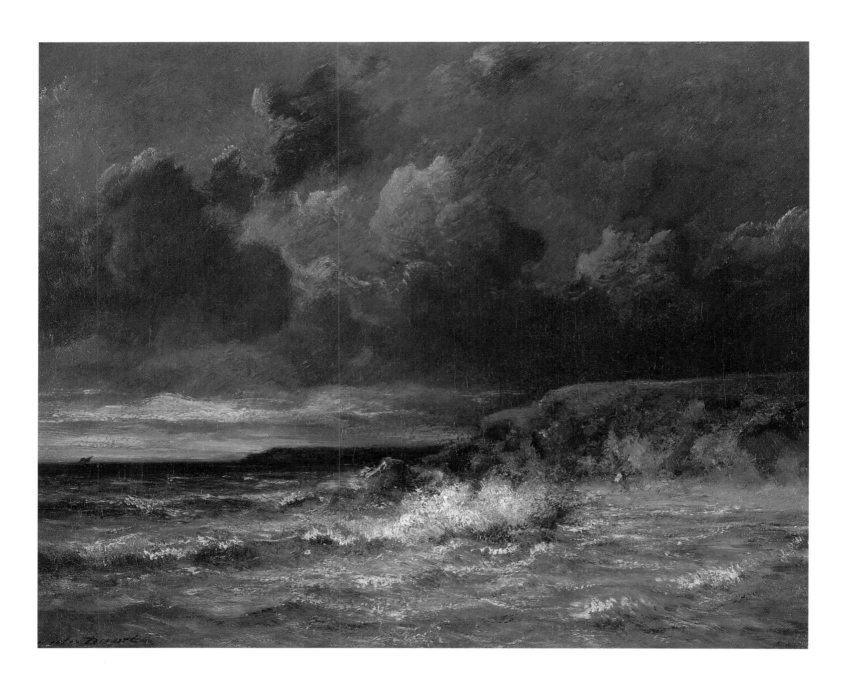

27

JULES DUPRÉ
Marine Landscape (The Cape and Dunes of Saint-Quentin), c. 1870
Oil on canvas, 73.5 x 92 cm
Musée des Beaux-Arts de Rouen. Donation Henri et Suzanne Baderou, 1975

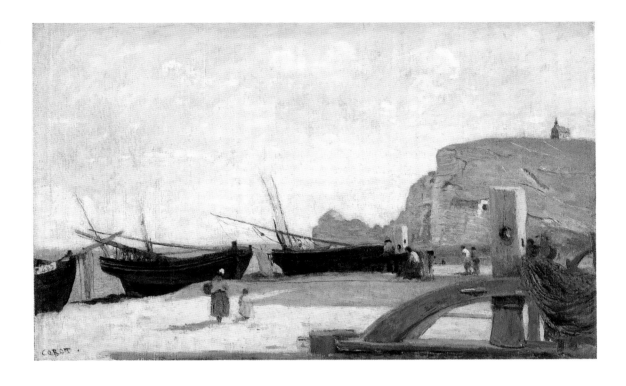

28

JEAN BAPTISTE CAMILLE COROT
The Beach, Etretat, 1872
Oil on canvas, 35.6 x 57.2 cm
Saint Louis Art Museum. Purchase 63:1932

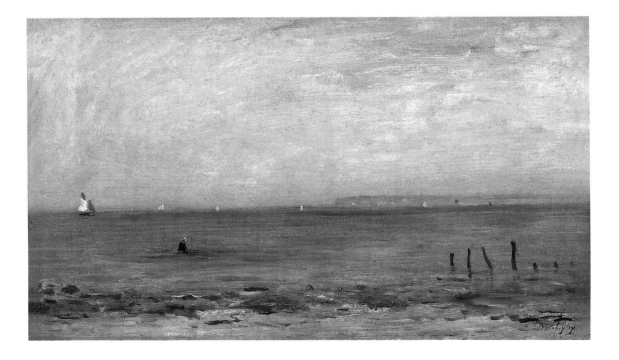

29

CHARLES FRANÇOIS DAUBIGNY
The Beach at Villerville,
known as *Cap Gris-Nez, c.* 1870
Oil on panel, 32.5 x 55.5 cm
Berwick Borough Museum and Art Gallery, Berwick-upon-Tweed

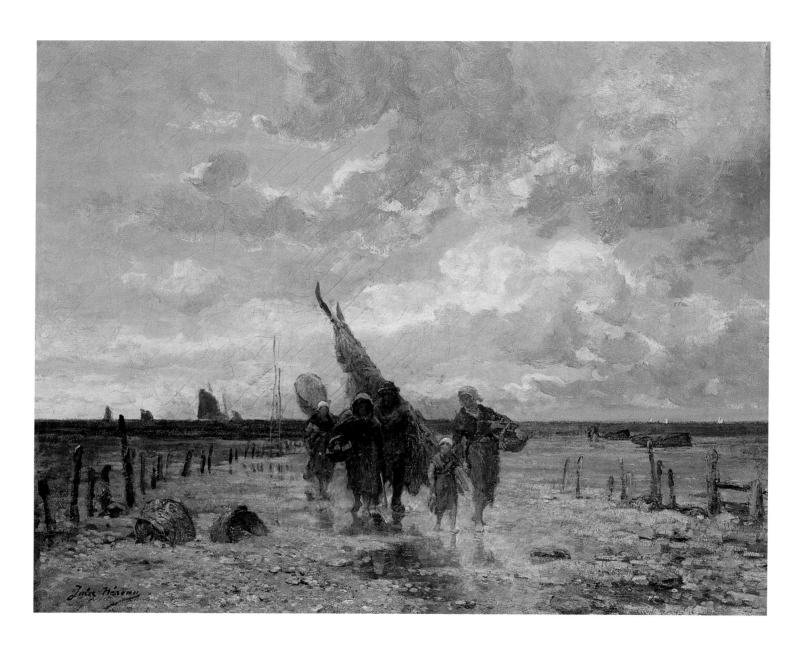

30
JULES HÉREAU
The Return from Shrimping, c. 1870
Oil on canvas, 60 x 73 cm
Musée Eugène Boudin, Honfleur

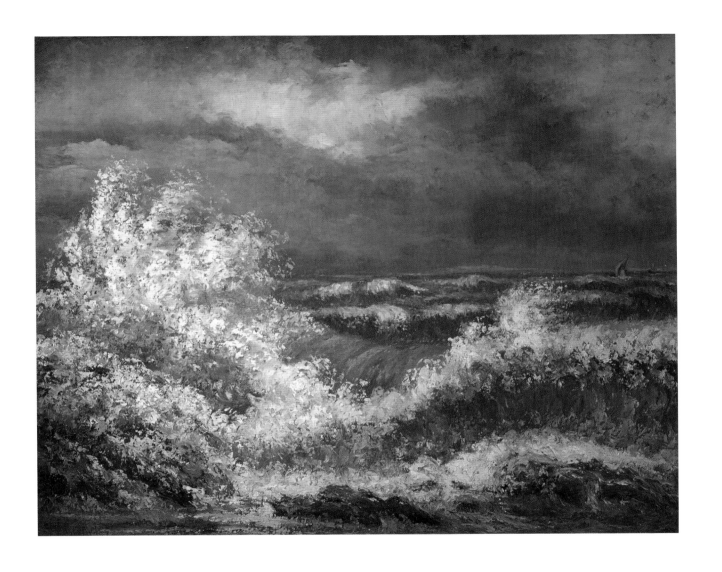

26

GUSTAVE COURBET
The Wave, 1869
Oil on canvas, 58.4 x 78.7 cm
Fine Art Museums of San Francisco.
Museum Purchase, Grover A. Magnin Bequest Fund
and Roscoe and Margaret Oakes Income Fund, 2006.58

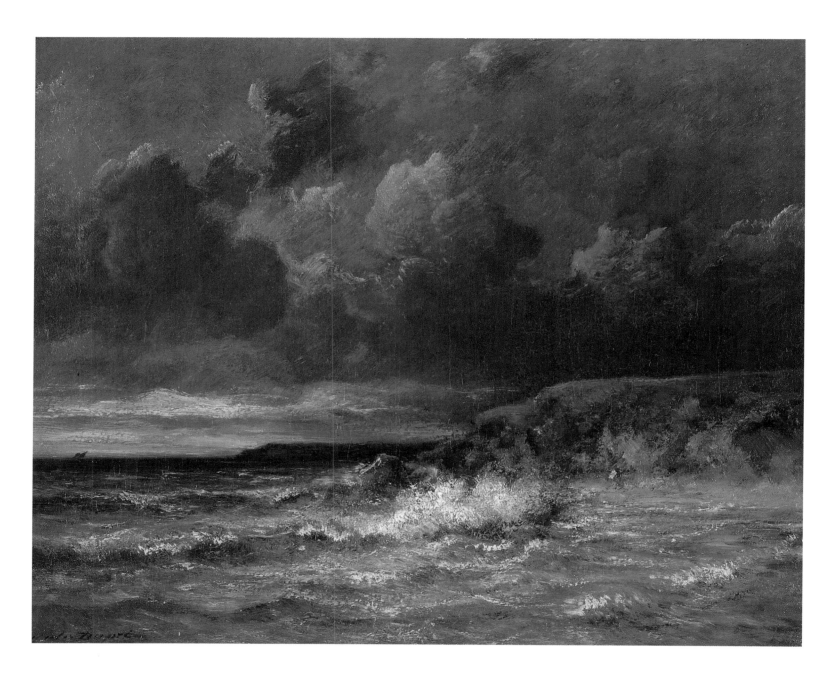

27
JULES DUPRÉ
Marine Landscape (The Cape and Dunes of Saint-Quentin), c. 1870
Oil on canvas, 73.5 x 92 cm
Musée des Beaux-Arts de Rouen. Donation Henri et Suzanne Baderou, 1975

28

JEAN BAPTISTE CAMILLE COROT
The Beach, Etretat, 1872
Oil on canvas, 35.6 x 57.2 cm
Saint Louis Art Museum. Purchase 63:1932

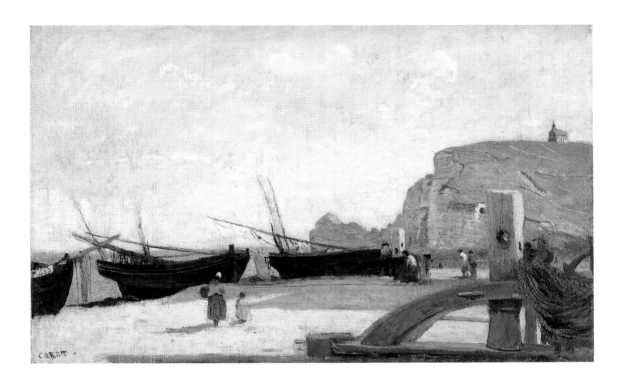

29

CHARLES FRANÇOIS DAUBIGNY
The Beach at Villerville,
known as *Cap Gris-Nez*, c. 1870
Oil on panel, 32.5 x 55.5 cm
Berwick Borough Museum and Art Gallery, Berwick-upon-Tweed

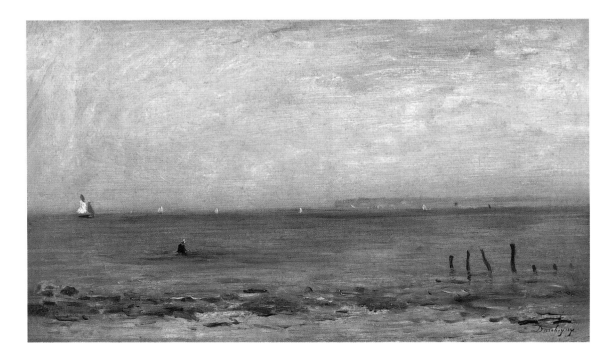

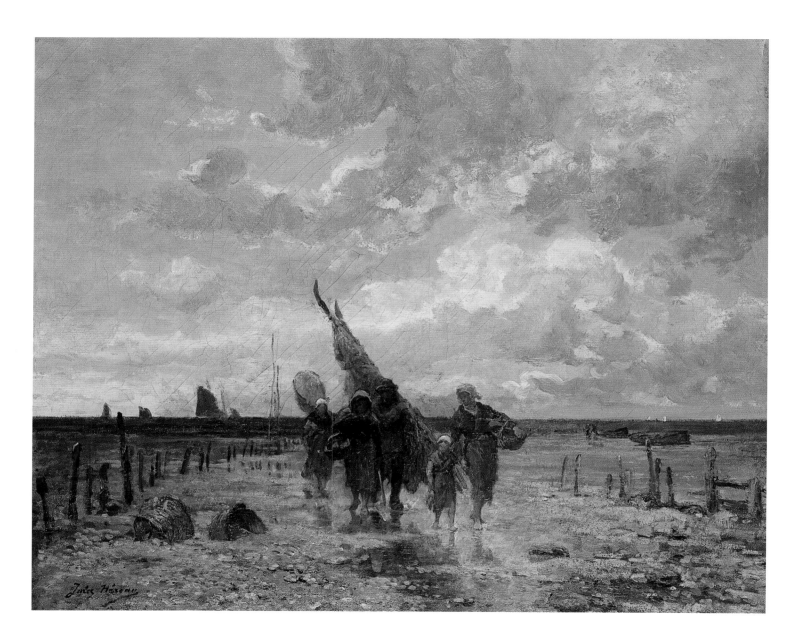

30
JULES HÉREAU
The Return from Shrimping, c. 1870
Oil on canvas, 60 x 73 cm
Musée Eugène Boudin, Honfleur

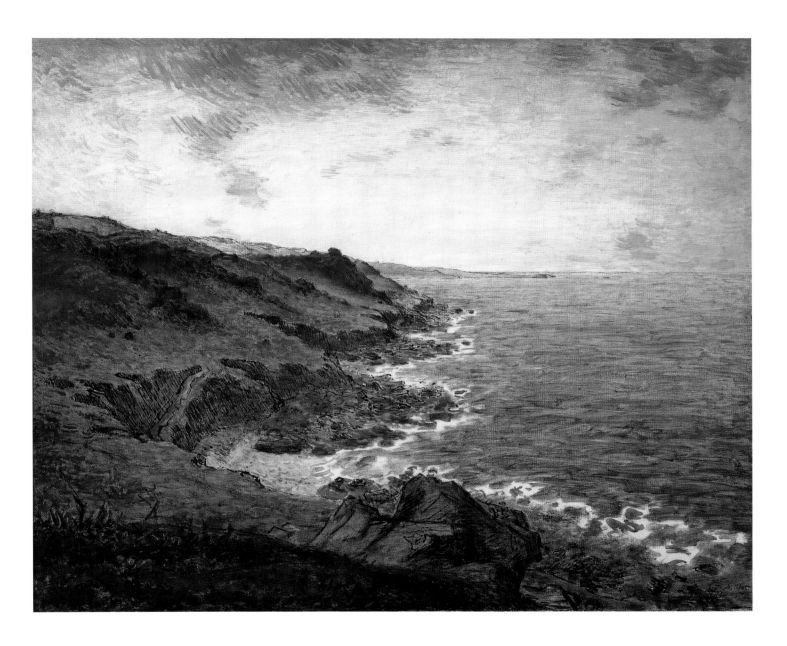

JEAN FRANÇOIS MILLET
The Cliffs of Gréville. c. 1854 and 1870/71
Oil on canvas, 60 x 73 cm
Nationalmuseum, Stockholm

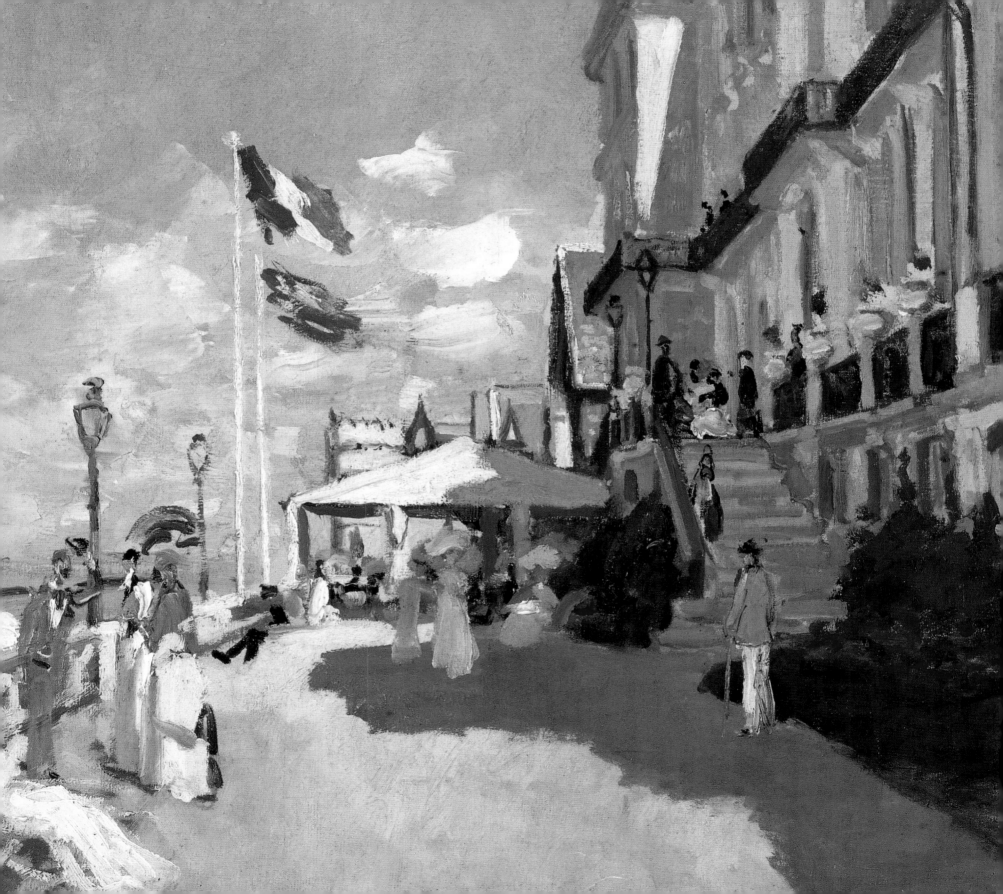

3 Early Impressionism

In the coastal scenes painted by Edouard Manet and Claude Monet in the late 1860s and early 1870s, the 'modern' beach plays the central role, as they took up the theme of holidaymakers by the sea pioneered by Eugène Louis Boudin earlier in the 1860s.

In his pair of canvases of the beach at Sainte-Adresse, Monet juxtaposed the two worlds of fishermen and holidaymakers, in one focusing on spectators watching a regatta (cat. 33), with the fishermen relegated to the background, while in the other (cat. 32) the fishermen and their boats are the prime focus, with a bourgeois couple seated beyond them, looking out to sea.

Manet's view of the beach at Boulogne (cat. 34) emphasised the separateness of the distinct groups of figures on the wide sands, each in their own world, not part of a collective community. Monet, in his more panoramic beach scenes painted at Trouville in 1870, highlighted the presence of the villas and hotels along the edge of the beach (cats 36 and 37), as the background to fashionable figures strolling on the sands and along the promenade; in *The Hôtel des Roches Noires, Trouville* (cat. 35) he depicted the terrace of the resort's most fashionable and luxurious hotel. His more informal paintings of his wife Camille and other figures, seen from close to, presented a more intimate view of the beach as the territory of the holidaymaker (cats 38 and 39), as did Manet when painting his wife and brother at Berck-sur-Mer in 1873 (cat. 40). Manet also explored the interplay of fishing boats on the beach at Berck in a number of freely brushed sketches (e.g. cat. 42).

The smaller canvases by Manet and Monet display their technique at its most informal and improvisatory, while Monet's larger views of Sainte-Adresse and Trouville deploy a virtuoso representational shorthand with the brush that conveys the complexities of the scene without distracting detail.

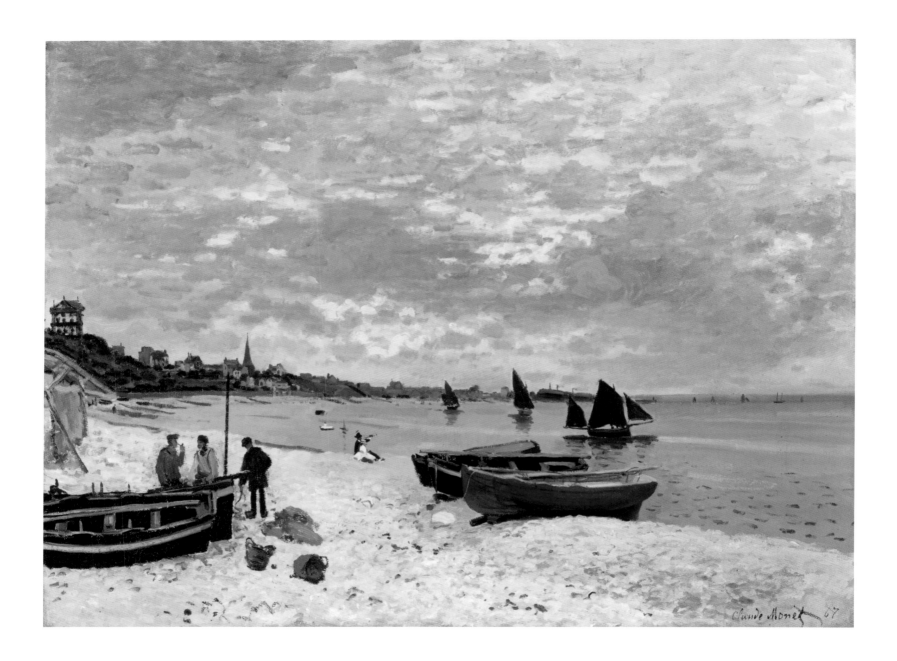

32

CLAUDE MONET

The Beach at Sainte-Adresse, 1867

Oil on canvas, 75.8 x 102.5 cm

The Art Institute of Chicago.

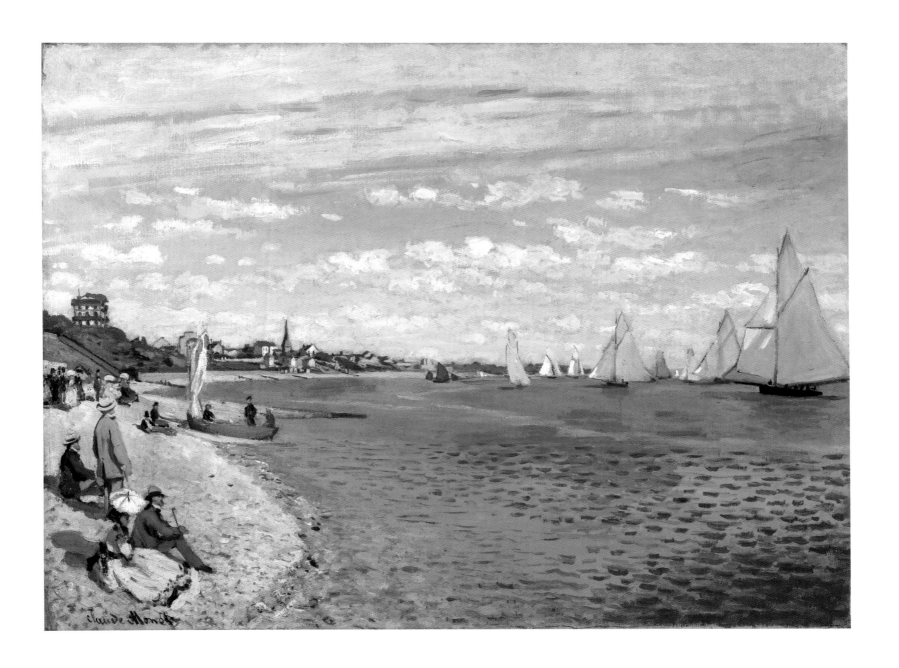

CLAUDE MONET
Regatta at Sainte-Adresse, 1867
Oil on canvas, 75.2 x 101.6 cm
The Metropolitan Museum of Art, New York.
Bequest of William Church Osborn, 1951 (51.30.4)

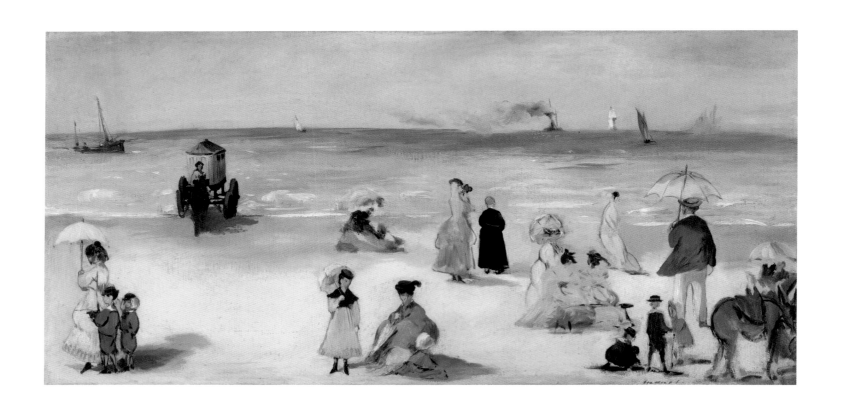

34
EDOUARD MANET
On the Beach at Boulogne, 1868
Oil on canvas, 32 x 65 cm

Virginia Museum of Fine Arts, Richmond

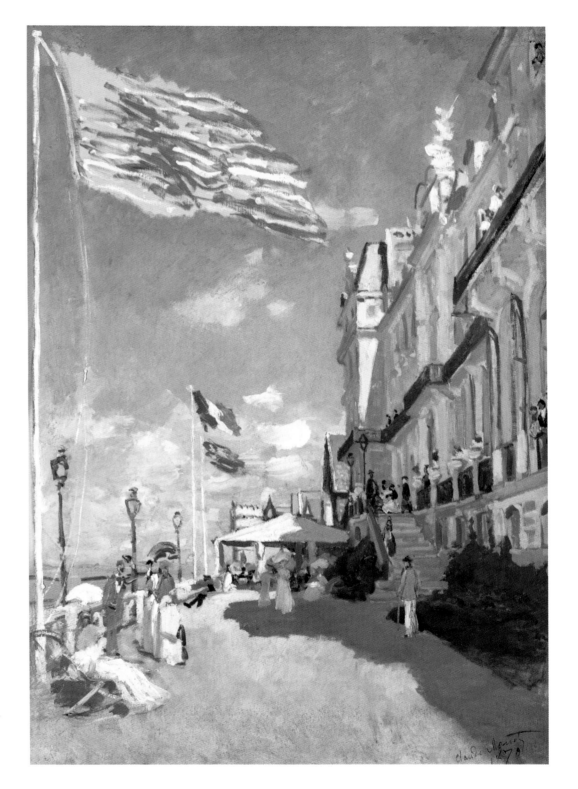

35
CLAUDE MONET
The Hôtel des Roches Noires, Trouville, 1870
Oil on canvas, 81 x 58 cm
Musée d'Orsay, Paris. Donation Jacques Laroche, 1947

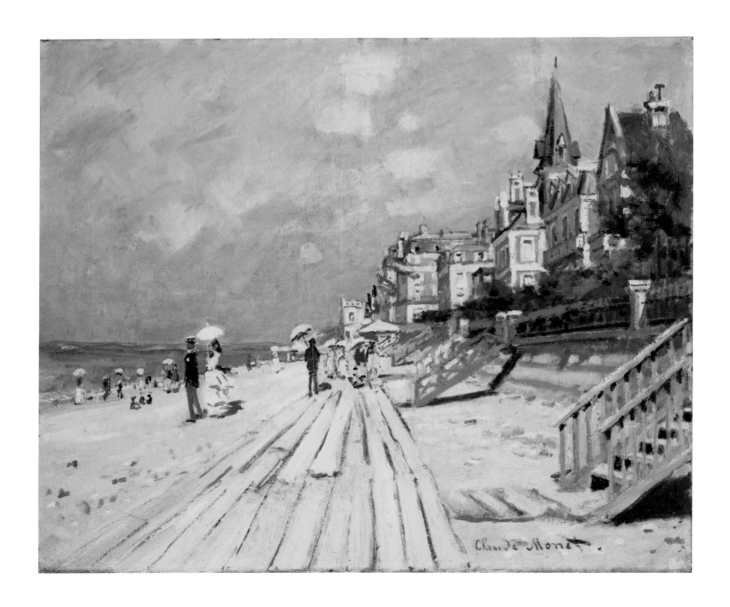

36

CLAUDE MONET

The Beach at Trouville, 1870

Oil on canvas, 53.5 x 65 cm

Wadsworth Atheneum Museum of Art, Hartford, CT.

The Ella Gallup Sumner and Mary Catlin Sumner Collection Fund

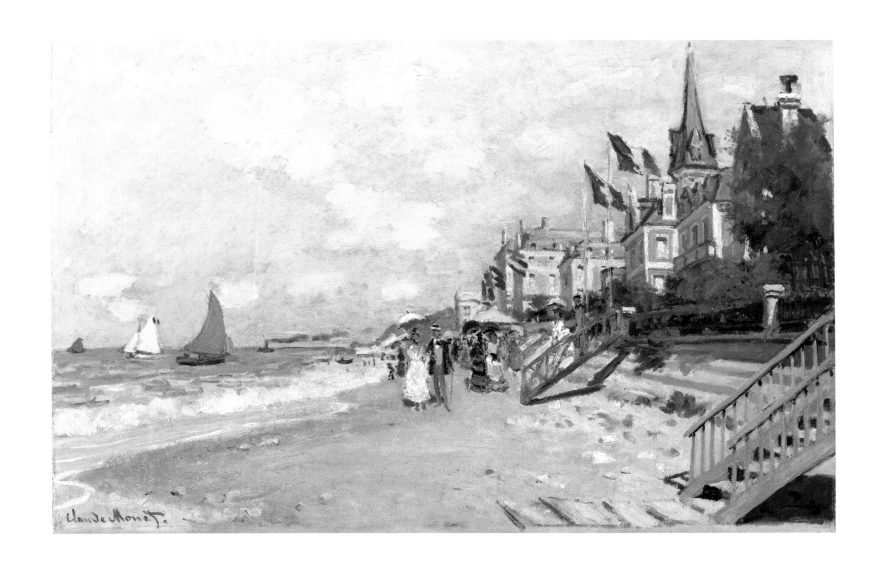

37

CLAUDE MONET

The Beach at Trouville, 1870

Oil on canvas, 48 x 74 cm

Private collection, courtesy of Sotheby's

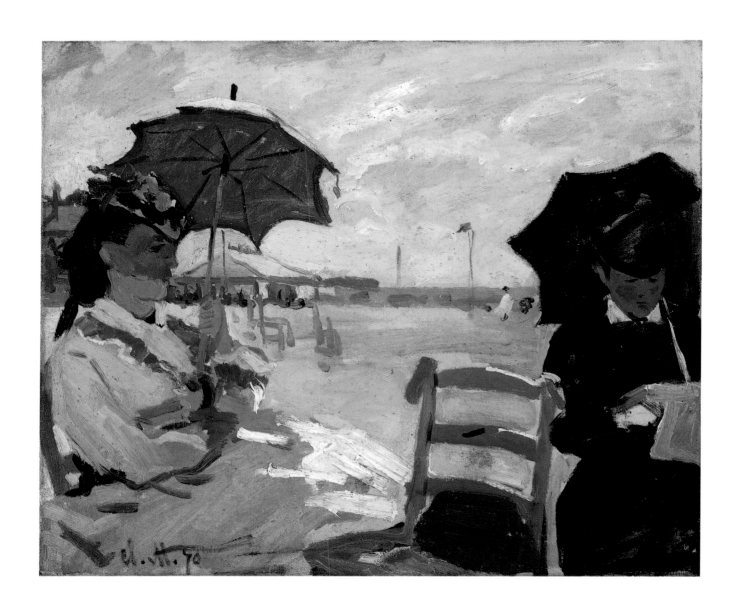

38

CLAUDE MONET

The Beach at Trouville, 1870

Oil on canvas, 38 x 46 cm

The National Gallery, London

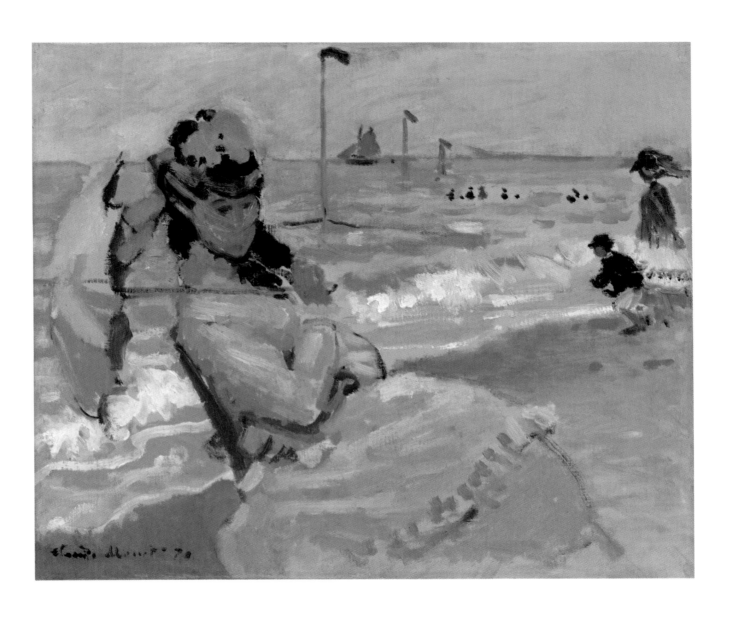

CLAUDE MONET
Camille on the Beach at Trouville, 1870
Oil on canvas, 38.1 x 46.4 cm
Yale University Art Gallery, New Haven.
Collection of Mr and Mrs John Hay Whitney BA, 1926, Hon. 1956

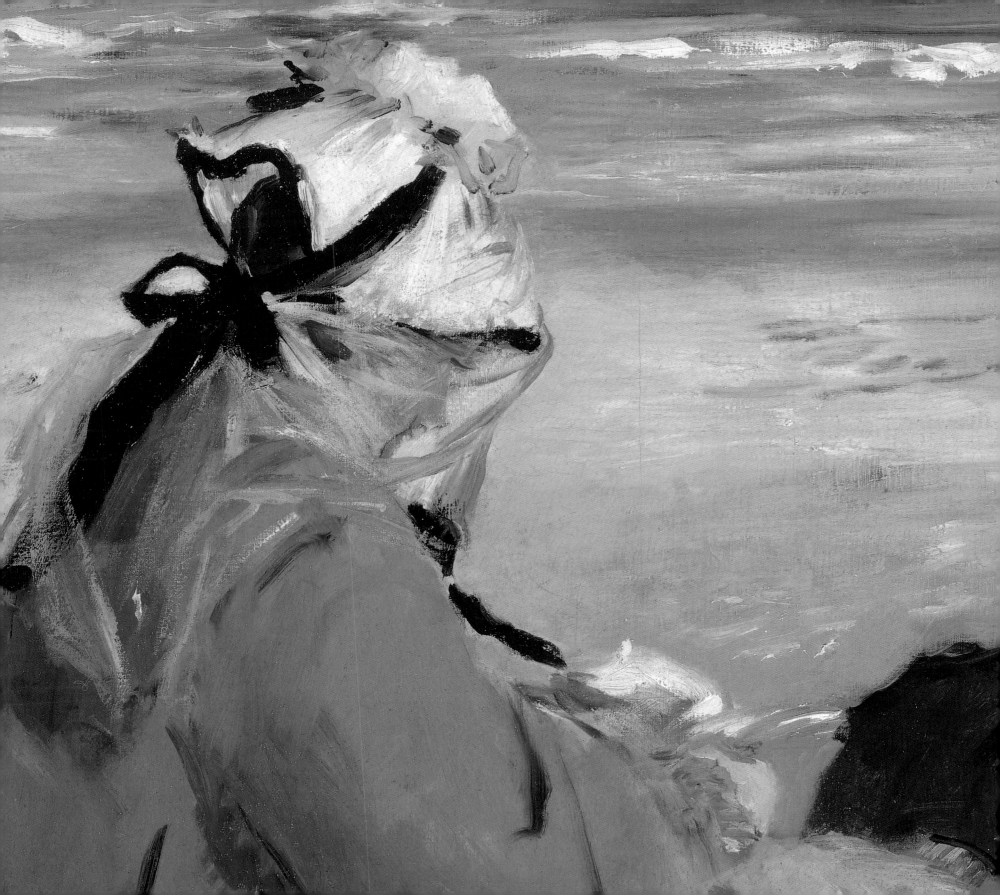

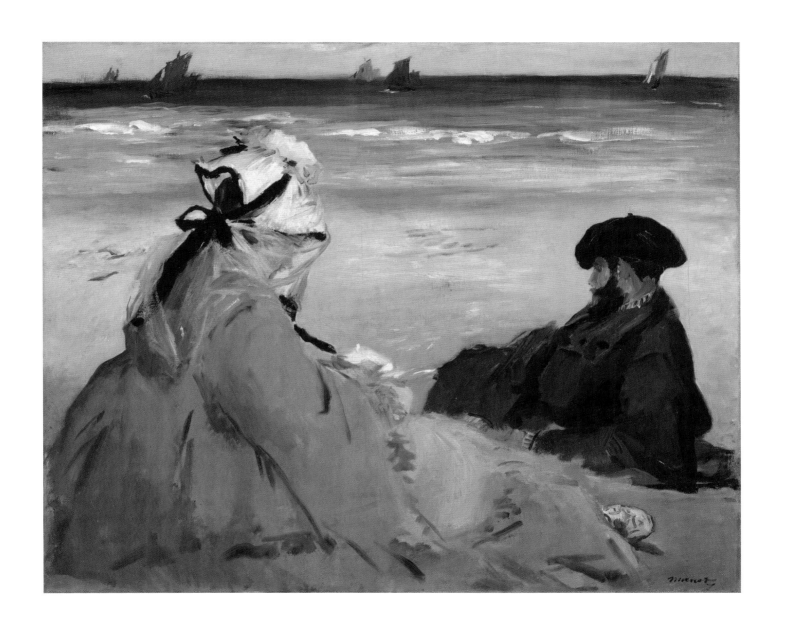

40

EDOUARD MANET
On the Beach: Suzanne and Eugène Manet at Berck, 1873
Oil on canvas, 60 x 73.5 cm
Musée d'Orsay, Paris. Donation Jean-Edouard du Brujeaud sous réserve d'usufruit, 1953

85

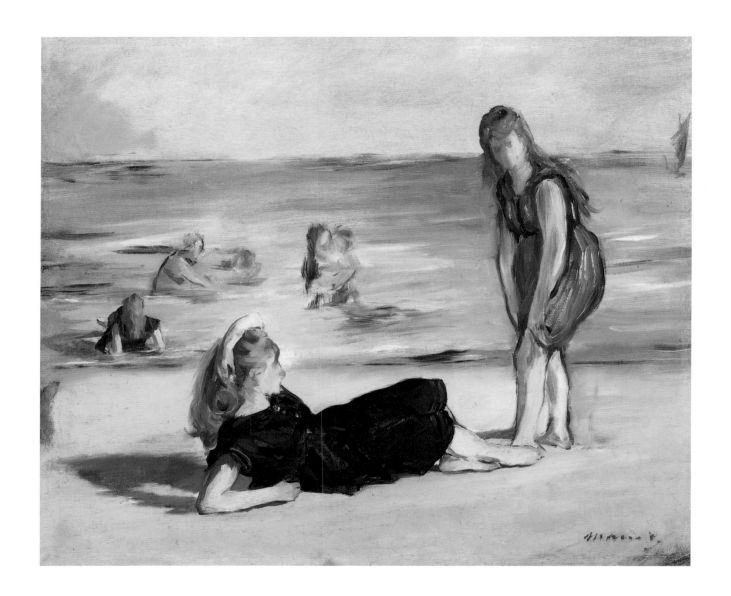

41

EDOUARD MANET

Women on the Beach, 1873?

Oil on canvas, 40 x 48.3 cm

The Detroit Institute of Arts. Bequest of Robert H. Tannahill

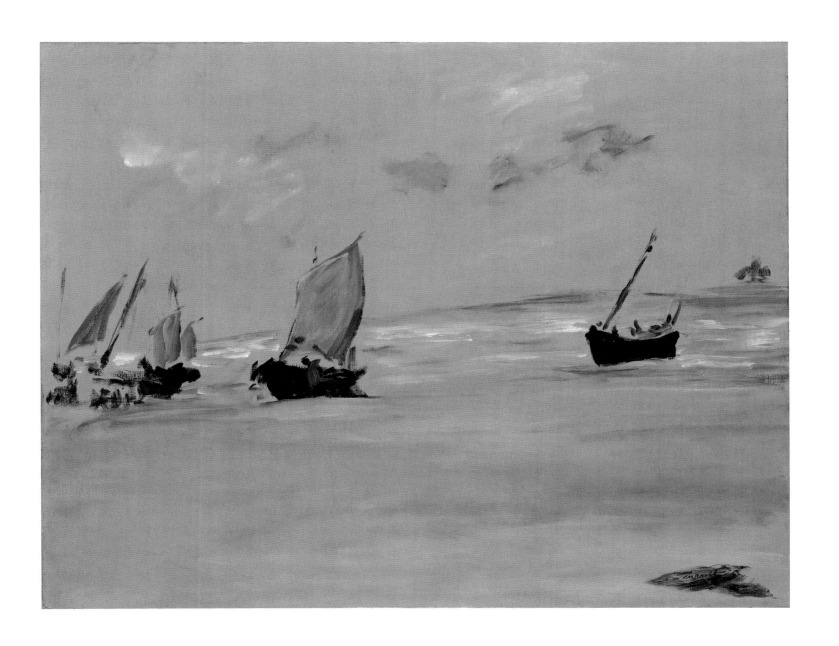

42
EDOUARD MANET
Low Tide at Berck, 1873
Oil on canvas, 55 x 72 cm
Wadsworth Atheneum Museum of Art, Hartford, CT.
The Ella Gallup Sumner and Mary Catlin Sumner Collection Fund

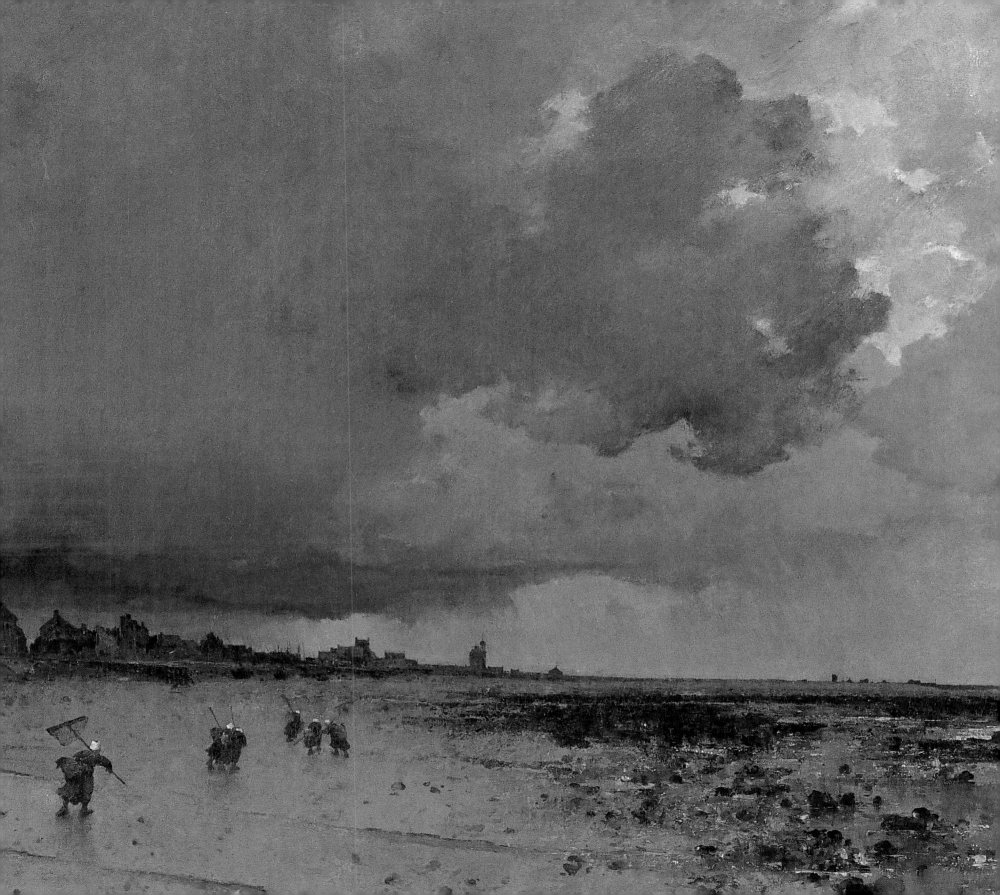

4 Beach Scenes at the Salon after 1870

Paintings of the coasts of France were common at the Paris Salon through the 1870s and 1880s, but very few of these canvases depicted the dramatic changes brought about by the development of the seaside resort. Instead they focused on the physical structure of the cliffs and on atmospheric effects; when the canvases are peopled, the figures in them are local fisherfolk, not holidaymakers.

Extreme effects of light and weather were especially popular. Charles François Daubigny's panoramic view over Villerville shows the vast spaces of the beach at low tide, bathed in the spectacular light of sunset (cat. 43), while both Jean Charles Cazin and Léon Germain Pelouse depicted the coast under dark, threatening rain clouds (cats 44 and 47). Although these large canvases were probably not executed outdoors, they reveal close attention to the specifics of the effects depicted.

Both Pelouse and John Singer Sargent focused on the local fisherfolk, Pelouse presenting them on a wide beach at low tide, carrying their harvest back to the village, while Sargent shows them arriving at the beach to gather oysters (cat. 46). However, the two artists treat their figures very differently; in Sargent's canvas they move in a dignified, almost processional group across the foreground, while Pelouse presents them in a slightly caricatural way, moving insect-like across the sands.

In Jean Baptiste Antoine Guillemet's canvas of the beach to the east of Dieppe, the tiny figures are subordinated to the massive cliffs (cat. 45), while Eugène Louis Boudin's view of Etretat, too, focuses on the spectacular rock formations of the Normandy coast, with only a boat lending human interest (cat. 48). His canvas of Deauville beach (cat. 49) relegates the holidaymakers to the background and focuses on effects of light and atmosphere in marked contrast to his canvases of the same beach painted during the 1860s.

43

CHARLES FRANÇOIS DAUBIGNY
The Beach at Villerville-sur-mer (Calvados), Sunset, 1873
Oil on canvas, 76.8 x 143.5 cm
Chrysler Museum of Art, Norfolk, VA. Gift of Walter P. Chrysler Jr, 71.635

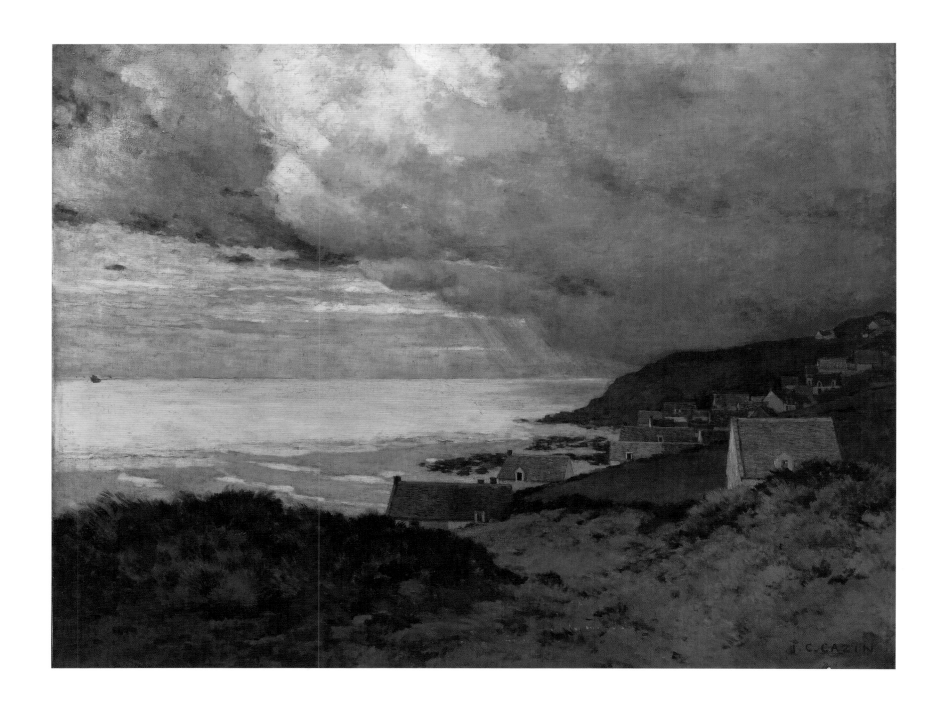

44
JEAN CHARLES CAZIN
The Storm (Equihen, Pas-de-Calais), c. 1876
Oil on canvas, 89.5 x 117 cm
Musée d'Orsay, Paris. Legs de Mme Julia Bartet, 1942

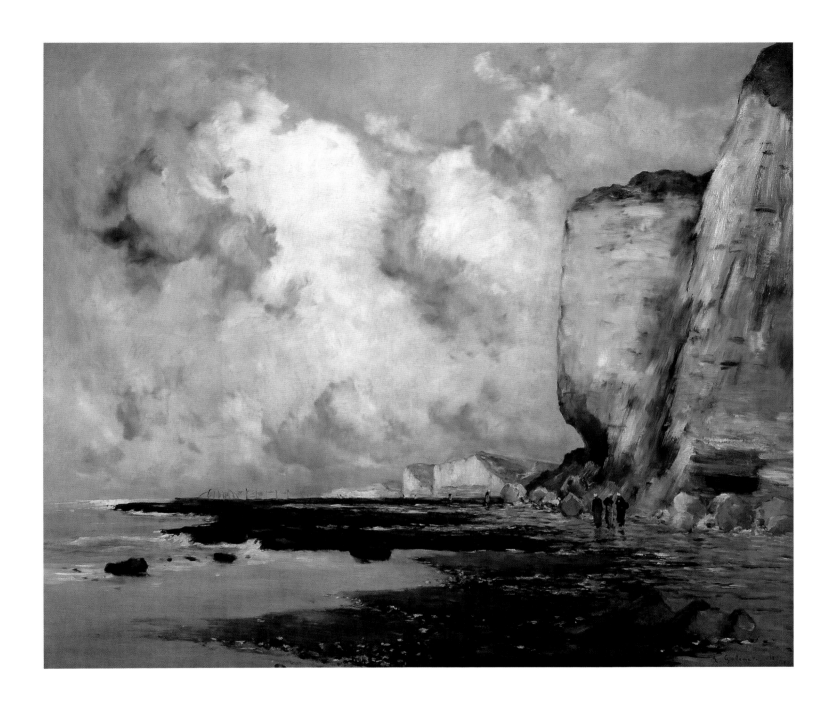

JEAN BAPTISTE ANTOINE GUILLEMET
The Cliffs of Puys at Low Tide, 1877
Oil on canvas, 87 x 103.5 cm
Château-Musée de Dieppe

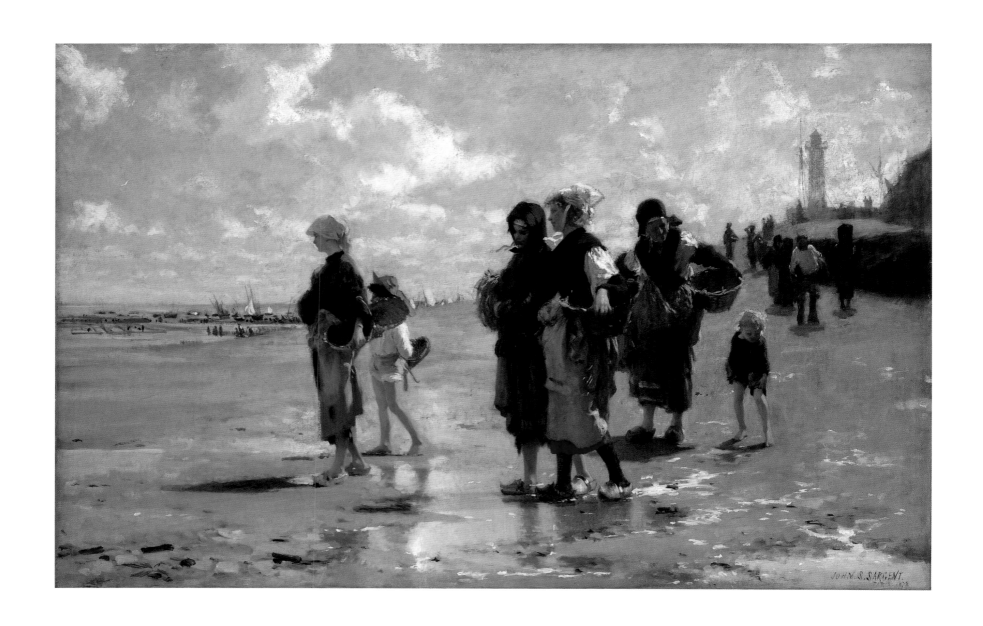

46

JOHN SINGER SARGENT
Oyster Gatherers of Cancale, 1878
Oil on canvas, 79 x 128.3 cm

The Corcoran Gallery of Art, Washington DC. Museum Purchase, Gallery Fund

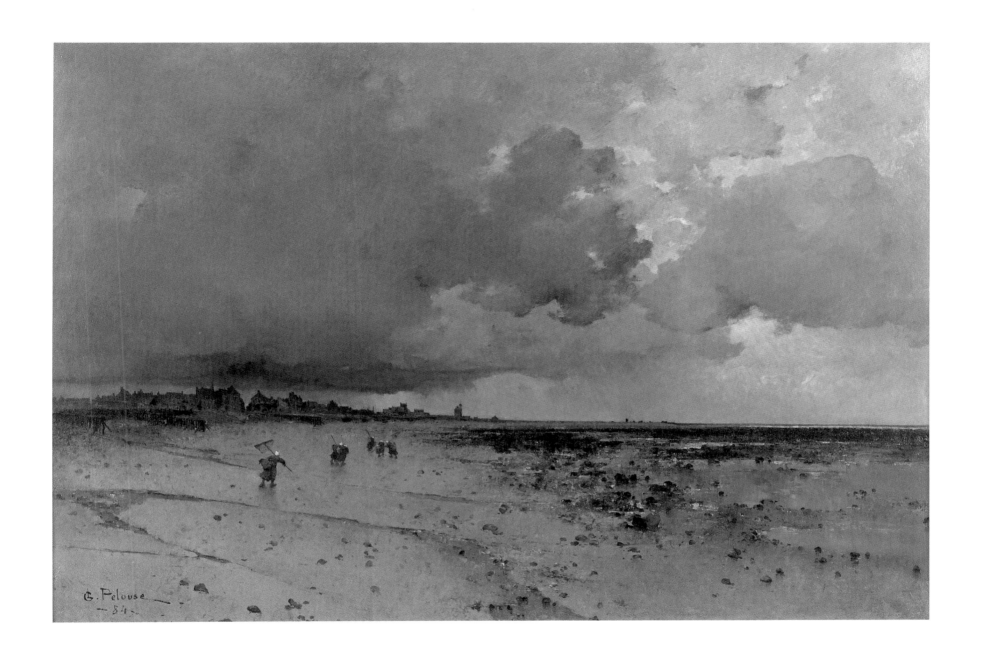

LÉON GERMAIN PELOUSE
Grandcamp, Low Tide, 1884
Oil on canvas, 97 x 147 cm
Musée des Beaux-Arts de Carcassonne

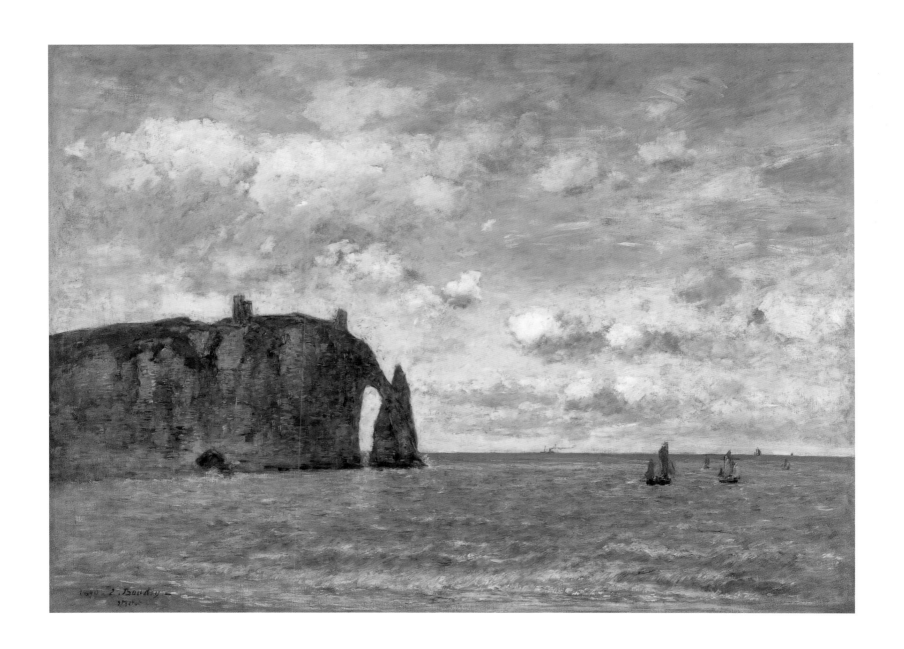

48

EUGÈNE LOUIS BOUDIN
Etretat, the Porte d'Aval, 1890
Oil on canvas, 79.9 x 109.9 cm
Carmen Thyssen-Bornemisza Collection. On loan at the Thyssen-Bornemisza Museum, Madrid

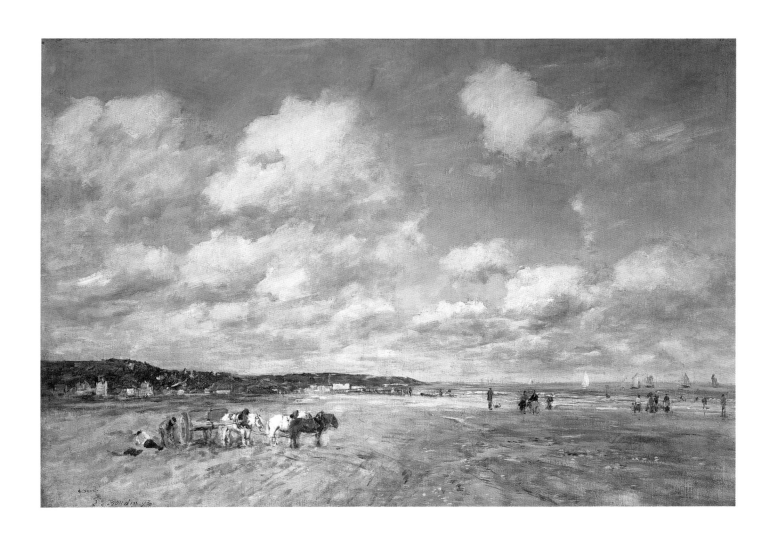

EUGÈNE LOUIS BOUDIN
Deauville, 1893
Oil on canvas, 50.8 x 74.2 cm
The Samuel Courtauld Trust, Courtauld Institute of Art Gallery, London

5 Impressionism in the 1880s

In contrast to their canvases of the late 1860s and 1870s, the Impressionists' coastal scenes of the 1880s did not in general pursue the theme of the modernity of the coastline. Only Gustave Caillebotte's canvases of the early 1880s continued to focus on the transformation of the seashore, with villas and sea seen from high viewpoints, stressing the contrast between the new buildings and the expanses of the coast and sea beyond (cat. 50). However, Paul Gauguin's figures on Dieppe beach of 1885 (cat. 68) have none of the relaxed informality of previous images of leisure. Pierre Auguste Renoir's canvas of a fashionable young woman by the seaside (cat. 64) placed his figure against a vista of cliffs and sea animated only by a few small sailing boats, while, on the island of Guernsey in 1883, though representing holidaymakers, he viewed them in terms of idyllic imagery from the art of the past (cat. 66).

It was Claude Monet, though, who in his coastal scenes of the 1880s broke most decisively with the aesthetics of modernity that had underpinned his work over the previous decade or more. In his paintings of Fécamp, Pourville and Etretat he systematically excluded any signs of the resort developments along the Normandy coast. His focus was on the forms of the cliffs and rocks along the seashore, and the effects of light and weather; his canvases of stormy seas (cats 51, 52 and 60) stress the elemental conflict between land and sea in ways that are reminiscent of Courbet's canvases of the 1860s and the romantic vision of the coast of the previous generation. Sometimes he included the local fishing boats, as in cats 60 and 63, but often his canvases include no sign of any human presence.

Monet's coastal scenes stress the unique qualities of his artistic vision in two ways. His very distinctive brush technique vividly evokes the most extreme natural effects, and the unexpected compositions of the pictures, whether on the cliffs or on the beach, invite the viewer to share his solitary exploration of the coast as he turned his back on the resorts and the holidaymaker, seeking viewpoints that conveyed the drama of his natural surroundings.

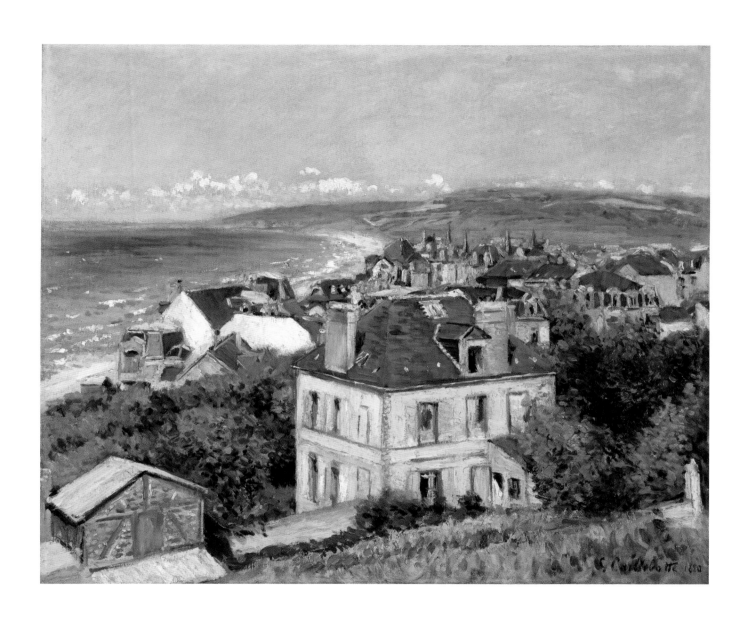

59
GUSTAVE CAILLEBOTTE
Villers-sur-mer, 1880
Oil on canvas, 60 x 73 cm
Private collection

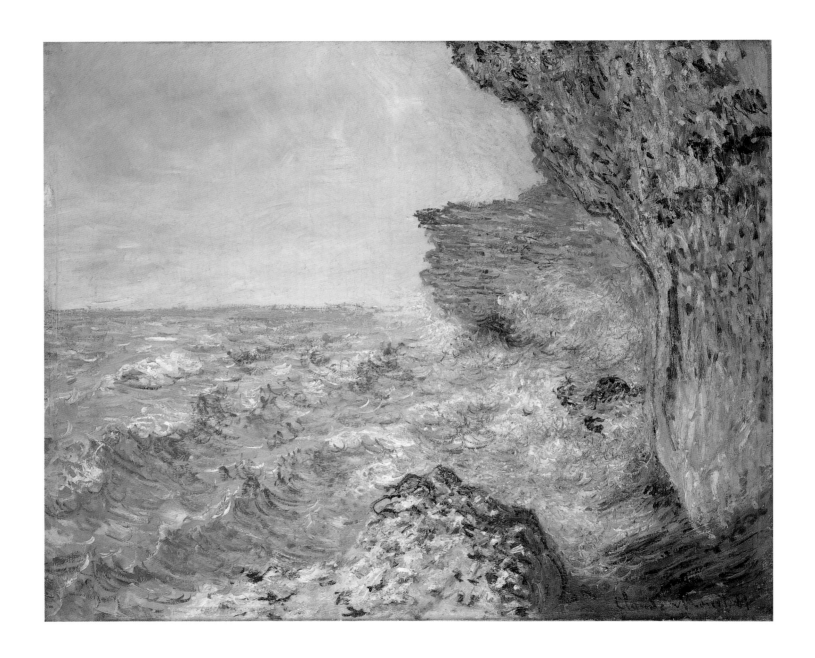

51

CLAUDE MONET

The Sea at Fécamp, 1881

Oil on canvas, 65.5 x 82 cm

Staatsgalerie, Stuttgart

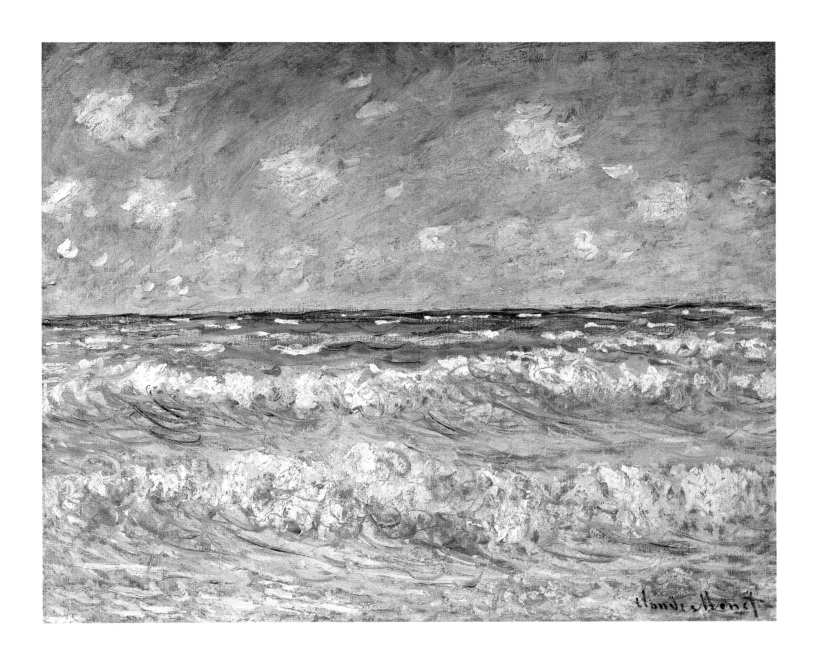

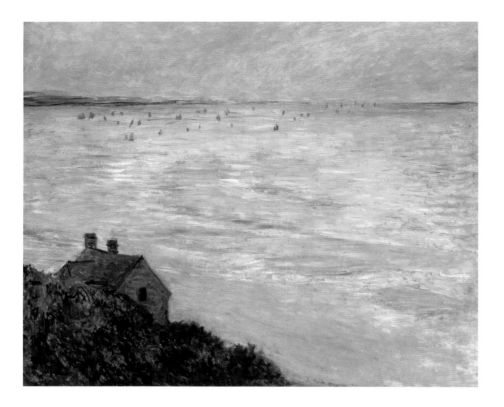

53
CLAUDE MONET
The Cottage at Trouville, Low Tide, 1881
Oil on canvas, 60 x 73.5 cm
Carmen Thyssen-Bornemisza Collection.
On loan at the Thyssen-Bornemisza Museum, Madrid

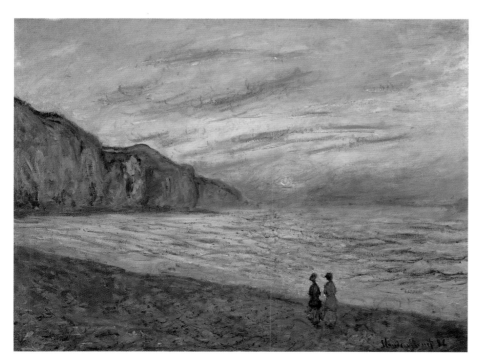

54
CLAUDE MONET
Sunset at Pourville, 1882
Oil on canvas, 60 x 81 cm
Courtesy of The Kreeger Museum, Washington DC

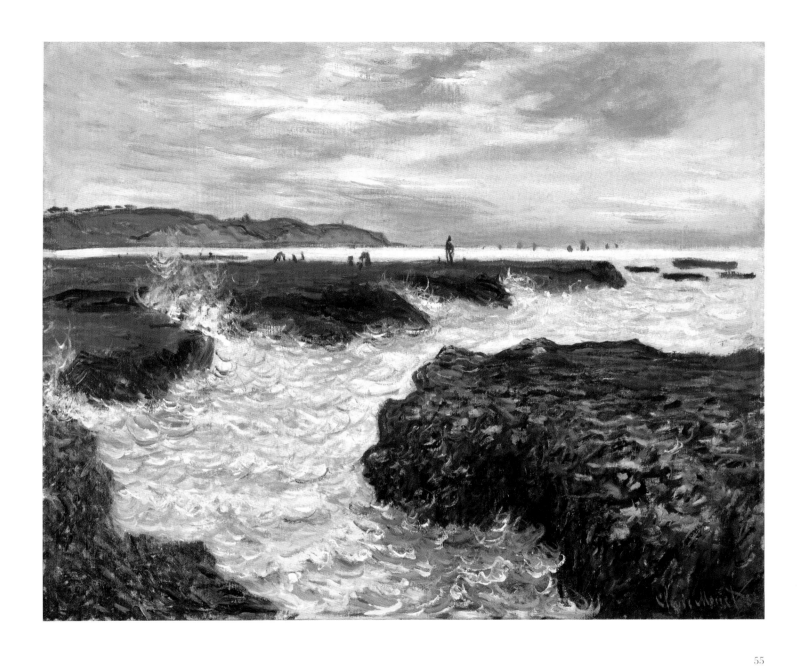

CLAUDE MONET
Rocks at Low Tide, 1882
Oil on canvas, 63 x 77 cm
Memorial Art Gallery of the University of Rochester, New York.
Gift of Emily Sibley Watson

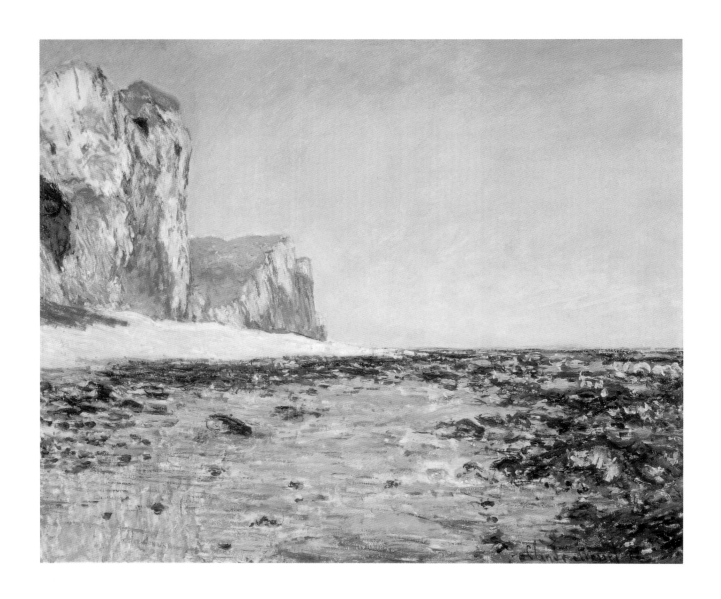

56
CLAUDE MONET
The Beach and Cliffs at Pourville, Morning Effect, 1882
Oil on canvas, 59 x 71 cm

Tokyo Fuji Art Museum, Tokyo

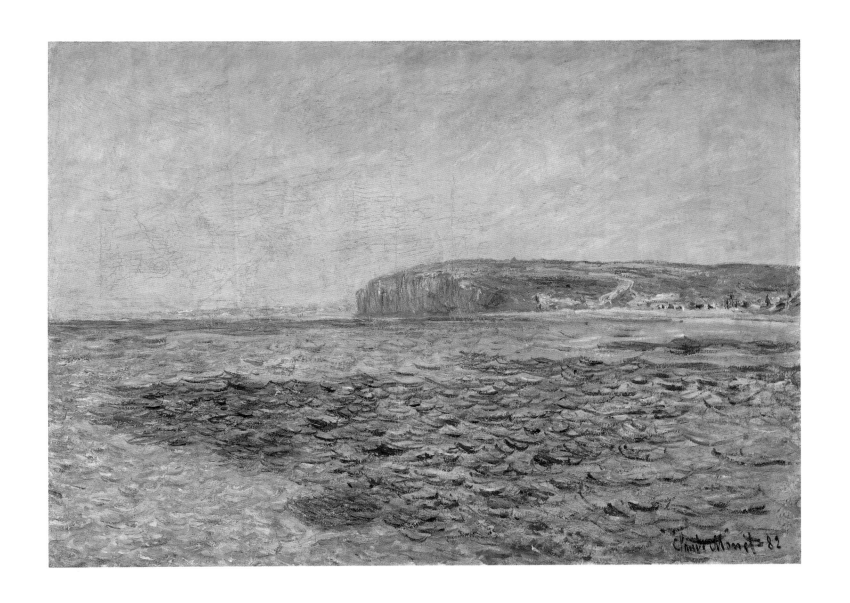

57

CLAUDE MONET
Shadows on the Sea, Pourville, 1882
Oil on canvas, 57 x 80 cm
Ny Carlsberg Glyptotek, Copenhagen

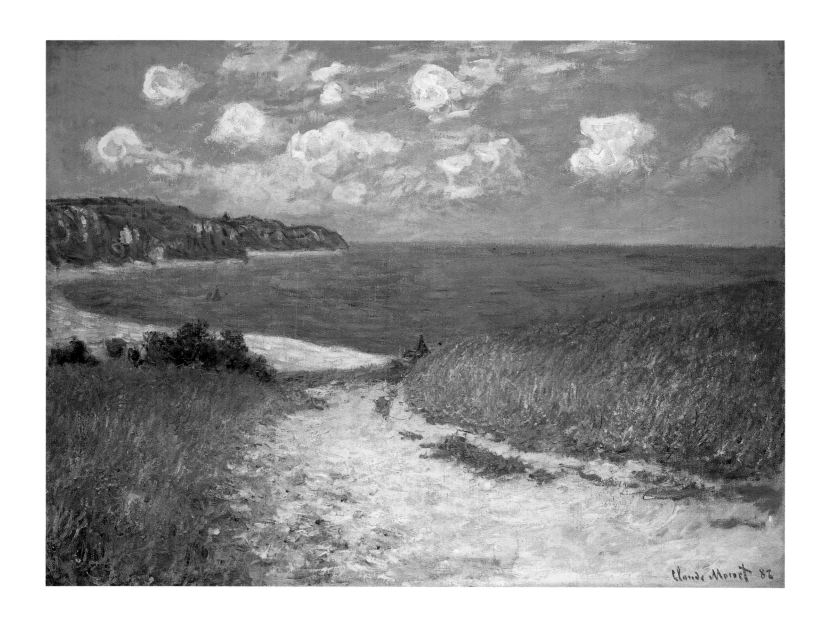

58
CLAUDE MONET
Path in the Wheatfields, Pourville, 1882
Oil on canvas, 58.2 x 78 cm
Collection of Frederic C. Hamilton

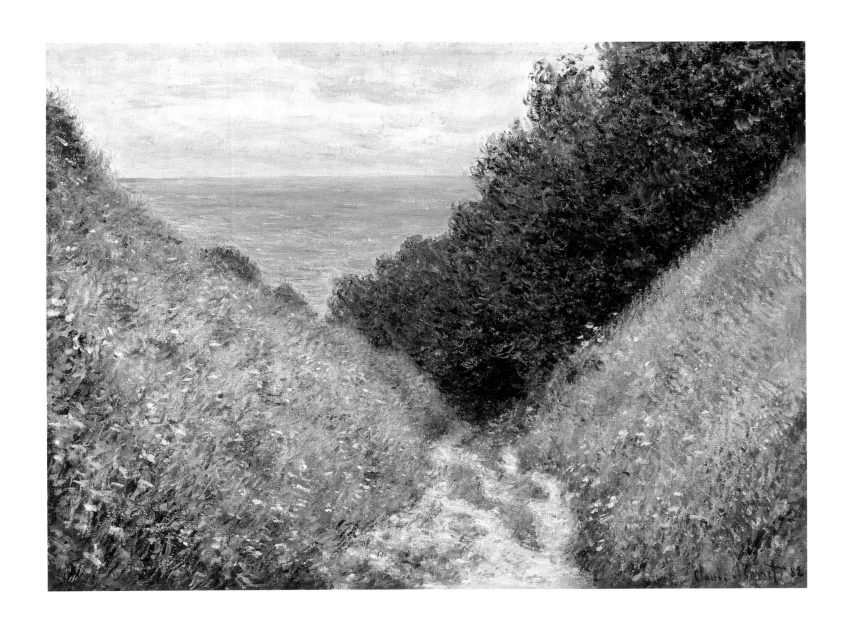

CLAUDE MONET
The Chemin de la Cavée, Pourville, 1882
Oil on canvas, 60.3 x 81.6 cm
Museum of Fine Arts, Boston. Bequest of Mrs Susan Mason Loring 109

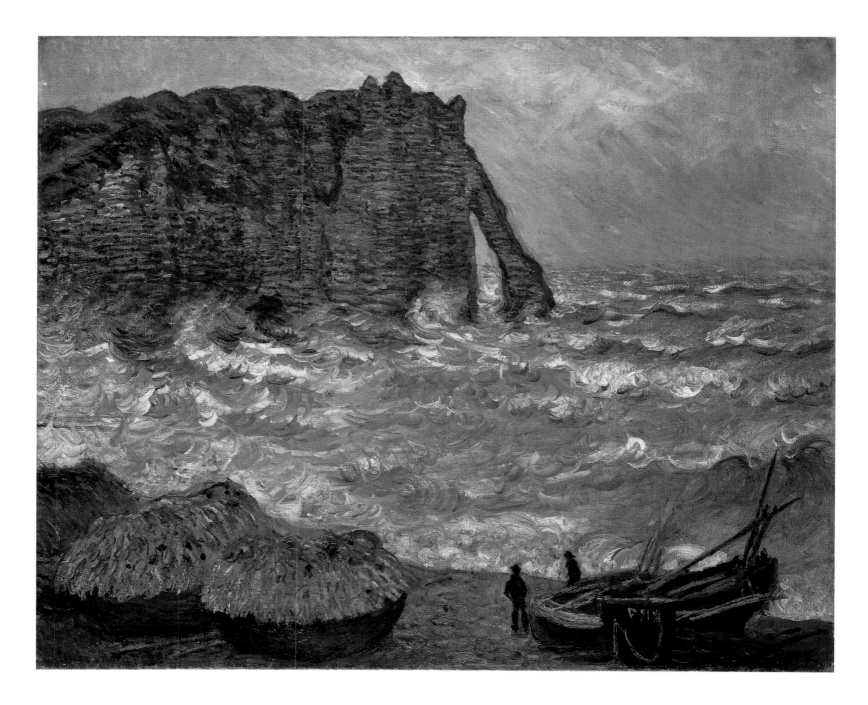

60

CLAUDE MONET
Etretat, Rough Sea, 1883
Oil on canvas, 81 x 100 cm
Musée des Beaux-Arts, Lyons

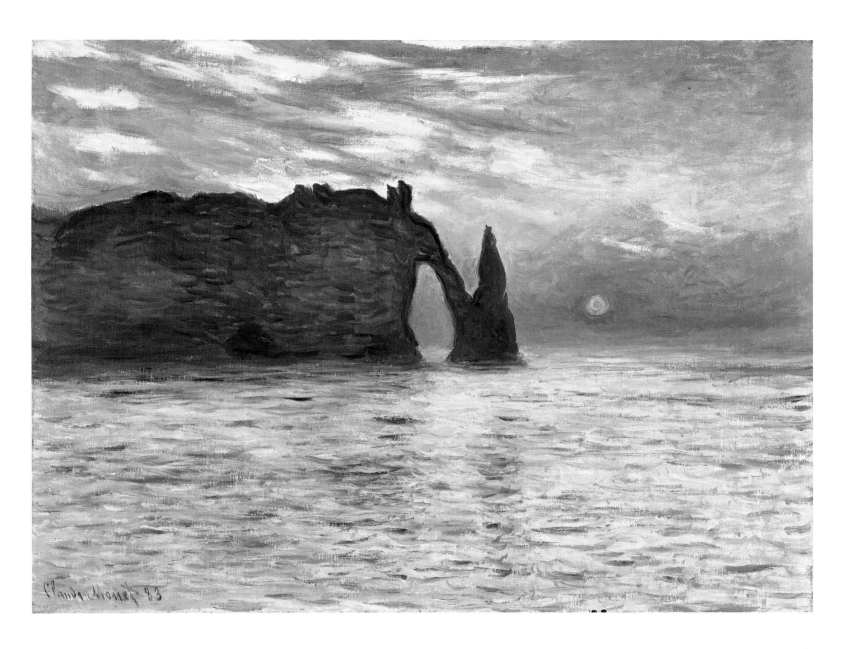

CLAUDE MONET
The Cliff at Etretat, Sunset, 1883
Oil on canvas, 60.5 x 81.8 cm
North Carolina Museum of Art, Raleigh, NC

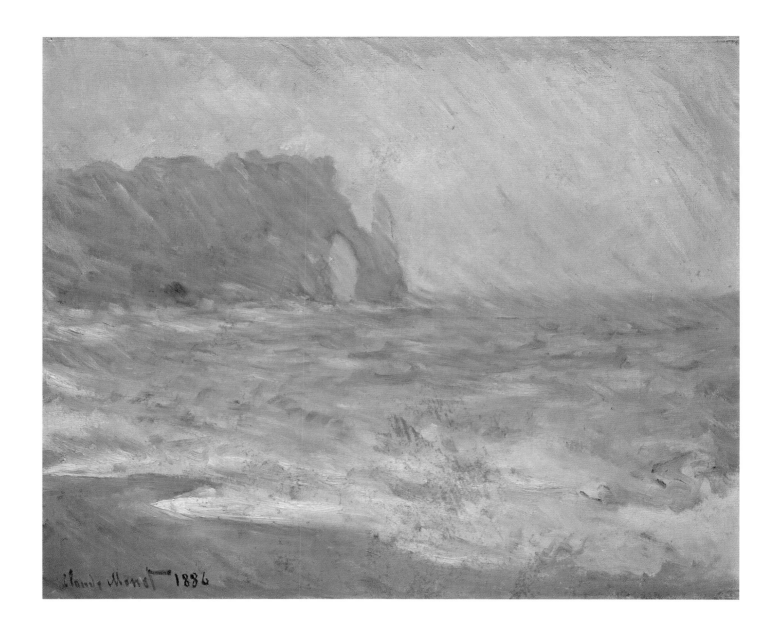

62

CLAUDE MONET

Etretat, Rainy Weather, 1885

Oil on canvas, 60.5 x 73.5 cm

The National Museum of Art, Architecture and Design, Oslo

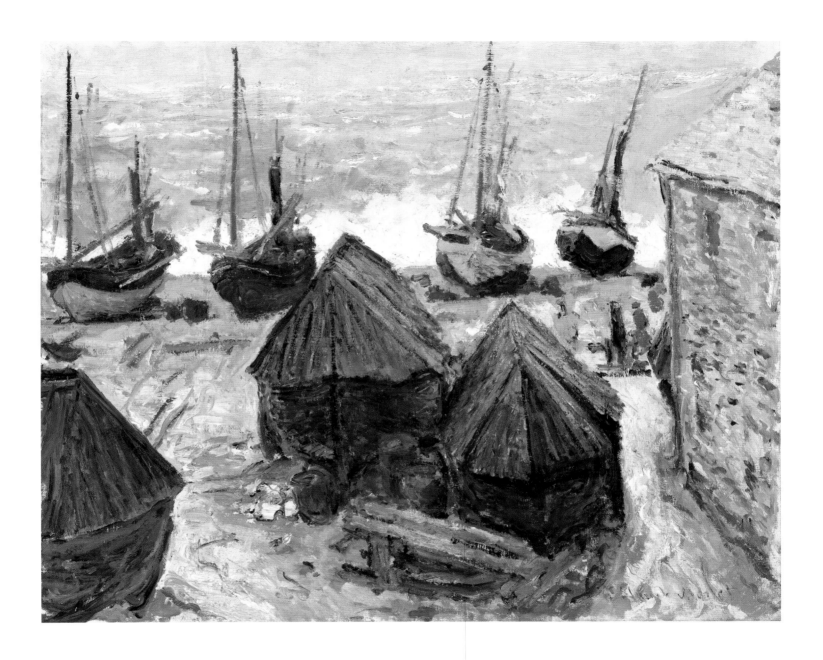

63

CLAUDE MONET
Boats on the Beach, Etretat, 1885
Oil on canvas, 65.5 x 81.3 cm
The Art Institute of Chicago. Charles H. and Mary F. S. Worcester Collection, 1947.95

64

PIERRE AUGUSTE RENOIR
By the Seashore, 1883
Oil on canvas, 92.1 x 72.4 cm
The Metropolitan Museum of Art, New York.
H. O. Havemeyer Collection.
Bequest of Mrs H. O. Havemeyer, 1929 (29.100.125)

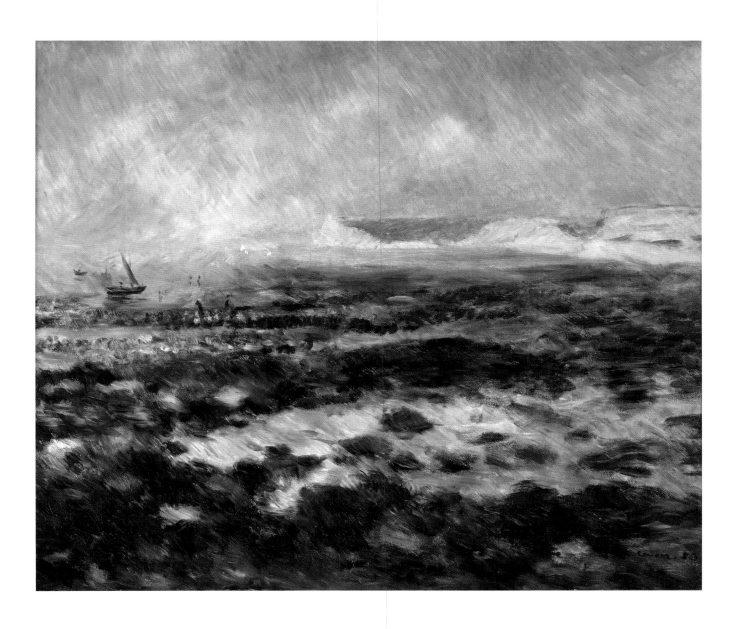

PIERRE AUGUSTE RENOIR
Low Tide, Yport, 1883
Oil on canvas, 54 x 65 cm
Sterling and Francine Clark Art Institute, Williamstown, Massachusetts

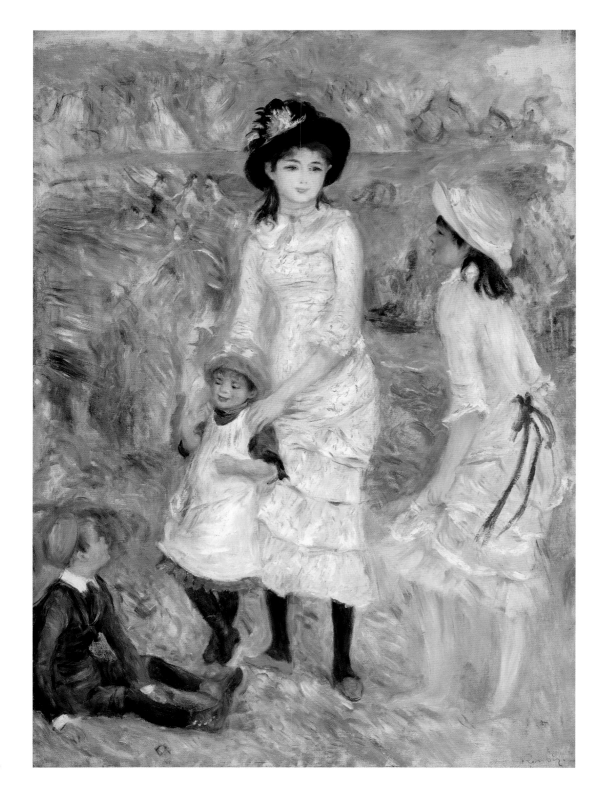

66

PIERRE AUGUSTE RENOIR
Children on the Seashore, Guernsey, c. 1883
Oil on canvas, 91.4 x 66.4 cm
Museum of Fine Arts, Boston. Bequest of John T. Spaulding

PIERRE AUGUSTE RENOIR
Sea and Cliffs, c. 1884/85
Oil on canvas, 51.4 x 63.5 cm
The Metropolitan Museum of Art, New York.
Robert Lehman Collection, 1975 (1975.1.200)

68

PAUL GAUGUIN

The Beach, Dieppe, 1885

Oil on canvas, 71.5 x 71.5 cm

Ny Carlsberg Glyptotek, Copenhagen

69

MARY CASSATT
Children at the Seashore, 1885
Oil on canvas, 97.5 x 73.7 cm
National Gallery of Art, Washington.
Ailsa Mellon Bruce Collection, 1970.17.19

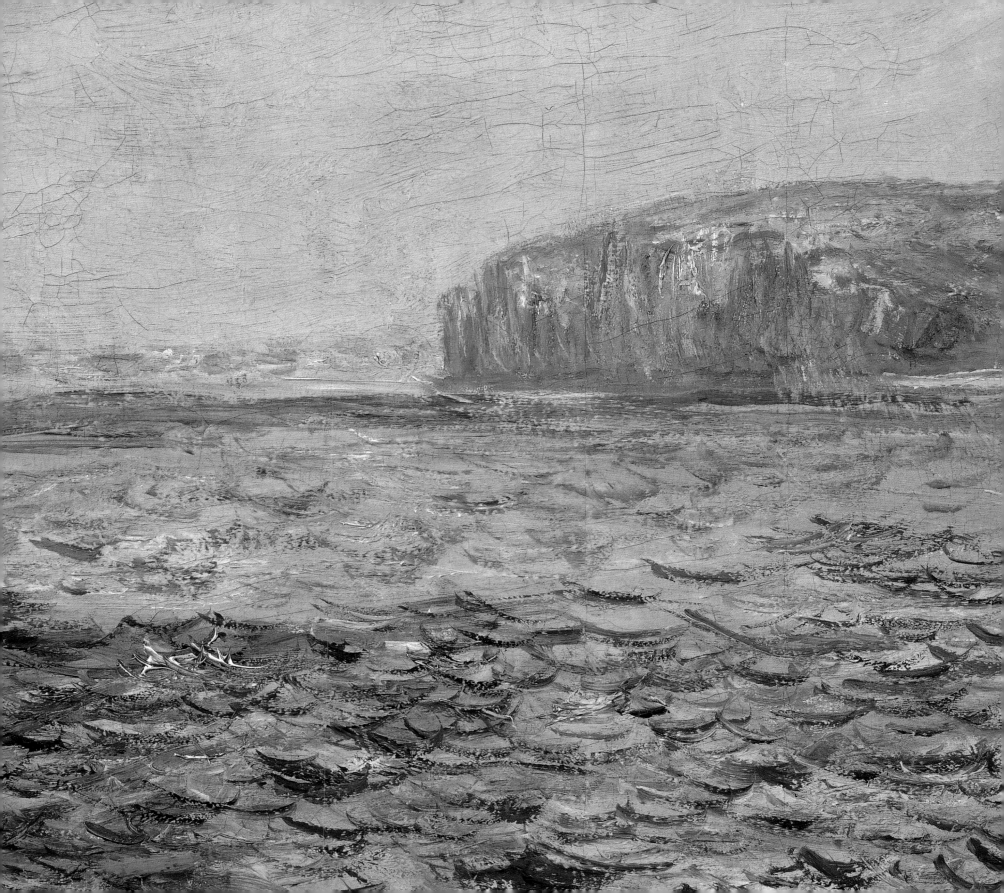

Catalogue entries

JOHN HOUSE

1 The Public Face of the Coast

1
EUGÈNE ISABEY (1803–1886)
Low Tide, 1861
Marée basse
Oil on canvas, 84 x 124 cm
Musée Malraux, Le Havre
Dépôt du Musée du Louvre, 1961
KEY REFERENCE: Miquel 1980, 2, no. 1260

Isabey was the most celebrated marine painter in France in the years around 1860. One of the artists who had played a most significant role in popularising the Normandy coast in the 1820s and 1830s, Isabey continued to paint coastal scenes throughout his career. He was noted for his virtuoso technique. As Théophile Gautier put it in 1855: 'In his method of applying colour, he shows a dazzling brio, an exciting energy, a remarkable spirit; he burns the canvas; his rapid and nervous touch … gives every object its proper value, while adding a sparkle to it' (Gautier 1856, p. 96). In 1859 Mathilde Stevens emphasised that the appeal of his art was only to the eye, not to the *esprit* (to the soul), and that those who believed that the artist should work 'under the direct impression of nature' would not take his work seriously (Stevens 1859, pp. 54–5). His Salon exhibit of 1859, *The Burning of the Steamer 'The Austria'* (fig. 28), was widely criticised for the mismatch between its overdramatised composition and the finesse and elegance of its technique (see e.g. Gautier 1992, p. 201; Stevens 1859, pp. 55–6).

Low Tide seems not to be based on a single topographical site, but, rather, to be an amalgam of Isabey's favourite coastal motifs. On the left, sailing ships on a stormy sea are treated in a way reminiscent of Dutch seventeenth-century precedents. On the foreground beach, fishermen appear to be trying to drag a massive beached vessel, though oddly the rope on which they are hauling is slack; beyond this is a massive wooden structure amid rocks – perhaps the remains of a wrecked ship that is being salvaged – and on the right we see the entrance to a busy and relatively sheltered port, with the factory chimney at far right giving the picture its only overt hint of contemporaneity.

The heavy clouds and sombre tonality of the canvas suggest the threatening force of the sea, while the boats and figures indicate the

Fig. 28 Eugène Isabey, *The Burning of the Steamer 'The Austria'*, 1858.
Oil on canvas, 242 x 430 cm. Musée des Beaux-Arts, Bordeaux

diverse ways in which fishing communities sought to counter the elements. The contrast between the storm-lashed coast and the relative calm of the enclosed harbour heightens the sense that the picture should be viewed as a generalised meditation on the complex relationship between man and the sea.

2
JAMES ABBOTT MCNEILL
WHISTLER (1834–1903)
Alone with the Tide, 1861
Seule
Oil on canvas, 87.2 x 116.7 cm
Wadsworth Atheneum Museum of Art,
Hartford, CT. In memory of William Arnold
Healy, given by his daughter, Susie Healy Camp
KEY REFERENCE: Young 1980, no. 37

Whistler visited Brittany in September/October 1861, and completed this canvas by the end of the year. He submitted it for exhibition, with the title *Seule* (*Alone*), in the Société nationale, the exhibiting organisation in Paris directed by Louis Martinet, in late December 1861, and exhibited it again at the Royal Academy of Arts in London in spring 1862, with the title *Alone with the Tide*. George du Maurier recorded Whistler's satisfaction with it when he brought the painting to London: 'There is not one part of the picture with which he is not thoroughly satisfied he says, and its open air freshness nothing can stand against' (Du Maurier, quoted in Young 1980, 1, pp. 16–17). Many years later, Whistler still held the canvas in high regard, describing it to E. G. Kennedy in 1899 as: 'A beautiful thing – painted in Brittany – Blue Sea – long wave breaking – black and brown rocks – great foreground of sand – and wonderful girl asleep' (quoted in Young 1980, 1, p. 17).

Alone with the Tide emphasises the contrast between the reclining figure, the wide rocky beach and the expanses of the sea beyond. The precise site depicted has not been identified, but Whistler is recorded as having worked at Perros-Guirec, on the north coast of Brittany, to the north of Lannion, during his 1861 visit to the region (I owe this information to Nigel Thorp), and it seems very likely that the painting is based on the rocky coastline in that region. Almost twenty years after Whistler's visit, Henry Blackburn was still able to celebrate 'the peace of this retreat', still untouched by the incursions of the fashionable holidaymaker (Blackburn 1880, pp. 50–1).

The figure in *Alone with the Tide*, wearing Breton peasant costume, invokes clear memories of the stock imagery of the French, and specifically Breton, peasant that was so common in the painting of the period. She is self-absorbed, and her posture suggests melancholy or exhaustion; although she is not looking towards the sea, the title *Alone with the Tide* evokes the idea that the sound of the waves may play a part in her contemplation. By contrast, it is the painter and the viewer who, as outsiders, engage visually with the drama and beauty of this seemingly remote scene, and view her as part of its overall 'local colour'.

Whistler had met Courbet in Paris in the late 1850s, and it is very likely that he had seen some of Courbet's coastal scenes painted on the Mediterranean near Montpellier during his visits to his patron Alfred Bruyas between 1854 and 1857. The strong sense of the physicality of the rocks in Whistler's canvas and the broad horizon

beyond are clearly reminiscent of Courbet's work, though Whistler's paint handling is drier and more economical than Courbet's. Later in 1861, on a visit to the southwest coast of France, Whistler painted *The Blue Wave*, *Biarritz* (Hill-Stead Museum, Farmington, Connecticut), a canvas that focuses solely on a breaking wave, in a way that anticipates Courbet's many canvases of waves from the late 1860s (see cat. 26 and fig. 37, p. 128).

Whistler exhibited *Alone with the Tide* again at a number of exhibitions from 1874 onwards, but consistently gave it neutral titles such as *Scene on the Coast of Brittany* or *On the Brittany Coast* (see Young 1980, 1, p. 16). By the 1870s he had repudiated the sentimental and anecdotal dimension of painting suggested by the title *Alone with the Tide* in favour of an insistence on purely visual, aesthetic qualities. However, he did not, it seems, ever give this canvas one of his characteristic musical titles.

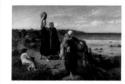

3
JULES BRETON (1827–1906)
A Spring by the Sea, 1866
Une Source au bord de la mer
Oil on canvas, 110 x 155 cm
Private collection
KEY REFERENCE: Arras 2002, no. 51

Jules Breton established his reputation during the late 1850s and early 1860s with his paintings of the peasants of his birthplace, Courrières, in northeastern France. He first visited Brittany in the summer of 1865, and *A Spring by the Sea*, included in the Paris Exposition Universelle of 1867, was the first picture he exhibited of a scene from Brittany.

The site represented is a freshwater spring on the Plage du Ris at Plomarc'h, on the eastern side of the bay of Douarnenez in Finistère in western Brittany. Soon after arriving at Douarnenez, he wrote to his uncle: 'There is a site that I aim to visit often, it is a washing-place, frequented all day by washerwomen who arrive and leave carrying their bundles of laundry on their heads in poses that are *d'un beau style*' (Bourrut Lacouture 1987, p. 108).

A Spring by the Sea is a fascinating amalgam of direct observation with a process of idealisation. This allowed Breton to view the figures themselves as revealing *un beau style*, and to treat them in a way that conveyed this sense of generalised beauty without losing sight of the specifics of their dress and setting. For Léon Lagrange, reviewing the 1867 Exposition, the 'ideal' never extinguished the 'life' in Breton's work, and his process of 'generalisation' allowed him to attain '*le style*' (Lagrange 1867, pp. 1017–18). However, Ernest Chesneau saw this process of 'embellishing nature' as producing 'results that are more sympathetic and more seductive for the public in the cities, for whom reality has little appeal and who are generally disgusted by the peasant' (Chesneau 1868, p. 306).

Many preparatory drawings of the ensuing picture survive, some exploring overall ideas for the composition, some, presumably made from posed models, focusing on individual figures. In comparison with the relative animation of the compositional studies, the final painting, executed over the next eighteen months in Breton's studio, emphasises the hieratic, processional quality of the figures walking down to the beach; the bundles of laundry on the figures' heads are

replaced by a water jar carried by a single figure (see Bourrut Lacouture 1987, pp. 108–16). The background landscape, too, was manipulated; in the final picture there is no sign of the port of Douarnenez, famed for its sardine fisheries, which would have been visible in the distance.

Many years later, in his autobiography, Breton recalled the difficulties he had encountered in finishing the canvas, particularly in integrating the figures into the background space, and evoked his first impressions of the sombre, melancholy atmosphere of Brittany, and of 'the women who resemble holy Virgins; … all this monastic rusticity, all this mystic savagery seemed to evoke in me confused and distant memories more ancient than those of my native Artois. And I felt that I must be descended from the Bretons' (Breton 1890, pp. 297–304). In responses such as these, Breton was echoing the stereotypical views of Brittany at the time, but also claiming that his vision gave him special, privileged insight into the spirit of Brittany even though, as he himself realised, he had no actual claim to be 'descended from the Bretons', despite his surname.

4
EUGÈNE ISABEY (1803–1886)
The Beach at Granville, 1863
La Plage de Granville
Oil on canvas, 83 x 124 cm
Musée du Vieux-Château, Laval
KEY REFERENCE: Miquel 1980, 2, no. 1249 bis

The Beach at Granville approaches the theme of the coast in a very different way from *Low Tide* (cat. 1). Most unusually for Isabey, the windy, wave-swept shoreline in *The Beach at Granville* is occupied by a crowd of women bathers in modern dress, on the beach and in the sea, some seeking shelter on the beach, some braving the shallows, and one group frolicking in the waves.

Granville, on the west coast of the Cotentin peninsula, a few miles north of Mont-Saint-Michel, stands apart from the resorts of the northern Normandy coast. It was primarily noted for its 'Ville haute', a rocky fortified outcrop crowned by the old town, and for its role as one of France's premier commercial and fishing ports; guidebooks repeatedly noted the fine physical qualities of the local fisherwomen

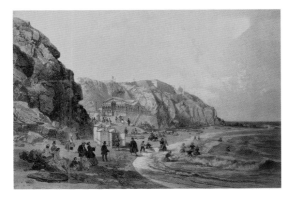

Fig. 29 Félix Benoist, *The Beach of Granville*, 1860.
Lithograph, Musée du Vieux Granville

(see p. 17 and fig. 2). In 1861, Jules Michelet, in *La Mer*, contrasted the sober mood and austere scenery of Granville with the 'gaiety' of the beaches of northern Normandy, 'rich and amiable, and sometimes rather vulgar' (Michelet 1983, p. 50).

By the 1860s, though, Granville also had a bathing station, beneath the cliffs to the north of the town, and a small casino. In 1869, Henry Blackburn, while noting the limitations of its facilities as a resort, warmly recommended it to holidaymakers as 'a pleasant and favourable spot in which to study the manners and customs of a seafaring people' (Blackburn 1869, pp. 124–5).

In Isabey's canvas we see in the background the rock on which stand the old town and church of Granville and, beneath it, the path leading down to the beach – sheltered by the cliffs and separated from the town, as many guidebooks noted (e.g. Conty 1877, pp. 94 and 279). There is, though, no sign of the casino; by 1860 this stood beneath the rock where the track meets the beach (see fig. 29). Isabey omitted the facilities that attracted the holidaymakers to Granville, and presents the modern bathers and their bathing huts as if they have been planted into an untouched, romantic landscape.

The body language of the bathers, face to face with the wind and waves, is deftly characterised, and the fluent, playful brushwork effectively complements the chosen subject – an unusual synthesis of bourgeois recreation with a romantic vision of the seashore.

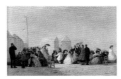

5
EUGÈNE LOUIS BOUDIN
(1824–1898)
The Beach at Trouville, 1864
La Plage de Trouville
Oil on canvas, 67.5 x 104 cm
Collection Art Gallery of Ontario, Toronto.
Anonymous gift, 1991
KEY REFERENCE: Schmit 1973, 1, no. 303

Boudin seems to have begun his long sequence of canvases of fashionable figures on the beach at Trouville in 1862 (see cats 13–17) and between 1864 and 1869 he exhibited a sequence of larger canvases of the subject at the Paris Salon. *The Beach at Trouville* can be identified as one of the two that he exhibited in 1865 from a drawing that Boudin made after it for publication in *L'Autographe au Salon* (fig. 30).

The work is particularly notable for the near invisibility of the sea, seen only as a distant horizontal beyond the figures at far right. The blowing flag shows that it is a breezy day, but the emphasis is firmly on the figures, crowded together on the sands beside the bathing huts. They show not the slightest interest in their natural surroundings; it is their social interchanges that concern them, not their location by the sea. Although all the figures are close to each other they are presented in separate clusters, separate small social units. However, Boudin avoids the sort of gestures or body language that invite the viewer to speculate about the details of the relationships between the figures; there are no hints at anecdote or emotional expression. Only the single male figure at far left stands out, seemingly looking for someone or something in the crowd, but we cannot tell whom or what he is seeking (compare Manet, cat. 34). The intermingling

of these groups of figures is closely reminiscent of the groupings in Parisian images such as Manet's *Music in the Tuileries Gardens* of 1862 (National Gallery, London); the social world of the Parisian bourgeois has been transferred wholesale to its summer habitat on Trouville beach (pp. 18–19).

Boudin saw his canvases of fashionable figures on the beach – his 'little puppets', as he called them – as his passport to success in the art world, and placed great importance on presenting them at the Salon in 1865. However, once the Salon had opened he felt dissatisfied with the results: 'The efforts that I have made for [the Salon] have tended to weigh down my painting, which does not present the fluent and delicate side of my art' (see letters to Martin, 12 February 1865 and 19 May 1865, in Pludermacher 2000, pp. 23–4 and 28). However, the critic in *L'Autographe au Salon* was enthusiastic about his work:

> We invite the reader to go to the Salon and see the painting of which we are publishing a drawing. He will find a fresh and joyous bouquet of colours. Equally charming and amusing as a colourist and a draughtsman, M. Boudin seems ideally suited to rendering modern elegance in its prettiest and most eccentric forms.
> (*L'Autographe* 1865, p. 27)

The Beach at Trouville is closely related to another, smaller canvas, dated 1864 (fig. 31), which shows virtually the same grouping of figures and bathing huts. Presumably this acted as some sort of

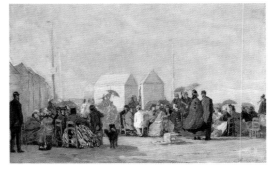

Fig. 30 Eugène Louis Boudin, *The Beach at Trouville*,
reproduction of drawing from *L'Autographe au Salon*, 1865

Fig. 31 Eugène Louis Boudin, *Beach Scene at Trouville*, 1864.
Oil on canvas, 31 x 48.5 cm. Private collection
(sold Sotheby's, London, 7 February 2006, lot 39)

123

preparatory study for the larger picture, as well as being completed as a work in its own right; even the smaller picture was probably executed in the studio (see entry for cats 13–16). The subtle changes made in the Salon picture offer a revealing insight into Boudin's thinking about his figure compositions when working on a larger scale for public exhibition. The male figure at far left is now shown with his arm raised, as is the male figure with a white jacket seated at the centre; the dog to the left of centre is replaced by a chair, and the overturned chair in the smaller picture is removed.

2 Before Impressionism

6
JOHAN BARTHOLD JONGKIND
(1819–1891)
Fécamp, 1852
Oil on canvas, 43.2 x 57.5 cm
Wadsworth Atheneum Museum of Art, Hartford, CT.
The Ella Gallup Sumner and Mary Catlin Sumner Collection Fund
KEY REFERENCE: Hefting 1975, no. 110

Of all the sites along the Normandy coast, Fécamp had the longest history; its abbey church, mostly dating from the twelfth century, and its important fishing port established it as a substantial town long before the arrival of the bourgeois holidaymakers. A bathing station was set up there before 1850, together with a casino, but its development as a seaside resort was physically separate from the old town, set back from the sea above the port.

Jongkind moved his base from his native Holland to France in 1846, initially working in the studio of Eugène Isabey (see cats 1 and 4). He first travelled to Normandy in 1847, returning there for longer periods in 1850 and 1851, and exhibited a number of scenes of Norman ports at the Salon in the early 1850s. *Fécamp* is one of the fully finished, smaller canvases he executed for sale through commercial art dealers.

Here, Jongkind brings together the beach and the port. The picture belongs to the long lineage of French port scenes of which Joseph Vernet's 'Ports of France' were the prime example (see p. 20); but Jongkind avoids the panoramic viewpoints characteristic of this genre, instead placing the viewer on a wedge of sand at the east side of the entry to the harbour, looking towards the old town, beyond the boats, with local figures close to our viewpoint on the shore. The informality of the figures and boats in the foreground is set off against the substantial and evidently old buildings of the town, giving a sense, perhaps, that the place has lost something of the distinction of its past; there is no trace of its new role as a resort.

The forms of the figures, boats and buildings are crisply delineated, thrown into relief by the contre-jour lighting that sets up sharp tonal contrasts between areas of light and shade. In these years, Jongkind seems to have executed his oil paintings in his studio; there is no evidence that he visited the coast during 1852, and it seems likely that, despite its very specific effects of outdoor light, the canvas was executed in his Paris studio, worked up from drawings and/or watercolours he had executed during his visits in previous years.

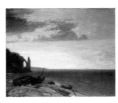

7
JOHAN BARTHOLD JONGKIND
(1819–1891)
The Sea at Etretat, 1853
La Mer à Etretat
Oil on canvas, 53.3 x 63.5 cm
Birmingham Museums and Art Gallery
KEY REFERENCE: Hefting 1975, no. 123
(with wrong dimensions and location)

By 1853, Etretat was already a thriving small holiday resort, but in *Etretat* Jongkind makes nothing of the place itself. In contrast to *Fécamp* (cat. 6), painted the previous year, he has turned away from the village and looks out to sea; rather than throwing the forms into relief, the contre-jour lighting here transforms them into virtual silhouettes, set against the light of the setting sun, out of sight behind the cliff on the left. Presented as it is here, Etretat is reduced to the simple juxtaposition between its celebrated rock formations (the Porte d'Aval and the Needle) and the fishing boats on the shore. The unobtrusive figure of a fisherman down by the sea acts as a reminder that this was a working village, and that the boats needed to be dragged up the shingle beach since there was no port. But the primary subject is the sunset and the visual effects that it created. Courbet and Monet later represented Etretat in very similar terms (see cats 25 and 60, and fig. 36).

Although Jongkind planned to visit the coast in 1853 (see letter to Eugène Smits, 7 June 1853, in Hefting 1969, p. 18), there is no evidence that this trip took place. Whether it did or not, it seems likely that the canvas was executed indoors, on the basis of preparatory studies, as was his standard practice at this date. Although the foreground is quite broadly and simply treated, the play of light through the clouds is handled with great finesse.

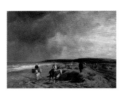

8
CONSTANT TROYON (1810–1865)
The Coast near Villers, c. 1860
La Côte près de Villers
Oil on canvas, 67.4 x 95.7 cm
The Walters Art Museum, Baltimore, 37.993
KEY REFERENCE: Johnston 1982, no. 49

By the 1850s, Troyon was renowned as one of France's leading painters of farm animals, primarily cows. A guidebook to the Normandy coast in 1862 recounted the story of a local peasant's response on hearing that one of his paintings of cows had recently sold for more than 4,000 francs: 'You must be joking; am I stupid enough to believe that a cow in a painting, which is completely useless, sells for twenty times more than one of our finest Cotentin cows, which produce fifteen pots of milk a day?' (Morlent 1862, p. 294). However, Troyon had initially established a reputation as a painter of forest landscapes, and he continued to paint topographically specific landscapes, some of them based on sites he studied on his regular visits to the Normandy coast.

The Coast near Villers shows the view looking eastwards from Villers towards the future site of Deauville; the location is identified by an inscription on the stretcher of the canvas (see Johnston 1982, p. 66). The buildings in the distance appear to be those of Trouville; in the

opposite direction, behind the viewer, lay the very different terrain of the Vaches Noires cliffs, between Villers and Houlgate, depicted by Paul Huet in 1863 (see fig. 7, p. 21). Villers began to be developed as a resort in the late 1850s, but Troyon has given no indication of the resort development along the coast. Instead, this is an open, untouched shoreline, whose social dimension is supplied by the very diverse figures who people it, ranging from the fashionably dressed huntsman on the sand dunes to the woman on horseback with baskets that suggest that she has been gathering seafood on the shore.

Although the canvas is closely based on a specific site, its overall conception is particularly close to Dutch seventeenth-century coastal scenes by painters such as Adriaen van de Velde and Jacob van Ruisdael (e.g. fig. 6, p. 20). The view that Troyon shows here can be seen in the background of Caillebotte's *Villers-sur-mer* (cat. 50), painted around twenty years later. Caillebotte, in contrast to Troyon, made the newly developed resort his primary focus.

The carefully and delicately worked details of *The Coast near Villers* suggest that the canvas was largely or entirely painted in the studio. However, it captures particularly vividly the contrast between sun and rain, and the distinctive effect of sharp sunlight following a rain shower.

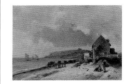

9
JOHAN BARTHOLD JONGKIND
(1819–1891)
The Beach at Sainte-Adresse, 1862
La Plage de Sainte-Adresse
Oil on canvas, 33 x 46 cm
Courtesy of the Ivo Bouwman Gallery, The Hague
KEY REFERENCE: Hefting 1975, no. 237

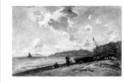

10
JOHAN BARTHOLD JONGKIND
(1819–1891)
On the Beach at Sainte-Adresse, 1862
Sur la plage de Sainte-Adresse
Oil on canvas, 27 x 41 cm
Collection of Phoenix Art Museum.
Mrs Oliver B. James Bequest
KEY REFERENCE: Hefting 1975, no. 236

Jongkind's 1862 beach scenes of Sainte-Adresse represent an important moment in the history of the genre, and in the prehistory of Impressionism. It was while he was painting them that Monet first met him, Monet later recalling that Jongkind was 'from that moment, my true master, and it is to him that I owe the definitive education of my eye' (Thiébault-Sisson 1998, p. 20).

The canvases represent the view looking northwards from the beach to the north of Le Havre, with the Pointe de la Hève in the distance, seen from closer to in Monet's canvases of 1864–65 (cat. 11 and fig. 32); in 1867, Monet painted a view particularly close to cat. 10 (see fig. 33). Sainte-Adresse was by this date beginning to be transformed by suburban development out of Le Havre and by its development as a resort, and commentators' opinions were sharply divided about the benefits this had brought (see entry for cats 11 and 12). However, Jongkind chose to depict

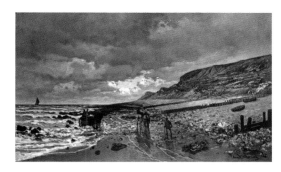

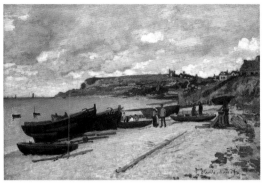

Fig. 32 Claude Monet, *The Pointe de la Hève at Low Tide*, 1865.
Oil on canvas, 90.2 x 150.5 cm. Kimbell Art Museum, Fort Worth

Fig. 33 Claude Monet, *Sainte-Adresse, Fishing Boats on the Shore*, 1867.
Oil on canvas, 57 x 80 cm. National Gallery of Art, Washington DC
(partial and promised gift)

the beach as the territory of the local fisherfolk, with no visible sign
of these changes.

Beach scenes of this sort, representing the informal, everyday life
of the coast, have their parentage in Dutch canvases of the
seventeenth century (see fig. 6, p. 20), but Jongkind's canvases differ
in two crucial ways from these prototypes. First, he was far more
concerned with specific and ephemeral effects of light, as in the
contre-jour cloud effect in cat. 10 and the raincloud above the
Cap de la Hève in cat. 9; and second, his brushwork was far more
variegated, deploying a wide range of different marks as a visible form
of shorthand for representing the diverse forms and textures of the
scene. Cat. 10 is the more broadly sketched of the two canvases, but
the paint handling in the more highly finished cat. 9 remains fluent
and highly visible. Both Jongkind's paint-handling and his concern with
specific weather effects were of fundamental importance among the
lessons Monet learned from him.

However, Jongkind does not seem to have executed even such
small canvases as these outdoors in front of the motif. In 1862 he
wrote from Le Havre to his dealer Martin describing the 'charm' of his
walks along the beach, commenting: 'I do not know how far I shall be
able to transform this view into a satisfactory painting. I have made
some drawings and water-colours of it' (letter to Martin, 8 September

1862, in Hefting 1969, p. 131). The following year he wrote of his
attempts to paint a canvas directly from nature as if this experiment
was something new for him (letter to Martin, 25 September 1863,
in Hefting 1969, p. 141).

11
CLAUDE MONET (1840–1926)
The Pointe de la Hève, 1864
La Pointe de la Hève
Oil on canvas, 41 x 73 cm
The National Gallery, London
KEY REFERENCE: Wildenstein 1974, no. 39
(Exhibited in London only)

12
CLAUDE MONET (1840–1926)
The Coast at Sainte-Adresse, 1864
Bord de la mer à Sainte-Adresse
Oil on canvas, 40 x 73 cm
Minneapolis Institute of Arts.
Gift of Mr and Mrs Theodore Bennett
KEY REFERENCE: Wildenstein 1974, no. 22

These two canvases show the same stretch of coastline, beneath the
cliffs to the north of Sainte-Adresse, looking in opposite directions:
cat. 11 northwards towards the Pointe de la Hève, cat. 12 southwards,
with the silhouette of the town of Le Havre and the jetty of its port
in the background and, in the distance, the coast on the opposite
side of the Seine estuary.

In the 1860s, commentators were sharply divided about the
current state of Sainte-Adresse. For Eugène Chapus in 1862, despite
the new houses and kiosks, it retained its 'arcadian freshness': 'all the
seductions of solitude, silence and oceanic contemplation still reign
there' (Chapus 1862, p. 244). However, Eugène d'Auriac felt that it
had 'lost most of the rustic appearance which gave it its charm' (Auriac
1866, p. 200), while Adolphe Joanne described it as little more than
a dirty suburb of Le Havre, despite its popularity as a bathing station
(Joanne 1866, p. 105). Monet avoided any clear signs of modernity in
both canvases, despite the presence of Le Havre in the background of
cat. 12; in both he chose his viewpoint so that the recent developments
at Sainte-Adresse would be invisible, developments that he
foregrounded three years later in cats 32 and 33. Instead, the beach
is presented as an unspoiled, seemingly timeless space; one humble
cottage is visible on the hillside in cat. 11, and in both the sea is
animated by a single rowing boat and local fishing vessels.

It is not clear whether these canvases were begun outdoors.
In autumn 1864, around the date that they were executed, Monet
reported that he was in the process of making studio versions of
studies that he had painted outdoors (letter to Frédéric Bazille,
14 October 1864, in Wildenstein 1974, p. 421). There is only the
single version of each of the present subjects, which suggests that
the canvases may have been begun on the spot; both, too, show an
overcast weather effect, which would have allowed Monet to work
for longer before the lighting conditions changed. However, the
comparatively complex and delicate brushwork, especially in cat. 11,
is likely to have been the result of studio reworking; moreover, the

size of the rowing boats, both of them too large for their position
in the space, strongly suggests that they were added in the studio.
The delicate and variegated brushwork of the canvases, responsive
to the diverse textures in the scene, is particularly indebted to the
contemporary work of Jongkind (see cats 9 and 10), with whom
Monet was in close contact at this date.

Another version of the view of the Pointe de la Hève, of
approximately the same size, shows the scene at low tide; this formed
the basis for the large version of the subject that was one of Monet's
first two exhibits at the Paris Salon in 1865 (fig. 32).

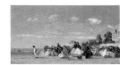

13
EUGÈNE LOUIS BOUDIN
(1824–1898)
The Beach at Trouville, 1863
La Plage de Trouville
Oil on canvas, 25.4 x 46.4 cm
Wadsworth Atheneum Museum of Art,
Hartford, CT. The Ella Gallup Sumner and
Mary Catlin Sumner Collection Fund
KEY REFERENCE: Schmit 1973, 1, no. 281

14
EUGÈNE LOUIS BOUDIN
(1824–1898)
The Beach at Trouville, 1863
La Plage de Trouville
Oil on panel, 18.4 x 34.9 cm
The Phillips Collection, Washington DC
KEY REFERENCE: Schmit 1973, 1, no. 283

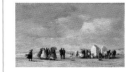

15
EUGÈNE LOUIS BOUDIN
(1824–1898)
The Beach at Trouville, 1865
La Plage de Trouville
Oil on canvas, 38 x 62.8 cm
Princeton University Art Museum.
Gift of the Estate of Laurence Hutton
(50-65)
KEY REFERENCE: Schmit 1973, 1, no. 347

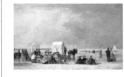

16
EUGÈNE LOUIS BOUDIN
(1824–1898)
Bathing Time at Deauville, 1865
L'Heure du bain à Deauville
Oil on panel, 34.5 x 58 cm
National Gallery of Art, Washington.
Collection of Mr and Mrs Paul Mellon,
1983.1.8
KEY REFERENCE: Schmit 1973, 1, no. 275

Boudin first established a reputation with his canvases of groups of
fashionable holidaymakers on the beaches of Trouville and Deauville.
By the late 1860s he was recognised as the inventor of a new genre of
painting (see p. 25). He exhibited a few larger canvases of this subject
at the Paris Salon (see cat. 5), but the vast majority were smaller

pictures designed for sale through art dealers to private collectors. During the 1860s, the years covered by the present group of pictures, his main dealer was Alfred Cadart.

In some canvases he included Trouville's casino and the hotels along the seafront (see also cat. 17), in others he looked out to sea across the wide expanses of sandy beach. In cat. 13 we see the villas at the northeastern end of the town, with a glimpse of the cliffs beyond; these cliffs, alone, appear in the background of cat. 15, and cat. 14 includes the jetty of Trouville harbour. Although the title of cat. 16 indicates that it represents Deauville, the newly created resort on the opposite side of the River Touques from Trouville, there is nothing about the picture itself that differentiates it from the Trouville canvases.

Bathing huts, together with the horses that hauled them across the beach, appear in cats 15 and 16, but the bathers are only summarily indicated in the background of the two pictures. Rather, it is the groups of figures on the beach, seated or strolling, that are the central theme. All of the canvases focus on the bourgeois holidaymakers, with one possible exception – the figure separated from the others on the left of cat. 13. It seems likely that he is a working figure, sweeping the sand (I owe this suggestion to Aileen Ribeiro); the inclusion of a representative of the 'service industry' at Trouville is most unusual in Boudin's beach scenes. And in all the canvases the figures interact with the elements; the skies are constantly varied, and in cat. 15 the waves and the women's clothing show that it is a windy day. The conditions of weather and light are integral to the subject of the pictures; we are witnessing the urban culture of the fashionable holidaymaker exposed to the forces of the elements.

Fully finished oil paintings such as these were not, it seems, executed outdoors. In one of his notebooks, Boudin wrote: 'Everything that is painted directly and on the spot has always a strength, a power, a vivacity of touch which one cannot recover in the studio' (Cahen 1900, p. 181). However, his attitude and his practice were not as straightforward as this suggests. Elsewhere he noted that: 'One can count as direct paintings things done on the spot or when the impression is fresh,' and urged himself to 'elaborate (*pousser*) his studies, whether in front of nature or under the impression [of nature]' (Cahen 1900, p. 183). In part, this was a simple recognition of the limitations of painting out of doors – that effects of weather and light change so quickly that the painter will inevitably have to finish a work from memory.

In Boudin's work of the 1860s there is a clear division between his fully finished oil paintings and the mass of studies, mostly in graphic media (there are very few informal oil sketches from this decade). But even in his studies there is a crucial division, between notations of light and weather, often made in pastel, and the vast numbers of pencil drawings, sometimes with added watercolour, of particular elements and details in the scenes that he was studying – drawings he used like a vast dictionary in composing his more elaborate paintings. Moreover, he also had a notion of the qualities a complete picture should have, and recognised that these went beyond a mere notation. He noted in 1865: 'One should consider one's picture in advance and ponder it well.' In 1866 he wrote that the painter had to go beyond 'the simple and naive copy of nature'; in an undated note, he added: 'Colour, drawing and form must come together to express an idea' (Cahen 1900, pp. 191, 193 and 185).

In the execution of his canvases, Boudin used a deft, delicate touch, subordinating details to the overall effect, so that the eye takes in the scene as a whole rather than focusing on individual elements within it, though at the same time the succinct characterisation of the figures, through their clothing and body language, invites closer scrutiny.

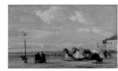

17
EUGÈNE LOUIS BOUDIN
(1824–1898)
The Empress Eugénie on the Beach at Trouville, 1863
L'Impératrice Eugénie sur la plage de Trouville
Oil on panel, 34.3 x 57.8 cm
Glasgow City Council (Museums)
KEY REFERENCE: Schmit 1973, 1, no. 280
(Exhibited in London only)

The Empress Eugénie on the Beach at Trouville is exceptional among Boudin's Trouville beach scenes in that it includes a celebrated individual. Although there is no firm documentary evidence that it represents the Empress Eugénie, wife of the Emperor Napoleon III, there seems no reason to doubt its traditional title (see Glasgow 1992, pp. 73–4). The women walking on the beach stand out as a distinctive and carefully ordered group, unlike the more informal clusters of figures in Boudin's other beach scenes (see cats 5 and 13–16). Yet the figures in this group are not treated in any detail, and there is no clear indication as to which of them represents the Empress – perhaps it is the figure in white at the centre of the group, but we cannot be sure. This image of the Empress with her ladies in waiting makes an amusing contrast with Winterhalter's celebrated picture of the subject, *The Empress Eugénie surrounded by her Ladies-in-Waiting* of 1855 (Musée National du Château de Compiègne), in which the Empress is presented as the unequivocal focus of the composition.

In Boudin's canvas, the Empress's position is further undercut by the fact that her passage across the beach is ignored by the other figures, most notably by the couple on the bench on the left, who seem to be engaged in their own conversation. Only the small white dog (a Pekinese?) pays any attention to the Empress's group, while the two other dogs (mongrels, perhaps) are absorbed in their own interchange. Boudin regularly used dogs to act as a witty complement to the figure groups in his beach scenes (see also cats 5 and 13–16). From his own viewpoint, all of the specific elements in the picture are subordinated to the overall effect of light and atmosphere.

The scene depicted shows the beach from its southwestern end, near the port and the estuary of the River Touques. We see the Hôtel de la Mer on the right with, beyond it, the flags on the terrace in front of the casino (see Glasgow 1992, pp. 48 and 66–7). In the distance, across the estuary of the Seine, are the cliffs of Sainte-Adresse, to the north of Le Havre – the subject of Jongkind's canvases of 1862 and Monet's of 1864 (cats 9–12). Monet's Trouville canvases of 1870 (cats 36 and 37) view the place form further to the northeast, beyond the casino.

The Empress Eugénie on the Beach at Trouville is a prime example of *peinture claire*, the luminous, all-over light-toned palette pioneered by Corot. In later years Monet acknowledged that it was Boudin's use

of this means of conveying the effects of outdoor light that had been his model at the outset of his career (see e.g. cat. 35; Shiff 1984, pp. 199ff; and House 1986, p. 110).

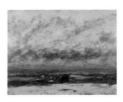

18
GUSTAVE COURBET (1819–1877)
Marine Landscape ('Eternity'),
c. 1865
Paysage de mer ('L'Eternité')
Oil on canvas, 64.7 x 79.3 cm
Bristol's Museums, Galleries and Archives
KEY REFERENCE: Fernier 1977, no. 502
(Exhibited in London only)

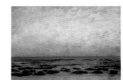

19
GUSTAVE COURBET (1819–1877)
The Shore at Trouville:
Sunset Effect, c. 1865/69
La Plage de Trouville:
Coucher de soleil
Oil on canvas, 71.4 x 102.2 cm
Wadsworth Atheneum Museum of Art, Hartford, CT. The Ella Gallup Sumner and Mary Catlin Sumner Collection Fund
KEY REFERENCE: Not in Fernier 1977–78

20
GUSTAVE COURBET (1819–1877)
Calm Sea, 1866
Mer calme
Oil on canvas, 54.1 x 63.9 cm
National Gallery of Art, Washington. Collection of Mr and Mrs Paul Mellon 1985.64.10
KEY REFERENCE: Fernier 1978, no. 591

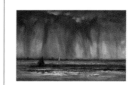

21
GUSTAVE COURBET (1819–1877)
The Waterspout, c. 1866
La Trombe
Oil on canvas on gypsum board, 43.2 x 65.7 cm
Lent by the Philadelphia Museum of Art. John G. Johnson Collection, 1917
KEY REFERENCE: Fernier 1978, no. 595

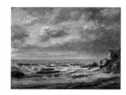

22
GUSTAVE COURBET (1819–1877)
Rough Sea near a Cliff, c. 1865/66
Vue d'une mer agitée près d'une falaise
Oil on canvas, 61 x 81 cm
The Matthiesen Gallery, London
Not in Fernier 1977–78
(Exhibited in Washington and Hartford only)

Courbet's first significant seascapes were painted during his visits to the Mediterranean coast in the 1850s, most famously *The Sea at Palavas (Courbet Saluting the Mediterranean)* (fig. 34). In these canvases he first explored the panoramic view from the shore across the open sea,

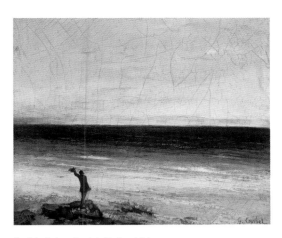

Fig. 34 Gustave Courbet, *The Sea at Palavas*
(*Courbet Saluting the Mediterranean*), 1854.
Oil on canvas, 37 x 46 cm. Musée Fabre, Montpellier

the format he explored again from 1865 onwards in a long sequence of canvases of the Normandy coast.

The Sea at Palavas (Courbet Saluting the Mediterranean) also evokes the intense personal engagement Courbet felt with the experience of the coast – so unlike the enclosed valleys of his native Franche-Comté landscape in eastern France. Around the time that he painted this image of himself saluting the sea with such assurance, he wrote in a letter: 'Oh sea, your voice is formidable, but it will never succeed in blotting out the voice of Fame crying out my name to the whole world!' (letter to Jules Vallès, *c.* 1854, quoted in Paris 1977, p. 127). Ten years later, before he began to paint the Normandy coast, he articulated his feelings for the sea in a letter to Victor Hugo: 'The sea! The sea with its charms saddens me. In its joyful moods it makes me think of a laughing tiger; in its sad moods it recalls the crocodile's tears and, in its raging fury, the caged monster that cannot swallow me up' (letter to Hugo, 28 November 1864, in Chu 1992, p. 249).

Courbet spent around three months at Trouville in the autumn of 1865, followed by a month at nearby Deauville in 1866 and a brief stay at Saint-Aubin-sur-Mer, further west along the coast, in 1867. The result was a long sequence of what he called *paysages de mer* – wide views of the open sea. He claimed to have executed 25 seascapes on the 1865 visit alone, and exhibited groups of these at the Paris gallery of the dealer Jules Luquet early in 1866, and in the one-artist exhibition that he mounted to coincide with the Paris Exposition Universelle of 1867. Most of the canvases are undated (except, in the present group, cat. 20, dated 1866), and so cannot be firmly tied to a particular moment. Indeed, it seems that he painted further *paysages de mer* in the studio in the years after 1867 (see Wagner 1981), and at least one is dated 1869 (Victoria and Albert Museum, London). Most of the canvases are relatively small, of a scale that could readily be worked on in the open air. However, cat. 19 is exceptional in the group because of its far larger size; it clearly had a special status for Courbet, but we have no evidence that it was exhibited or presented in any special way.

Nor can the location depicted in most of the canvases be identified with any confidence. The rocks in cat. 19 seem to be the *roches noires* that are exposed at low tide at Trouville, but even where a low cliff is visible, in cat. 22, it is treated in a somewhat generalised way and cannot be precisely located. This marks out the difference between the *paysages de mer* and the cliff scenes that Courbet painted during his visit to Etretat in 1869 (e.g. cat. 25), in which the distinctive forms of the cliffs are a central focus of attention.

In a letter to his friend and patron Alfred Bruyas shortly after his return from Trouville, Courbet described the canvases as 'twenty-five autumn skies, each one more extraordinary and free than the next' (letter to Bruyas, January 1866, in Chu 1992, p. 273). In all of them, the sky plays the dominant role, occupying two-thirds or more of the canvas, and dictating the dominant tone of the whole. The effects of light and weather are constantly varied, ranging from stillness and serenity (cat. 20) to windy conditions with breaking waves (cat. 22), from torrid sunsets (cat. 19) to an astonishing virtuoso evocation of a rain shower (cat. 21). Although he claimed in a letter after his exhibition *chez* Luquet that his seascapes had been 'done in two hours' (letter to Urbain Cuenot, 6 April 1866, in Chu 1992, p. 277), he clearly found some difficulties in completing the canvases to his satisfaction, quite understandably given the very transitory effects they represent, and deferred his return from Trouville in November 1865 so that he could continue work that had been delayed by unfavourable weather (letter to Victor Frond, 19 November 1865, in Chu 1992, p. 269).

There is a central paradox about the *paysages de mer*. They present wide vistas from deserted beaches, yet they were painted at the most fashionable and busiest resorts, whose beaches were the prime places for promenades, as represented so many times in these years by Boudin (cats 5 and 13–15), though in 1865 Courbet stayed at Trouville until late November, long after most of the holidaymakers had left. Courbet himself enthusiastically lived the life of the fashionable holidaymaker, as he wrote to a friend in 1865: 'I am here in Trouville in delightful circumstances. The casino has given me a splendid apartment overlooking the sea and there I paint the portraits of the prettiest women in Trouville' (letter to Urbain Cuenot, 16 September 1865, in Chu 1992, p. 267). In 1866, he was the house guest of the Comte de Choiseul in Deauville, where he entertained Boudin and Monet at Choiseul's villa. Yet the world that the paintings create is one of solitary contemplation, inviting the viewer to share the painter's private moment, face to face with the infinite space of the ocean, as is evoked by Whistler's canvas depicting Courbet on the beach (fig. 35). The human presence in Courbet's *paysages de mer* is suggested only by the occasional small fishing boat, far out to sea, and also, perhaps, metaphorically by the placing of a single boulder on the beach in a canvas such as cat. 18. The painter's viewpoint can also be seen as analogous to that of the swimmer, making his way alone to the shore; Courbet's letters reiterate his enthusiasm for sea bathing.

Courbet did not, though, give specific titles to individual canvases among the *paysages de mer*. Titles that some of the canvases bear today, such as *L'Immensité* or *L'Eternité*, were not Courbet's, and cannot be used as evidence of his vision of the sea.

Technically, the paintings are a tour de force; executed in part with the palette knife, in part with the brush, they deploy a remarkably

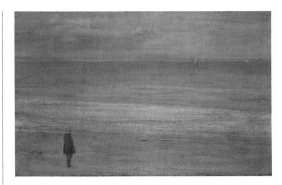

Fig. 35 James Abbott McNeill Whistler, *Harmony in Blue and Silver: Trouville*, 1865. Oil on canvas, 49.5 x 75.5 cm. Isabella Stewart Gardner Museum, Boston

wide and resourceful range of types of mark-making. Wholly lacking conventional modelling and draftsmanship, these touches differentiate with great delicacy and economy between the diverse textures in the scene – cloud formations, shallow waves and still water, wet and dry sand, and rocks on the beach. Characteristically, Courbet worked on dark-toned canvas primings, and viewed his own act of painting as analogous to the illumination of the sun: 'Nature, without sunlight, is black and obscure; I act as light does; I illuminate the projecting points, and the picture is done' (Riat 1906, pp. 218–19).

Courbet's supporters were divided in their critical opinion of the *paysages de mer*. Théophile Thoré, in his review of the 1866 Salon, recounted the story of Courbet's stay at Trouville and his observations of the sky and sea, and concluded that the paintings he had brought back created 'an extraordinary impression' and were 'of the most unusual quality' (Thoré 1870, 2, p. 281). By contrast, in 1868 Zola urged him to return to his earlier manner and to stop trying to 'paint blond': 'His talent has a breadth and severity that ill suits the cheerful, blond aspects of nature. I admit that I do not much like his recent marines, very fine, it is true, but rather slight for his rough and magisterial hand' (Zola 1970, p. 164).

23
**JAMES ABBOTT McNEILL
WHISTLER** (1834–1903)
Sea and Rain, 1865
Oil on canvas, 51 x 73.4 cm
University of Michigan Museum of Art, Ann Arbor. Bequest of Margaret Watson Parker
KEY REFERENCE: Young 1980, no. 65

24
**JAMES ABBOTT McNEILL
WHISTLER** (1834–1903)
The Sea, c. 1865
Oil on canvas, 52.7 x 95.9 cm
Montclair Art Museum, New Jersey.
Museum Purchase; Acquisition Fund
KEY REFERENCE: Young 1980, no. 69

Whistler spent a period at Trouville in October and November 1865 working alongside Courbet on a sequence of views of the open sea (see cats. 18–21). On 20 October, he wrote from Trouville to his patron Alexander Ionides:

> I am staying here to finish 2 or 3 sea pieces which I wish to bring back with me. I believe they will be fine – & worth quite anything of the kind I have ever done. This is a charming place – although now the season is quite over and everyone has left – but the effects of sea and sky are finer than during the milder weather. (As quoted in Young 1980, 1, p. 38).

Courbet wrote to a friend in November that he had been bathing 'with the painter Whistler who is here with me. He is an Englishman who is my pupil (*élève*)' – a designation Whistler would have been most unlikely to have welcomed (letter to Victor Frond, 19 November 1865, in Chu 1992, p. 269). The canvas that Whistler later titled *Harmony in Blue and Silver: Trouville* (fig. 35) is a testimony to the time that he and Courbet spent together; its composition clearly echoes Courbet's *The Sea at Palavas (Courbet Saluting the Mediterranean)* (fig. 34), but presents a less theatrical, and evidently stouter, Courbet alone on the beach looking out to sea.

Sea and Rain is similar in its composition to the painting of Courbet on the shore, but here the figure is a shadowy, anonymous silhouette, set against the wide empty space of sands and sea. Its execution is very spare, with broad liquid sweeps of paint suggesting the wet weather; here, the rain has none of the dramatic, theatrical quality that Courbet gave the rain shower in cat. 21. Despite its sketch-like quality, Whistler considered it a fully finished and significant canvas, signing and dating it, and exhibiting it at the Royal Academy annual exhibition in London in 1867. William Michael Rossetti urged Whistler to send it to the Royal Academy, and recorded that Whistler himself regarded it 'with predilection' (quoted in Young 1980, 1, p. 38). The canvas must have stood out as startlingly different from the other paintings on the Royal Academy walls; it received warm and eloquent praise from the reviewer in the *Daily Telegraph*:

> Earth, air, and sea repeated by three splashes on the canvas, a splash to an element … The streaming pour of rain slides down upon the water, smoothing out all form, washing all keenness from the wave – almost all substance away from everything. Thin grey veils of vapour, damp stream of mist, fill the air and blind the sight, and the result is a pervading liquid, dense, transparency – an aerial effect for which, in truth, we can appeal to no surer witness than Whistler's canvas. (Quoted in Young 1980, 1, p. 38).

The painting stands at a crucial turning point in Whistler's career. As the above review testifies, it can be viewed in naturalistic terms, as a vivid record of a weather effect, yet at the same time the unity of its paint surface and subdued and closely integrated colour harmony look forward to the self-contained aestheticised vision of his 'Nocturnes' of the early 1870s.

The Sea very probably dates from this stay at Trouville, although it differs from Whistler's other Trouville canvases in omitting the beach altogether, presenting the sea alone in an extended horizontal format. The execution of the canvas is a remarkable combination of economy and virtuosity. Much of it is laid in with simple sweeps of paint, broadly applied but quite thin, and subtly nuanced in colour; the breaking waves are added with the palette knife in quite thick impasto, yet delicately, while the clouds are treated in fluent and almost delicate sweeps of the brush. The boat at lower right was a late addition, after the remainder of the canvas was dry. Although there is no reason to see the canvas as unfinished, it was not exhibited or, it seems, sold in Whistler's lifetime.

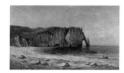

25
GUSTAVE COURBET (1819–1877)
The Porte d'Aval at Etretat, 1869
Etretat, la Port d'Aval
Oil on canvas, 79 x 128 cm
The Trustees of the Barber Institute of Fine Arts, The University of Birmingham
KEY REFERENCE: Fernier 1978, no. 719
(Exhibited in London only)

Courbet spent about a month at Etretat in the late summer of 1869 and, on his own account, painted about twenty seascapes there; two of these, *The Cliff of Etretat after the Storm* (fig. 36) and *Stormy Sea* (fig. 37), larger canvases than the others, were exhibited at the 1870 Salon, the only occasion on which he submitted coastal scenes to the Salon.

The Etretat paintings fall into two groups: those, like *Stormy Sea*, that depict breaking waves (see cat. 26), and those that represent the physical landscape of the bay. It was the remarkable rock formations that were the prime attraction of the place, described in evocative terms in countless travel narratives and guidebooks. Soon after arriving at Etretat, Courbet reported: 'We are very comfortable in Etretat. It is a charming little resort place. There are rocks here that are bigger than in Ornans, quite curious' (letter to his family,

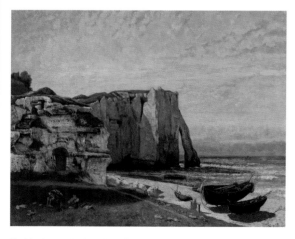

Fig. 36 Gustave Courbet, *The Cliff of Etretat after the Storm*, 1869–70.
Oil on canvas, 133 x 162 cm. Musée d'Orsay. Paris (MNR561)

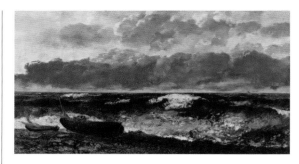

Fig. 37 Gustave Courbet, *Stormy Sea*, 1869–70.
Oil on canvas, 117 x 160.5 cm. Musée d'Orsay, Paris (RF 213)

September 1869, in Chu 1992, p. 352). *The Porte d'Aval at Etretat* is one of the most ambitious of the canvases that explore these rocks, depicting, like *The Cliff of Etretat after the Storm*, the cliffs to the southwest of the town (the Falaise d'Aval and the Needle), the more dramatic of the rock formations that flank the bay (see also cats 7 and 60–62), though here viewed from a greater distance, so that the Needle is clearly visible (see also Monet, cat. 62).

In none of Courbet's Etretat canvases is there any trace of the 'charming little resort place' that made his stay there so 'comfortable' (see Le Poittevin, fig. 19, p. 25). Human presence is generally indicated, if at all, only by the inclusion of fishing boats. The single boat at the water's edge in *The Porte d'Aval at Etretat* gives little sense of the beach as a busy working space, described by many visitors (see also Monet, cat. 32), where boats had to be dragged up the steep shingle bank because there was no natural estuary, though the juxtaposition of boat and rock arch was already by this date something of a stereotype in the imagery of Etretat (see cat. 7 and fig. 8, p. 21). In one canvas that does include references to work, *The Cliff of Etretat after the Storm*, the tiny figures of women washing their clothes in the freshwater spring on the beach are treated so summarily that they are readily overlooked (see Herbert 1995; contrast Jules Breton's painting of this theme, cat. 3). Courbet's focus in all of these canvases is on the physicality of the rocks, and especially on the complex textures of the cliff face. In *The Porte d'Aval at Etretat*, this effect is emphasised by the extended horizontal format of the canvas.

Reviewing the two canvases at the 1870 Salon, Alfred Sensier vividly characterised the essence of his vision, as residing in the intensity of his physical, sensory responses to the world, and the total absence of any transcendental vision:

> M. Courbet can leave his marines uninhabited by sailors or shipwreck victims in distress … he gives an intense sense of the crystalline qualities of capes and rocks. In all his work he has inserted a world of sensuality into the world of the coarse elements. Everything in his art is voluptuous, one might say, from the raging tempest to the glistening pebble. He is an admirable materialist who loves nature passionately. (Sensier 1870, p. 385)

26
GUSTAVE COURBET
(1819–1877)
The Wave, 1869
La Vague
Oil on canvas, 58.4 x 78.7 cm
Fine Art Museums of San Francisco.
Museum Purchase, Grover A. Magnin
Bequest Fund and Roscoe and
Margaret Oakes Income Fund, 2006.58
KEY REFERENCE: Fernier 1978, no. 677

Courbet seems to have begun his long sequence of canvases of waves breaking on the shore during his stay at Etretat in the late summer of 1869 (see cat. 25). The effects he depicted are characteristic of steeply shelving shingle beaches like those of Etretat, rather than the wide sandy beach he had depicted at Trouville in 1865–66 (see cats 18–22). The wave paintings fall into two main groups: those that focus on a single, monumentalised wave, notably *Stormy Sea* (fig. 37), shown at the 1870 Salon, and those that show a wider band of waves, with no central focus, rolling towards the beach. Many of these canvases are virtual repetitions of each other, executed in the studio in the last years of Courbet's life.

The present canvas is, it seems, unique in the sequence in its divided focus between the wave that is about to break on the right and the spray of the wave that has broken. The effect is more dynamic and animated than in many of the wave canvases, with the force of the waves set off against a dramatic and threatening sky.

Courbet's wave paintings have been seen as the culmination of his project to create an anti-authoritarian form of landscape painting that promoted a pantheistic view of nature that saw every element in the scene as of equal value; this standpoint, in turn, has been viewed as standing metaphorically for Courbet's rejection of the authoritarian regime of Napoleon III (see Herding 1991, especially pp. 96–8). Courbet's very personal response to the sea is well documented (see entry for cats 18–22). However, it is hard to pinpoint the nature of any personal investment in the image of the breaking wave. In canvases like *Stormy Sea* the boats on the shore might be viewed as standing for Courbet's vulnerable position as an independent artist in the face of the forces of authority; in the present canvas the viewer occupies the position of those boats, face to face with the breaking wave. Yet at the same time a parallel can be drawn between the dynamic forces of the waves and Courbet's own act of painting – the virtuoso execution, with the palette knife and the brush, that so many contemporaries watched in amazement as the artist seemingly conjured up a painting out of nothing.

In the context here, what emerges is the dual nature of Courbet's project in the wave paintings – at one and the same time a return to a 'romantic' celebration of elemental forces and a thoroughly modern concern with the bold use of paint to convey the artist's sensory experiences of the natural world. It was this dualism that Monet was to explore further in the 1880s (see especially cats 51, 52 and 60).

27
JULES DUPRÉ (1811–1889)
Marine Landscape (The Cape and Dunes of Saint-Quentin), c. 1870
Paysage marin (Cap et dunes de Saint-Quentin)
Oil on canvas, 73.5 x 92 cm
Musée des Beaux-Arts de Rouen.
Donation Henri et Suzanne Baderou, 1975
KEY REFERENCE: Aubrun 1980, no. S92

Dupré initially established his reputation as one of the landscapists of the 'generation of 1830' with his scenes of forests and meadows, indebted to Dutch seventeenth-century art and especially to the work of John Constable. However, in his later work he developed a more expressive, dramatic vision of landscape. *The Cape and Dunes of Saint-Quentin* is a fascinating amalgam of the conventions of romantic storm painting with the depiction of a specific site.

The site depicted can be identified from the etching by Léon Gaucherel after Dupré's canvas (fig. 38) that was published in March 1874 as plate 141 in the dealer Durand-Ruel's serial publication of his stock (Durand-Ruel 1873–75; see also Aubrun 1980, p. 71), with the title *Cap et dunes de Saint-Quentin*. The dunes of Saint-Quentin are situated at the extreme northwest of the estuary of the River Somme, on the coastline south of Boulogne, just northwest of Le Crotoy and across the estuary from Saint-Valery-sur-Somme.

Eugène Penel's guide to the region described the excursion to the dunes of Saint-Quentin as 'interesting for geologists, naturalists and hunters', but also acknowledged their dramatic natural forms: 'The form of the dunes is almost that of colossal waves that have been suddenly immobilised. … The appearance of all this is melancholy, strange and savage' (Pénel 1866, pp. 207–8). Viewed in these terms, the site offered the ideal natural motif for the sort of tragic landscape Dupré was exploring. In a letter of 1879 about his ideas on art, he emphasised that the artist should study nature ceaselessly, but should 'use it like bees use flowers, and, like them, make from it something

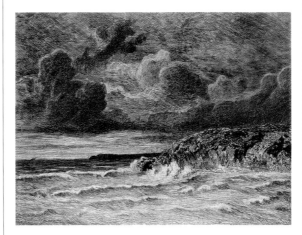

Fig. 38 Léon Gaucherel, etching after Jules Dupré, *Maritime Landscape (The Cape and Dunes of Saint-Quentin)*, published in Galerie Durand-Ruel, *Recueil d'estampes*, March 1874. Private collection, London

that is personal; that is what constitutes individuality which is the most important of all qualities in the arts' (letter to Jules Claretie, 18 May 1879, in Aubrun 1974, p. 33).

The whole canvas is dominated by animated, turbulent brushwork and a dark, sombre tonality; sky and sea alike seem to threaten the unstable forms of the sand dunes, and the sense of vulnerability is enhanced by the little boat out to sea, and the fleck of paint on the beach which suggests the presence of a figure, close to the waves (this does not appear in Gaucherel's etching). Dupré's painting makes a fascinating contrast with Courbet's canvases of stormy seas from the same years (see cat. 26 and fig. 37), which focus more on the sheer physicality of the waves rather than the overall effect of the storm.

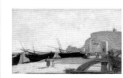

28
JEAN BAPTISTE CAMILLE
COROT (1796–1875)
The Beach, Etretat, 1872
Etretat, la plage
Oil on canvas, 35.6 x 57.2 cm
Saint Louis Art Museum. Purchase 63:1932
KEY REFERENCE: Robaut 1905, no. 2054

Throughout his career, Corot made small outdoor oil sketches. Sometimes these acted as preparatory studies for the more elaborate, larger canvases he exhibited at the Salon, but most of them served no such function; Corot treated them as autonomous works in their own right, and from the 1850s onwards found a ready market for them through art dealers. In 1854 Frédéric Henriet contrasted the Italianate works Corot showed at the Salon with the 'intimate, informal aspect of his talent' revealed by the paintings on view in the dealers' shops of Rue Laffitte in Paris (quoted in Paris 1996, p. 463).

The Beach, Etretat was, it seems, painted in September 1872, during a two-week stay at Etretat with the family of Stumpf, one of his patrons. This was part of an extended period of travel through France in the second half of 1872, testimony to Corot's lasting energy and to his continuing commitment to working outdoors from direct observation. He continued to travel widely, making outdoor studies of the varied sites he visited, until shortly before his death in 1875.

The beach at Etretat is here viewed towards the Porte d'Amont, the less spectacular of the rock arches that flank the bay (see cats 25 and 60). The half of the beach towards the Porte d'Amont was set aside for bathers, as seen in Le Poittevin's canvas of 1866 (see fig. 19, p. 25), the other half for the local fishermen. However, Corot formulated his view so that we see the Porte d'Amont beyond a row of fishing boats, with a wooden structure, presumably a winch for hauling the boats up the beach, in the immediate foreground (for a photograph of the site, see Herbert 1994, p. 104). Small, locally dressed figures walk along the promenade, and there is no trace of the holidaymakers who would doubtless have still been present in September. This is an Etretat untouched by modernisation.

With its overall blonde tonality, the canvas is a prime example of *peinture claire*, the method of suggesting the effects of diffused daylight adopted, following Corot's example, by Boudin, and by Monet in his early works (see e.g. cats 11, 17 and 36–37).

29
CHARLES FRANÇOIS DAUBIGNY
(1817–1878)
The Beach at Villerville,
known as *Cap Gris-Nez, c.* 1870
Oil on panel, 32.5 x 55.5 cm
Berwick Borough Museum and Art Gallery,
Berwick-upon-Tweed
KEY REFERENCE: Hellebranth 1976,
no. 614

Like Corot (see cat. 28), throughout his career Daubigny made open-air oil sketches alongside the more elaborate paintings he executed for the Salon (see cat. 43). On occasion he was reported to add sunsets or other dramatic light effects to his initial outdoor notations in order to make them more saleable (see Tryon 1896, p. 164), but here there is no sign of such reworking; Daubigny seems to have been satisfied with the initial broadly brushed effect.

This canvas has traditionally been titled *Cap Gris-Nez*, and it has been suggested that it was painted in 1871 while Daubigny was staying at nearby Etaples, on his return from London where he had taken refuge during the Franco–Prussian War. However, Robert Hellebranth has identified the site as Villerville, the coastal village between Trouville and Honfleur where Daubigny painted repeatedly from the 1850s onwards (see cat. 43). This suggestion is supported by the close similarity of the cliffs here to those seen in the background of Boudin's *The Empress Eugénie on the Beach at Trouville* (cat. 17); what we see are the cliffs of Sainte-Adresse, to the north of Le Havre on the opposite side of the Seine estuary (see Monet, cat. 11).

The broad, economical sweeps of paint create a unified atmospheric effect. However, the composition is also carefully organised around the succession of smaller accents – the posts and buoy in the foreground water, and the sequence of sails across the background, with the nearer boat to the left acting as an unobtrusive framing device for the whole composition.

30
JULES HÉREAU (1839–1879)
The Return from Shrimping, c. 1870
Le Retour de la pêche à la crevette
Oil on canvas, 60 x 73 cm
Musée Eugène Boudin, Honfleur
(Exhibited in London only)

Héreau regularly exhibited landscapes, cityscapes and coastal scenes at the Salon from 1855 until his death, winning medals in 1865 and 1868. He contributed to the painted decoration of the Auberge Ganne at Barbizon, the main meeting place of the artists who worked in the Fontainebleau forest (see Lyons 2002, p. 109), and was listed by Boudin in 1868 as a friend of Monet (letter to Ferdinand Martin, 26 March 1868, in Pludermacher 2000, p. 61). In 1871 he was a member of the Paris Commune, given responsibility for protecting the collections of the Louvre; as a result of his involvement with the Commune he was charged and imprisoned for six months in 1874. He committed suicide in 1879.

The Return from Shrimping is a fascinating combination of pictorial modes. The semi-processional group at the centre of the canvas, coming up the beach with their catch, carries echoes of the idealising imagery of the peasant in the work of artists such as Jules Breton (see cat. 3); however, the figures themselves are more informally treated, and include a man and an older woman, rather than focusing on statuesque figures of young women, as Breton did. Beyond this, the figures, though central to the composition, are by no means its only focus; the painting is centrally concerned with the play of light, breaking through the clouds and reflected on the pebbles and sand of the beach. In these terms, its luminous grey palette and variegated touch invite comparison with the work of Boudin and Jongkind.

Reviewing a canvas by Héreau of a comparable subject, *Seaweed-Gatherers on a Beach*, at the 1868 Salon, Théophile Thoré described his work as 'painting *de vive impression*' (Thoré 1870, 2, p. 497), using the term '*impression*', as was commonplace in the 1860s, to characterise the depiction of fleeting effects of light and weather. It was later to be used, in the following decade, to describe the work of the 'Impressionists' at the group exhibitions they mounted from 1874 onwards.

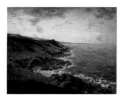

31
JEAN FRANÇOIS MILLET
(1814–1875)
The Cliffs of Gréville, c. 1854
and 1870/71
Les Falaises de Gréville
Oil on canvas, 60 x 73 cm
Nationalmuseum, Stockholm
KEY REFERENCE: Grate and Hedström 2006,
pp. 181–3

The canvas represents the coastline just to the east of Millet's birthplace, Gruchy, a remote hamlet, part of the village of Gréville, to the west of Cherbourg on the northern coast of the Cotentin peninsula in western Normandy. Gruchy itself is out of sight beyond the rocky outcrop at the centre of the canvas (for a recent photograph of the site, see Lepoittevin 2000, p. 237).

Millet had a complex relationship with his birthplace, visiting it only very rarely after his youth. He was there in 1853 at the time of the death of his mother, and again in 1854; the death of his sister brought him back in 1866, and he took refuge there from the Franco–Prussian War in 1870–71. Meanwhile, his primary base, from 1849 onwards, was Barbizon on the edges of the Fontainebleau Forest to the southeast of Paris. However, his sense of his own Norman identity and memories of his birthplace played a significant role in the image he presented of himself and his work. Describing another canvas of Gruchy in 1866, he wrote: 'Oh, you spaces that made me dream so much in my childhood, will I ever be able to give a hint of what you are like?' (Paris 1975, p. 238; see also London 1995, p. 88). Viewed in these terms, *The Cliffs of Gréville* is one of the canvases in which Millet was seeking to evoke these memories of his childhood explorations of the landscape around his home; this is not the vision of the tourist, holidaymaker or artist-explorer visiting the site from elsewhere, but the viewpoint of an insider for whom the intimate knowledge of these cliffs was a birthright.

Describing the peacefulness that he was trying to convey in another of his Gruchy views, he wrote: 'I should like to have given the viewer a vague idea of the thoughts that must enter, for life, the head of a child who has never received any impressions other than these, and how he will later feel completely out of his element in busy, noisy surroundings' (letter to Théophile Silvestre, 20 April 1868, published in Boston 1984, p. 243).

The date of *The Cliffs of Gréville* remains uncertain. It seems likely to have served as a study for a larger canvas of the same view (Albright-Knox Art Gallery, Buffalo), and a drawing of the site also exists (Musée Thomas-Henry, Cherbourg, reproduced in Lepoittevin 2000, p. 279). It has been suggested that the drawing and the present picture both date from his visit to Gruchy in 1854 (the visible underdrawing in the present picture is consistent with his methods in the 1850s), and that work continued on this canvas during his return to the hamlet in 1870–71, when he began the larger canvas (see Paris 1975, pp. 267–8, and Grate and Hedström 2006, pp. 181–3). In the event he finished neither canvas; both were included in his studio sale after his death. However, even in its unfinished state, the present picture vividly evokes the meeting of sea and shore, with the bare primed canvas suggesting the play of waves against the rocks.

3 Early Impressionism

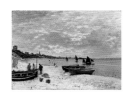

32
CLAUDE MONET (1840–1926)
The Beach at Sainte-Adresse, 1867
La Plage à Sainte-Adresse
Oil on canvas, 75.8 x 102.5 cm
The Art Institute of Chicago
Mr and Mrs Lewis Larned Coburn
Memorial Collection, 1933.439
KEY REFERENCE: Wildenstein 1974, no. 92

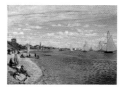

33
CLAUDE MONET (1840–1926)
Regatta at Sainte-Adresse, 1867
Régates à Sainte-Adresse
Oil on canvas, 75.2 x 101.6 cm
The Metropolitan Museum of Art, New York.
Bequest of William Church Osborn, 1951
(51.30.4)
KEY REFERENCE: Wildenstein 1974, no. 91

A crucial turning point in Monet's choice of landscape subjects occurred in 1867 when, for the first time, he engaged directly with the explicitly modern, contemporary environment, both in his views of Paris seen from the Louvre and in this pair of canvases of the beach at Sainte-Adresse. His 1864 views of the beach at Sainte-Adresse (cats 11 and 12) show no sign of the recent developments on the coastline; in contrast, in these two canvases the changes are foregrounded, most obviously by the presence of bourgeois figures on the beach and by the inclusion, at far left, of an evidently new building – a hotel or a substantial villa, testimony to the developments that were transforming the place (see also entry for cats 11 and 12).

Monet's viewpoint here is only a short distance further south and nearer to the town than in cat. 12, but his decision to shift his viewpoint in this way involved creating a wholly different type of landscape.

The Beach at Sainte-Adresse and *Regatta at Sainte-Adresse* are evidently a complementary pair of canvases, in many ways. One depicts low tide, one high tide. In one the weather is luminous but overcast, in the other sunny. And in one the main figures are local fishermen, standing beside their boats, and the boats at sea are fishing boats; in the other the nearby figures are bourgeois, and the boats recreational yachts. However, crucially each picture contains a reference to the world that dominates in the other. In *The Beach at Sainte-Adresse*, a bourgeois couple sit by the edge of the sea, the man looking out to sea through a telescope (upwards, implicitly at the sky), while his female companion sits quietly beside him. In *Regatta at Sainte-Adresse*, one brown-sailed fishing boat appears out to sea, to the left of the yachts. Viewed together, the two paintings offer a complex and perceptive vision of the very different worlds that met on the beach at Sainte-Adresse in these years.

Though they are so clearly related to each other, there is no evidence that Monet ever sought to exhibit or sell these two paintings together. From 1864 onwards he regularly made such pairs of pictures (see cats 36 and 37), and throughout the 1880s he often executed significant numbers of canvases of the same site (see cat. 54). However, he did not exhibit these groups of paintings together as a series until, in 1890, he undertook the series of paintings of 'Grainstacks' at Giverny, exhibited in spring 1891 (on the evolution of his series, see House 1986, pp. 193–201).

The paintings mark a significant development in Monet's technique. Like his 1864 beach scenes (cats 11 and 12) they use varied brushstrokes to suggest the diverse textures in the scene, following the example, especially, of Jongkind (see cats 9 and 10). However, by 1867 Monet's touch had become far more flexible and delicate; the deft shorthand by which he indicated, for instance, the bourgeois couple on the beach in *The Beach at Sainte-Adresse* is very economical, but also remarkably vivid in its ability to suggest form and gesture. Moreover, there are points on the beach in this canvas where the play of the brush seems less closely linked to the representation of specific objects.

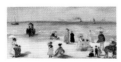

34
EDOUARD MANET (1832–1883)
On the Beach at Boulogne, 1868
Sur la plage de Boulogne
Oil on canvas, 32 x 65 cm
Virginia Museum of Fine Arts, Richmond
KEY REFERENCE: Rouart and Wildenstein
1975, 1, no. 148
(Exhibited in Washington only)

Manet spent extended periods in Boulogne in the summers of 1864 and 1868. By this date Boulogne was a well-established beach resort, as well as one of the main ports for cross-Channel ferry services to England; it had been connected to Paris by rail in 1848. During these visits, Manet gathered materials for paintings of a number of themes – the port and the ferry boats, the jetties, boats on the open sea, and Boulogne's beach – though he never represented the elaborate buildings along the seafront (see Chicago 2003, pp. 61–71).

On the Beach at Boulogne gives no indication of its topographical location. The composition is organised in three virtually parallel bands – beach, sea and sky – and animated by the boats at sea and the figures, the bathing hut and the donkey on the beach. Manet would doubtless have been well aware of Boudin's Trouville and Deauville beach scenes (cats 5 and 13–17), but *On the Beach at Boulogne* presents the figures in groupings that are far more staccato and disjointed than Boudin's. Each small group seems wholly isolated from the others, and there is no obvious overall compositional pattern that unifies the canvas in any conventional sense. The figures all seem to represent fashionable holidaymakers, including mothers and daughters, young boys and, by the sea, a boy in a seminarian's uniform alongside a young woman who looks out to sea through binoculars (compare Monet, cat. 32), and one solitary man with a parasol. The boats at sea are diverse, and give a vivid sense of the different functions of the port at Bordeaux – fishing, commerce, recreation, transportation (see Chicago 2003, p. 68).

Nearly every figure in the canvas is based on a drawing in one of the sketchbooks Manet used at Boulogne in 1868 (Musée d'Orsay, Paris; see Chicago 2003, pp. 68–9 and 120). The fact that they were based so closely on drawings shows that Manet composed the picture in the studio. However, the composite nature of its execution raises a basic question about its seemingly compositional incoherence: was this a by-product of the way in which it was pieced together, or was it a wholly deliberate effect? During the later 1860s, even in his most elaborate exhibition pictures, such as *The Balcony* (Musée d'Orsay, Paris) and *Luncheon* (Bayerische Staatsgemäldesammlungen, Munich), both exhibited at the 1869 Salon and both apparently conceived at Boulogne in 1868, Manet created compositions in which the figures do not engage with each other, challenging the viewer to make sense of the relationships between them. *Luncheon*, in particular, was the result of extended reworking and compositional adjustment (see London 2003); X-rays of *On the Beach at Boulogne* show that it, too, was extensively reworked.

Viewed in these terms, the fragmented composition in *On the Beach at Boulogne* must be seen as a wholly deliberate effect. It evokes the social world of the seaside holiday, during which families and other groups who are not acquainted with each other find themselves in close proximity in their lodgings and on the beach. Indeed, the single adult male figure, the man with the parasol, apparently seeking someone or something, may be seen as wittily evoking another aspect of the rituals of the summer holiday: the husband joining the rest of the family only for brief periods or at weekends (compare Boudin, cat. 5).

Despite the complex process by which it was composed, the execution of the picture is rapid and summary; the quick notations with the brush give the sense that the gestures of the figures have been captured directly, on the spot. This paint handling is a crucial complement to the vision of modernity that the canvas presents, of a world that can only be grasped through a sequence of fleeting visual experiences that never coalesce into a coherent, unified world view.

35
CLAUDE MONET (1840–1926)
The Hôtel des Roches Noires, Trouville, 1870
L'Hôtel des Roches Noires, Trouville
Oil on canvas, 81 x 58 cm
Musée d'Orsay, Paris. Donation Jacques Laroche, 1947
KEY REFERENCE: Wildenstein 1974, no. 155
(Exhibited in London only)

The Hôtel des Roches Noires, opened in 1866, was the most luxurious and one of the newest hotels in Trouville when Monet painted its terrace in 1870. Situated towards the far northeastern end of the town, it dominated the seafront with its facade 'adorned with Corinthian columns and surmounted by … the statue of Neptune, two and a half metres high' (Joanne 1866, p. 390). For a visitor in 1871, its terrace, along with that of the Hôtel de Paris, was one of the 'two really good things about Trouville' (the other being the drives into the surrounding countryside):

> These terraces are singularly good breakfast places. You sit under an awning, eating Normandy bread-and-butter, which is about the very best that ever came from corn and cows, and you have the sea and the Seine before you, with the ships going in and out of Havre; it is cheery and satisfactory to an excessive degree. (Marshall 1871, p. 487)

Monet, staying at a far more modest hotel, positions himself on the terrace, but not under the awning, and not as a consumer of the plenty that the hotel offered. His is the viewpoint of the outsider, watching the social byplay of the hotel's rich and fashionable clientele. The figures are deftly and wittily notated, hinting at social interactions – the man's polite greeting at left, the man at the bottom of the steps glancing to his left – but quite without anecdotal detail or hints at private emotional experience. The hotel is a crucial presence, dominating and casting its shadow over the terrace. The flurry of cursive brushstrokes atop the facade presumably represents the statue of Neptune mentioned by Joanne, but this would be wholly unrecognisable without insider knowledge. The sea itself is scarcely visible, but its presence is felt vividly in the brisk breeze that animates the clouds and the flags – the two French tricolours, and the summarily sketched flag that dominates the foreground, presumably the American Stars and Stripes, though without its stars (see Nochlin 2006, especially pp. 155–9).

Throughout the canvas, the handling is rapid and fluent, varied in touch and texture, so as to suggest the diverse elements in the scene. As in cat. 38, areas of light-grey priming are left unpainted and play a significant part in establishing the overall tonal register of the canvas – dominantly *peinture claire*, like cats 36 and 37, but with the sharp reds in the flags picked up by the warm pinks of the hotel facade.

The form of the signature is most unusual in Monet's oeuvre – his full name, unlike in cat. 38, but written in a form that resembles his everyday handwriting, in contrast to the formal script he almost always used to sign his canvases at this date (e.g. cats 36 and 37). Closely similar signatures are found on three other canvases – *Bathing at La Grenouillère* (National Gallery, London) and *Boats at La Grenouillère* (Kunsthalle, Bremen), both painted in 1869, and *The Bridge at Argenteuil* of 1874 (Bayerische Staatsgemäldesammlungen, Munich) –

and it seems very likely that all four were signed at the same time, during or soon after 1874, and that all were destined for a friend rather than for the open market. Though it cannot be firmly documented, it is possible that these were among the five canvases Monet sold to Edouard Manet in June 1875; it is known that Manet was later the owner of at least one of the La Grenouillère canvases.

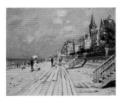

36
CLAUDE MONET (1840–1926)
The Beach at Trouville, 1870
La Plage à Trouville
Oil on canvas, 53.5 x 65 cm
Wadsworth Atheneum Museum of Art, Hartford, CT.
The Ella Gallup Sumner and Mary Catlin Sumner Collection Fund
KEY REFERENCE: Wildenstein 1974, no. 156

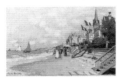

37
CLAUDE MONET (1840–1926)
The Beach at Trouville, 1870
La Plage à Trouville
Oil on canvas, 48 x 74 cm
Private collection, courtesy of Sotheby's
KEY REFERENCE: Wildenstein 1974, no.157

These two canvases form a clear pair, one showing the beach at low tide with the boardwalk of planks laid out at the top of the beach, the other the scene at high tide with the boardwalk removed. However, as with cats 32 and 33, there is no evidence that Monet exhibited the two pictures together, despite their evidently complementary subjects. Monet's viewpoint in the two canvases is identical, but the more extended, horizontal format of cat. 37 emphasises the expanse of the beach, and the squarer canvas of cat. 36 heightens the effect of the plunging perspective of the boardwalk. His standpoint is somewhat further along the beach to the northeast than Boudin's in cat. 17. In both canvases we see the sequence of villas close-packed along the seafront, with the Hôtel des Roches Noires, the subject of cat. 35, in the background, its position indicated by the flags.

In cat. 36 the sea is relegated to the distance, and appears wholly placid and passive. By contrast, in cat. 37 the waves encroach close to the promenading figures, though only the little dark figure of a child beyond the foreground couple (compare cat. 39) seems to be taking any notice of them. In both canvases, the figures treat the sea as if it, like the shoreline, was wholly tamed and domesticated by the leisure industry. The treatment of the scene is clearly comparable to Boudin's characteristic beach scenes (cats 5 and 13–17), but Monet's figure groups are more scattered, and greater prominence is given to the architecture of the buildings along the seafront.

In both canvases the viewer is placed in the role of promenader – as one of the holidaymakers who animate the beach. In cat. 36 a couple walk down the beach towards the sea, while two pairs of women walk towards us along the boardwalk and pass by the only solitary figure, a man with a white parasol, just as they will soon pass us, if we imagine the viewer, like the artist, to be a solitary male. In cat. 37 it is a couple who walk towards us across the sand. It is significant

that neither canvas includes a solitary female figure; both present Trouville as a resort in which the conventions of respectable promenading were scrupulously observed.

Unlike cats 35 and 39, Monet completed and signed both of these canvases around the time they were painted. Cat. 37 seems to have been among the first paintings that he sold to the dealer Paul Durand-Ruel, soon after they met late in 1870 while both painter and dealer were taking refuge in London from the Franco–Prussian War. Although they are executed with considerable breadth and brio, and the figures in the background are particularly summary, the paint surfaces of both canvases are more consistently worked, and the main elements, both figures and buildings, are defined with some care, though wholly without conventional draftsmanship or illusionistic detail. Their overall tonality is blonde, with individual, vividly coloured accents; Monet later acknowledged his debt to Boudin for introducing him to this *peinture claire* as a means of representing the effects of bright daylight (see cat. 17 and House 1986, p. 110).

Infrared photography of cat. 36 shows that originally the canvas was dominated by a large image of a sailing boat; even in normal viewing conditions, this can be seen beneath the paint layers in the upper centre of the picture. Presumably this was the failed beginning of a quite different picture, since it bears no relationship to the present image. Monet often reused canvases in the early part of his career, when he had few resources to buy painting materials.

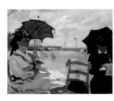

38
CLAUDE MONET (1840–1926)
The Beach at Trouville, 1870
La Plage à Trouville
Oil on canvas, 38 x 46 cm
The National Gallery, London
KEY REFERENCE: Wildenstein 1974, no. 158
(Exhibited in Washington and Hartford only)

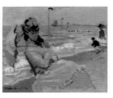

39
CLAUDE MONET (1840–1926)
Camille on the Beach at Trouville, 1870
Camille sur la plage de Trouville
Oil on canvas, 38.1 x 46.4 cm
Yale University Art Gallery, New Haven.
Collection of Mr and Mrs John Hay Whitney BA, 1926, Hon. 1956
KEY REFERENCE: Wildenstein 1974, no. 160
(Exhibited in Hartford only)

In late June 1870, Monet married Camille Doncieux, the mother of their son Jean (born in 1867), and the three honeymooned at Trouville, lodging for about two months in the Hôtel Tivoli, a relatively modest hotel situated away from the beach. *The Beach at Trouville* and *Camille on the Beach at Trouville* are two of three identically sized canvases showing female figures on the beach. In all three, the main figures are viewed from close up, as if the painter is a part of their social group, in contrast to the distanced viewpoints in cats 36 and 37 and in Boudin's characteristic beach scenes (cats 5 and 13–16).

The figure on the left in *The Beach at Trouville* (cat. 38) clearly represents Camille; Jean's presence is indicated only by the brown brushstroke at top left of the empty chair, which can be seen as a child's beach shoe. The other female figure, in mourning, cannot be securely identified, but it seems very possible that she is Boudin's wife Marie-Anne; in a letter many years later, Boudin remembered the two couples spending time together on the beach at Trouville during that summer (letter from Boudin to Monet, 14 July 1897, in Jean-Aubry 1922, p. 106). There is no overt communication between the figures, but their proximity to each other suggests easy, symbiotic friendship.

Camille is the principal figure in cat. 39, too, this time alone near the water's edge and turning towards the painter and viewer as if to acknowledge our presence. Beyond her, a roughly indicated female figure and a deftly sketched small boy – perhaps Jean – stand at the water's edge, the boy in an animated pose as if running towards the water, in contrast to the stillness of the other figures (compare the child's figure beside the sea in cat. 37). In the background we see the flags that demarcated the zones of the bathing beach at Trouville, and bathers in the water, schematically notated by a few small dark dabs of paint.

The execution of cat. 38 is remarkably informal and economical, with broad sweeps of liquid paint alternating with bold individual brushstrokes, notably where the sun falls on Camille's dress. The shadow of the chimney at far left shows that the sun is ahead of us, and that the figures are viewed contre-jour; thus the seeming shadow across Camille's face must be interpreted as representing a veil, not the fall of sunlight (the veil is depicted more explicitly in cat. 39). Extensive areas of the light-grey canvas priming are left unpainted in both canvases. In cat. 38 this is used by Monet to create subtle pictorial effects. Whereas in the centre of the canvas, above the chair, the unpainted areas on the sandy beach read as a soft mid-grey, the same priming appears as a near-white on the hand of the figure on the right when surrounded by black paint (see London 1990, pp. 126–31). Even in a canvas so rapidly executed as this, Monet demonstrates remarkable control of such pictorial effects. In cat. 39, the grey priming is left visible in many parts of the canvas – sea, sky, figure, parasol – and establishes a soft-toned base against which the warm and cool hues of the paint strokes are played off.

The presence of many grains of sand in the paint layer of cat. 38 shows that the painting was executed outdoors, and testifies to the breezy conditions that it depicts. The near-circular area, largely made up of sand, between the lower bars of the chair does not seem to represent anything in the scene; may we imagine that it is a thumb-print by which Jean left his mark on his father's work?

The early history of the cat. 38 cannot be traced. Its signature, with initials only, rather than Monet's usual full signature, suggests that its first owner was a friend, and the handwriting shows that it was signed near the time that the canvas was painted. If the second figure does represent Marie-Anne Boudin, it is very possible that Boudin was its first owner. Nothing is known of the early history of cat. 39, either. However, the rough handwriting of its signature, in contrast to the incisive script on cat. 38, indicates that it was signed very late in Monet's life, presumably before being sold to a dealer or collector.

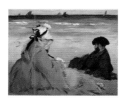

40
EDOUARD MANET (1832–1883)
*On the Beach: Suzanne and Eugène
Manet at Berck*, 1873
*Sur la plage: Suzanne et Eugène
Manet à Berck*
Oil on canvas, 60 x 73.5 cm
Musée d'Orsay, Paris. Donation Jean-Edouard
du Brujeaud sous réserve d'usufruit, 1953
KEY REFERENCE: Rouart and Wildenstein
1975, 1, no. 188

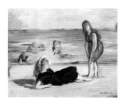

41
EDOUARD MANET (1832–1883)
Women on the Beach, 1873?
Femmes sur la Plage
Oil on canvas, 40 x 48.3 cm
Detroit Institute of Arts.
Bequest of Robert H. Tannahill
KEY REFERENCE: Rouart and Wildenstein
1975, 1, no. 189
(Exhibited in London only)

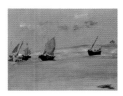

42
EDOUARD MANET (1832–1883)
Low Tide at Berck, 1873
Marée basse à Berck
Oil on canvas, 55 x 72 cm
Wadsworth Atheneum Museum of Art,
Hartford, CT. The Ella Gallup Sumner and
Mary Catlin Sumner Collection Fund
KEY REFERENCE: Rouart and Wildenstein
1975, 1, no. 198

Manet spent the month of July 1873 at Berck-sur-Mer, a small resort and fishing port on the northern French coast between Boulogne and the estuary of the River Somme. Unlike the resorts of Normandy, Berck had little infrastructure for the holidaymaker; its primary asset was its wide sandy beach – part of the stretch of sandy coastline that stretched as far south as Le Crotoy (see cat. 27). Eugène Pénel's guide to the region had little to say in favour of the place:

> The healthiness of the beach at Berck is its only appeal to the outsider; nothing is as melancholy as this vast plain of uninterrupted sand, bordered by a line of arid hillocks. There are neither cliffs nor pebbles, and doubtless it was the disposition of the beach that led to the foundation of a bathing establishment there, frequented especially by the inhabitants of the nearest towns.
> (Pénel 1866, pp. 213–14)

Manet's canvases make little of the topography of the place, focusing instead on figures and boats on the wide expanses of the beach. *On the Beach* is exceptional in the group, depicting Manet's wife Suzanne and his brother Eugène set against the open sea. There is no overt communication between the two. Suzanne seems immersed in the book she is reading, while Eugène gazes out across the sands, but we cannot see what, if anything, has attracted his attention. The pairing of figures, placed close to the viewer, is comparable to Monet's beach scenes of 1870 (see cat. 38), and it is possible that Manet was aware of these. At the same time, the placing of figures facing each other

but not attending to each other carries a distant echo of Manet's own *Le Déjeuner sur l'herbe* of 1863 (Musée d'Orsay, Paris), for which Eugène also posed, though wholly lacking the tension and suggestiveness of that canvas.

The fishing boats in the background in *On the Beach* introduce the theme of Manet's other Berck canvases, including *Low Tide at Berck*. Pénel's guide noted Berck's importance as a centre for herring fishing in winter, but wrote disparagingly about the dangers of the tides on the beach of a place that had no natural harbour (see fig. 9, p. 21, set at nearby Etaples) and about the disused boats on the beach and in the town in which sailors lived: 'This may be ingenious, but it is undoubtedly very ugly' (Pénel 1866, pp. 213–14). In Manet's various canvases, the boats are on the beach or at sea. In one, titled *Toilers of the Sea* of 1873 (Museum of Fine Arts, Houston; see Chicago 2003, pp. 84 and 151), the artist places himself, and the viewer, in a boat with the fishermen (its title presumably derives from Victor Hugo's novel of the same name – see p. 15), otherwise the viewpoint is on the beach. In *Low Tide at Berck*, the boats act as informal punctuation points in front of the broad sweep of sea and horizon.

Low Tide at Berck is very rapidly sketched, with the light-grey priming of the canvas playing a major role in determining the overall tonality of the picture. Though it is so summary, Manet considered it a finished work of art, signing it, with characteristic wit, on the driftwood in the right foreground – a seemingly casual detail whose inclusion plays a vital role in holding together the composition. *On the Beach* is more elaborated, though the modelling of the figures' clothing is suggested only by rapid and schematic brushmarks; the red accents on Suzanne's shoe add a single sharp colour accent to the canvas. The presence of sand in the paint shows that the canvas was, in part at least, executed on the beach (see Chicago 2003, p. 82).

Women on the Beach has traditionally been dated to Manet's stay in Berck in 1873, but it has recently been suggested that it dates from his stay at Boulogne in 1868, on the basis of a comparison between the figures in the water and those in a watercolour that was certainly executed at Boulogne (see Chicago 2003, pp. 122–3). However, the similarities are not very close, and the freely brushed technique of the canvas suggests that the traditional date may indeed be correct.

Here, the theme of bathing is central: there are two young women in bathing costumes on the beach, with further bathers in the water, including what seems to be a woman carrying a child, and the theme of fishing relegated to a single boat in the distance at the right margin. Though the subject is freely sketched and informally treated, the pose of the reclining figure carries echoes of a wide range of artistic precedents, including Manet's own *Olympia* of 1863 and Cabanel's famous *Birth of Venus* of 1863 (both Musée d'Orsay, Paris), and, perhaps most closely, the Roman 'Cleopatra' figure in the Vatican, of which a cast was available in Paris; the distinctive gesture of the figure's arm across her head is particularly reminiscent of this (see Haskell and Penny 1981, pp. 184–7). Viewed in this context, Manet's bather becomes a modern-life nymph or a modern Venus, newly born on the Channel coast, an analogy that directly echoes a conceit in Jules Michelet's *The Sea* (see p. 18).

4 Beach Scenes at the Salon after 1870

43
CHARLES FRANÇOIS
DAUBIGNY (1817–1878)
*The Beach at Villerville-sur-mer
(Calvados), Sunset*, 1873
*Plage de Villerville-sur-mer
(Calvados), soleil couchant*
Oil on canvas, 76.8 x 143.5 cm
Chrysler Museum of Art, Norfolk, VA.
Gift of Walter P. Chrysler Jr, 71.635
KEY REFERENCE: Hellebranth 1976, no. 618

Daubigny showed this sunset scene at the 1873 Salon together with the equally spectacular *Snow* (Musée d'Orsay, Paris). The broad sweeps of the palette knife and spare, chilling effect in *Snow* create a dramatically different effect from the complex, rich surface textures and hot colouration of the present canvas. Viewed together, the two would have been a strikingly contrasting pair, as well as demonstrating Daubigny's painterly mastery over the most diverse and extreme natural effects.

By 1873, Villerville had a small bathing station, but was quite unlike Trouville, just 6 kilometres down the coast to the southwest. The lie of the land prevented the development of a seafront like that at Trouville; instead, the town was set back from the sea, in the low hills that rose directly from the shore. A guidebook in the 1870s recommended it as a holiday site for families and those on a limited budget, and contrasted its modesty with the Parisian luxury of Trouville: 'One comes to Villerville to breathe the air of the sea, and that is all' (Conty 1876, p. 197). Another writer commented: 'To understand and love Villerville one must be an artist, because there are no other recreations than the contemplation of rustic nature' (James 1869, p. 353).

Daubigny painted Villerville on many occasions from the 1850s onwards, never showing any sign of the resort development. *The Beach at Villerville-sur-mer (Calvados), Sunset* is the most spectacular of these canvases. The viewer is placed up on the hill overlooking the sea, with just one cottage visible, silhouetted against the horizon. Beyond we see the vast expanse of the beach with the rocks that were exposed at low tide, and a few small figures of fisherwomen climb the hill, carrying their gleanings from the mussel beds on the rocks. Daubigny's chosen view was eloquently described by Charles Deslys, who had first 'discovered' Villerville: 'Looking to the left one sees the sea and the innumerable beauties of the setting sun. Yes, I was a fortunate Christopher Columbus, the day that I invented Villerville-sur-mer!' (Deslys, quoted in Joanne 1866, p. 397).

The picture attracted much and generally favourable attention from the critics at the Salon in 1873. Georges Lafenestre admired the truthfulness of the work, but compared his 'imagination' unfavourably with Corot:

> M. Daubigny is seeking increasingly to broaden his style in a poetic and decorative direction; his *Beach at Villerville-sur-mer at Sunset* and his *Snow* astonish the Parisian by their strangeness, but enthral the man who has used his eyes by their truthfulness; but M. Daubigny's faculties of interpretation always remain less powerful

than those of M. Corot, and, however large his canvases and however freely brushed they are, they always address themselves more to the viewers' memory than to their imagination. (Lafenestre 1873, p. 56)

Jules Castagnary, by contrast, after describing the picture at length, concluded:

Nothing could be more solemn and more religious. Some people have objected that the effect is extraordinary and unfamiliar, and that they have never seen the sun in the form of an orange. But the effect is more frequent than they imagine. Many people have seen it. For me, what I find most unusual is not the natural phenomenon placed before our eyes, but the prodigious talent of the painter who, placing the sun so far down the sky, has been able to give the viewer such a sensation of space. (Castagnary 1892, 2, p. 59)

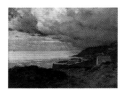

44
JEAN CHARLES CAZIN
(1841–1901)
The Storm (Equihen, Pas-de-Calais),
c. 1876
L'Orage (Equihen, Pas-de-Calais)
Oil on canvas, 89.5 x 117 cm
Musée d'Orsay, Paris.
Legs de Mme Julia Bartet, 1942

Cazin first gained wide critical attention at the Salon in 1880 with *Ismael* (Musée des Beaux-Arts, Lille) and *Tobias* (Musée des Beaux-Arts, Tours), two canvases in which biblical subjects were represented in outdoor settings derived from the dune landscapes of Cazin's native region, the Pas-de-Calais. His later work was primarily devoted to smaller, atmospheric tonal landscapes of this region. *The Storm* seems to predate Cazin's biblical subjects, and to have been painted in the years immediately after his return to France in 1875 from extensive travels across Europe, when he settled near his birthplace, at Equihen, the village depicted in *The Storm*.

Equihen is a village about 6 kilometres south of Boulogne, about 20 kilometres north of Berck-sur-Mer (see cats 40 and 42). It was described in an 1866 guidebook as a 'poor fishing village' (Pénel 1866, p. 264), though later, like all the small places along this coast, it acquired a modest bathing station. Cazin's canvas presents it as a village wholly untouched by modernisation, with its humble cottages enfolded protectively by the surrounding dunes. The chosen weather effect, of an approaching storm, emphasises the theme of man's struggle against elemental forces, and the sombre tonality of the canvas enhances this, with the dark clouds casting deep shadows across the village and masking the brighter sky out at sea.

The Storm reflects the aesthetic of Cazin's teacher, Lecoq de Boisbaudran, whose emphasis on the cultivation of pictorial memory distinguished him decisively from the Impressionists' emphasis on direct observation. Despite its ambitious scale, the canvas seems not to have been exhibited at the date that it was painted; however, it was included in the Paris Exposition Universelle of 1900, at the Exposition Centennale devoted to French art of the century before 1889.

Reviewing this exhibition, André Michel made a close analysis of the distinctive qualities of Cazin's art, in contrast to the Impressionists:

While the Impressionists, in their notation of ephemeral sensations, too often make an end of what should only be a starting point, Cazin, after protracted contemplation and meditation, rendered the aspects of nature best suited to nurture moral life. From his melancholy cliffs, he followed the progress of the clouds across the infinite sky, the beginning and the end of the day; he sensed how the most delicate modulations of light may give a serene or an overcast mood to a landscape. … From all this, following the hours and the days, he created a great poem, intimate and tender, mysterious and gentle. (Michel 1900, p. 481)

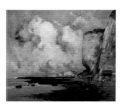

45
JEAN BAPTISTE ANTOINE
GUILLEMET (1843–1918)
The Cliffs of Puys at Low Tide,
1877
Falaises de Puys à marée basse
Oil on canvas, 87 x 103.5 cm
Château-Musée de Dieppe

During the 1860s, Guillemet was a close associate of Paul Cézanne and Camille Pissarro, but from 1870 onwards he developed wider public attention through the large canvases he exhibited at the Paris Salon, which depicted the Normandy coastline in a generally sombre tonality and with a breadth of treatment reminiscent of Daubigny (see cat. 43). By the mid-1870s, Emile Zola, another close associate from the 1860s, was using his praise for Guillemet as a pointed contrast to his disappointment at the recent developments in the art of the Impressionists. Reviewing his *Villerville (Calvados)* (Musée des Beaux-Arts, Caen) at the 1876 Salon, he wrote:

It gives a strong impression of melancholy and grandeur; one feels the salty spray of the sea on one's face. … Guillemet's originality derives from the fact that he has preserved the vigour of his brushwork whilst talking great care over the smallest detail. He used to belong to the revolutionary group of young painters who prided themselves on only producing sketches; the more a picture tried to mask its technical clumsiness, the more it was eulogised. Guillemet, a reasonable man, parted company with this group: taking greater care over his canvases was enough to arouse great enthusiasm for his work. Gradually he became a celebrity, without, I hope, recanting on his previous beliefs. He is perfecting his technique, and his love for the truth remains the same. (Zola 1970, pp. 272–3)

The Cliffs of Puys at Low Tide, though not exhibited at the Salon, reveals just the combination of broad handling and attention to detail that so pleased Zola. Without tight, illusionistic detail, the canvas gives a vivid sense of the diverse textures of cliffs, sand and the different types of rock exposed by the tide. At the same time, the small figures of local fisherfolk, together with their nets, seen hung out to dry in the distance, establish a human dimension to the scene that betrays no trace of the modernisation of the coastline

(however, contrast his *The Beach at Villers*, shown at the 1878 Salon; see p. 24 and fig. 16).

The canvas depicts the cliffs at Puys, just to the northeast of Dieppe. The picture's asymmetrical composition, setting the massive cliff mass on the right against the wide spaces of shore and sea, strikingly anticipates the ways in which Monet formulated many of his views of the beach at nearby Pourville, five years later (see cats 55 and 56). Writing in 1877, Duranty perceptively noted that Guillemet disliked 'closed' landscapes: 'He wants the landscape open, with deep recession, giving free play to the eye, leaving space for the sky, for the light' (Duranty 1877, p. 574).

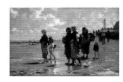

46
JOHN SINGER SARGENT
(1856–1925)
Oyster Gatherers of Cancale, 1878
Oil on canvas, 79 x 128.3 cm
The Corcoran Gallery of Art, Washington DC.
Museum Purchase, Gallery Fund
KEY REFERENCE: Williamstown 1997, no. 3
(Exhibited in Washington only)

Sargent visited Cancale, on the coast in northeastern Brittany between Saint-Malo and Dol-de-Bretagne, during July and August 1877. Though apparently hampered by poor weather, he made a number of studies there. In Paris the following winter he worked them up into two versions of a sunlit scene of oyster gatherers crossing the sands to gather their harvest (see Williamstown 1997, pp. 74–5). In March 1878 he exhibited the smaller version (fig. 39) at the inaugural exhibition of the Society of American Artists in New York with the title *Fishing for Oysters at Cancale*, and in May showed the large one (cat. 46) at the Paris Salon as *En route pour la pêche*. Both pictures were warmly received on their first showing (see Williamstown 1997, pp. 82–3).

Cancale was especially celebrated for its oysters, and the activities of the local population, gathering and landing their catch, were themselves one of the major tourist attractions of the place. The Conty guide published in the year of Sargent's visit celebrated the spectacle: 'A pretty natural port forming a horseshoe, with a jetty and a lighthouse. Gracious and smiling women, of a beautiful type, with large eyes and splendid teeth; superb children and solid, well-built men from a pure stock; local costume that is particular to the place. … Nothing is so original and picturesque as the sight of Cancale harbour with all its little boats, which from a distance look just like cockleshells.' At the same time, the guide noted that the place was in the process of transformation, and that new roads were planned (Conty 1877, pp. 167–8).

Sargent's two canvases are a fascinating synthesis of different pictorial modes. The statuesque, processional quality of the figures and the low viewpoint, which silhouettes their heads against the sky, may be compared to the idealising image of the Breton peasant seen in canvases such as Jules Breton's *A Spring by the Sea* (cat. 3). At the same time, the fluent, painterly brushwork betrays the influence of Sargent's teacher Carolus-Duran and of Manet, while the luminous open-air effect shows his awareness of the work of painters such as Boudin and also, perhaps, of Monet, whom Sargent seems to have met in 1876, though they only became close friends in the mid-1880s.

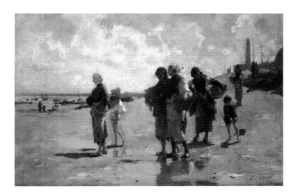

Fig. 39 John Singer Sargent, *Fishing for Oysters at Cancale,* 1878. Oil on canvas, 41 x 61 cm. Museum of Fine Arts, Boston

The success of the large canvas at the Salon in 1878 was marked by the inclusion of a drawing Sargent made after it in the leading Parisian art journal of the day, the *Gazette des Beaux-Arts*. In the accompanying review, Roger-Ballu wrote: 'M. Sargent's canvas has given me great pleasure. This artist paints with bold, broad touches which, seen from close to, seem confused but, from a distance, give relief and brilliance to the figures. One has a real sense of the sun illuminating the wet sands of the beach, punctuated here and there by the blue reflections of the sky in the little patches of water' (Roger-Ballu 1878, p. 185).

It seems likely that the smaller canvas (fig. 39) acted as a compositional sketch (*esquisse*) for the Salon painting as well as being worked up by Sargent as an independent work in its own right. By working from initial studies via an *esquisse* to the final work, Sargent was following traditional academic practice. Apart from their physical size, the differences between the two are seemingly slight, but not insignificant. In the large version there is a sharper demarcation between tones and colours, and the addition of extra figures descending the path on the right enhances the processional quality of the image.

47
LÉON GERMAIN PELOUSE
(1838–1891)
Grandcamp, Low Tide, 1884
Grandcamp, marée basse
Oil on canvas, 97 x 147 cm
Musée des Beaux-Arts de Carcassonne

By the 1880s, Pelouse had gained a reputation for his sombre canvases of remote sites from the French countryside and coasts exhibited at the Paris Salon. He heightened the tone of his work by favouring dramatic weather effects, as in *Grandcamp, Low Tide*, or depicting sites that are overgrown or decayed. Grandcamp is on the Normandy coast to the northwest of Bayeux, around 80 kilometres to the west of Trouville. It had a bathing beach, but its primary attraction was its fisherfolk – the 'numerous fishing boats which, by their comings and goings, lend animation to the place' (Conty 1876, p. 248), and its 'hard-working and heroic population' (Joanne 1887, p. 347). Pelouse's canvas focuses on fisherwomen returning along the beach, with the low tide exposing

the 'magnificent rocks covered with seaweed' noted in another guidebook (Conty 1896, p. 337). The wide vista includes in the distance the low-lying shoreline of the eastern side of the Cotentin peninsula; Grandcamp appears as a remote seaside village, exposed to the forces of both sea and sky. The composition stresses the horizontality of the scene, but the figures, rocks and the bands of wet sand create a strong sense of recessional space.

In his technique, Pelouse sought to combine breadth with the suggestion of detail. The sky and beach are treated with great fluency, and the whole canvas is unified by its overall tonal harmony of greys and beiges. Yet it is also full of local incident, small elements such as the figures and the rocks, which from a distance appear to be treated in great detail, but from close to the rocks on the beach, in particular, dissolve into a free play of varied tonal dabs, animated by delicate light-hued touches that suggest the play of light and water. The poses of the little figures hint at the weight of their burdens and the effort of walking into the wind, but their silhouettes have a slightly crude and caricatural quality that differentiates them markedly from the dignified figures in Breton's and Sargent's canvases (cats 3 and 46); they are more precisely characterised than the dark silhouettes of the figures on the rocks in Monet's *Rocks at Low Tide* (cat. 55). Monet's canvas makes a revealing comparison with Pelouse's; though Monet's rich weave of coloured brushstrokes is quite unlike Pelouse's combination of detail with tonal breadth, there are clear similarities in the ways in which the two pictures are formulated.

Critics could not agree whether Pelouse's view of the natural world should be seen as eloquent and poetic or dispassionate and objective. Castagnary, writing in 1878, criticised Pelouse's 'tendency to dramatise nature, to infuse it with passion' (Castagnary 1892, 2, p. 353). However, in 1880 Maurice du Seigneur viewed this in positive terms, describing Pelouse's exhibits, including *Bank of Rocks at Concarneau* (Musée de Brest), a canvas very comparable to *Grandcamp, Low Tide*, as 'so marvellous in their impression, so full of the grandiose sentiment of nature that they put poetry in your soul and would make you compose alexandrine verses' (du Seigneur 1880, p. 92). However, in 1884 Armand Dayot, while praising *Grandcamp, Low Tide*, criticised what he saw as the limitations of Pelouse's art:

> He paints with a prodigious skill, and possesses, like no-one else, the secret of reproducing precisely the objects that are reflected in his eye, like a faithful mirror. And yet, in front of his pictures … one remains cold: 'It's marvellously painted. It really is.' And then one passes on. This will not change, M. Pelouse, until this nature, whose plastic beauty you can reproduce so well, is reflected in your heart as it is in your eyes. (Dayot 1884, p. 79)

48
EUGÈNE LOUIS BOUDIN
(1824–1898)
Etretat, the Porte d'Aval, 1890
Etretat: la Porte d'Aval
Oil on canvas, 79.9 x 109.9 cm
Carmen Thyssen-Bornemisza Collection.
On loan at the Thyssen-Bornemisza Museum, Madrid
KEY REFERENCE: Schmit 1973, 3, no. 2727

After the 1860s, modern-life beach scenes came to play an increasingly smaller part in Boudin's production. During the 1870s he painted a sequence of canvases of French ports, and in the 1880s he came to focus at times on scenes of the open sea, and also on canvases of the resorts of the French coast – on both the English Channel and the Mediterranean – in which the holidaymakers are conspicuous by their absence. In his late work, even on the wide sands of Deauville, the figures of holidaymakers are subordinated to those of the local working people. This shift coincides with the decision taken by Monet to turn his back on the 'modern' coast (see especially cat. 53), and is part of a more general tendency among the painters of modern life of the 1860s and 1870s to focus on less topical, more seemingly timeless subjects (see above, p. 26–27).

Etretat, the Porte d'Aval is one of the two relatively large canvases that resulted, together with many smaller canvases, from Boudin's stay at Etretat in the early autumn of 1890. It seems very likely that this and a picture of the same size looking in the opposite direction towards the Porte d'Amont (fig. 40) were the canvases exhibited together with the titles *Etretat, falaise d'amont* and *Etretat, falaise d'aval* at the Salon of the Société Nationale des Beaux-Arts in 1891. In the former, the foreground beach is animated by the traditional imagery of the equipment and boats of the local fishermen (compare Corot, cat. 28), but in the present canvas we see only a small wedge of the beach at bottom left, with a sequence of fishing boats heading out to sea. In both, Etretat appears only in its most traditional, non-modern guise.

The one strictly contemporary element in Boudin's painting is the tower silhouetted on top of the cliff; this was the Fort de Fréfossé, a pseudo-medieval gatehouse that gave access to the cliff edge. It does not appear in Monet's canvases of this cliff (see cats 60–62), and it is not clear whether Monet omitted it, or whether it was built after his last visit in 1886 (on the 'Fort', see Herbert 1994, p. 130, and note 17 on p. 142).

The delicate, varied brushwork in the sky gives a vivid sense of a coastal breeze, but the execution of the cliff face and the sea is more detailed and elaborate than in Boudin's earlier work; in his last years, he clearly felt that a greater degree of complexity and finish was appropriate for the more ambitious canvases he completed for exhibition.

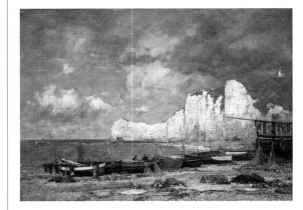

Fig. 40 Eugène Louis Boudin, *Etretat,* 1891. Oil on canvas, 78.7 x 110.5 cm. Chazen Museum of Art, University of Wisconsin, Madison

Boudin continued to paint at Trouville and Deauville throughout his career, but his later visions of the region are quite unlike the modern life scenes of the 1860s (cats 5 and 13–17). Instead of focusing on the social interplay of the holidaymakers, he looked out across the open expanses of the beach. In *Deauville*, the small, rapidly sketched figures down by the waterside are indicated in just enough detail for them to be identified as bourgeois; one man is accompanied by a dog. But more prominent are the working men with their horses and cart – Boudin is at pains to indicate the varied uses of the beach.

He also turned his back on the villas and hotels that lined Deauville beach, looking southwest towards Villers (see Troyon, cat. 8, and Caillebotte, cat. 50). A few buildings and some structures on the beach are lightly indicated in the distance, but throughout the picture the signs of modernisation are subordinated to the vast expanse of the sands at low tide and to the light effects that give such a vivid sense of the characteristic atmosphere of the Channel coast on a breezy day.

The painting is composed around the dominant contrast between the blues of the sky and sea and the yellow-beige of the beach, with soft touches of green in the distance and a sequence of tiny red touches – a roof, a flag, a figure – that give an almost imperceptible animation to the scene. Although Boudin had worked with Monet and clearly knew his work well, his use of colour and brushwork show little direct sign of the younger man's influence. Boudin uses a crisper, more graphic touch to indicate individual forms in the canvas with broader sweeps of paint for the open spaces, in contrast to the all-over weave of animated coloured strokes characteristic of Monet's work by the 1880s (see e.g. cats 51 and 59).

Technical examination has shown that the canvas was extensively reworked. The initial working of the sky was rubbed or scraped down and subsequently repainted (see Bruce-Gardner 1987, p. 23); this is

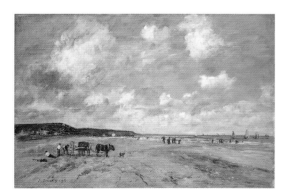

Fig. 41 Eugène Louis Boudin, *Deauville Beach*, 1893.
Oil on canvas, 50.5 x 74.5 cm. Musée des Beaux-Arts, Caen

a salutary reminder of the complexities of the practice of open-air painting, and suggests that the final effect in *Deauville*, for all its apparent freshness and immediacy, may have been achieved in the studio. Indeed, the existence of a closely similar painting of the scene (fig. 41), on a canvas of the same size and taken to a very similar degree of finish, is a further indication that the present canvas, as well as its pair, may have been painted in the studio; the two pictures differ in many small details, but the placing of the main elements, including the figure groups, is the same in both.

5 Impressionism in the 1880s

Caillebotte paid a number of visits to the Normandy coast during the early 1880s, in part to paint, in part to pursue his passion for sailing. His stay at Villers in 1880 followed an extended and very successful period of competitive sailing in his yacht *Inès* at the regattas at Le Havre, Trouville and Fécamp (see Chicago 1995, p. 341). The majority of his coastal scenes focus directly on the new resorts. Villers, a short distance to the west of Deauville and Trouville, began to be developed in the late 1850s. By 1880 it was well established as a seaside resort, wedged between the Vaches Noires cliffs to the southwest (see fig. 7, p. 21) and the open marshland to the northeast, seen in the background of Caillebotte's canvas, and the focus of Troyon's painting executed about twenty years earlier (cat. 8).

Caillebotte's treatment of the subject is very distinctive. Whereas Boudin and Monet, in their canvases of between 1863 and 1870, had viewed Trouville from the beach, Caillebotte consistently, as here, viewed his coastal scenes from above the new resort developments, with the wide vista of the seashore seen beyond the irregular silhouettes of the buildings. The viewpoints he chose were deliberately anti-picturesque in conventional terms. In *Villers-sur-mer*, the small building at bottom left – a garden shed or stable, perhaps – juts into the composition, the white structures to the left of the main house are particularly shapeless and inelegant, and the house itself is less visually interesting than the more elaborate villas beyond it.

This reversal of conventional values presents a particularly interesting perspective on the coastline; it is seen neither from the ideal position of the holidaymaker, promenading on the beach, nor from the standpoint of the independent artist escaping the resorts. Instead we are presented with the stark contrast between the irregular and often fragmented visual experience of these new developments and the serene beauty of the coastline beyond. Pictures like *Villers-sur-mer* seem to be an explicit commentary on the commodification of the coastline, though this is not presented as a critique. This treatment of the coast stands in sharp contrast to Monet's careful avoidance of

the signs of resort developments in his sequence of coastal paintings begun in the same year (see especially his 1881 view of Trouville, cat. 53). Caillebotte's approach can be compared to the unusual treatment of his still-life subjects in these years, treated as if laid out for sale, rather than configured by the artist into aesthetic arrangements (see Chicago 1995, pp. 232–7).

The artist's technique here is loosely Impressionist in its variegated brushwork, modified so as to suggest the diverse textures in the scene, and in the overall blonde and richly coloured register of the canvas. It is possible that this was the canvas he exhibited with the title *Villers-sur-mer* at the seventh Impressionist group exhibition in Paris in 1882. Reviewing the show, Armand Silvestre described this and another of Caillebotte's coastal scenes as being of 'a questionable but very amusing harmony' (reprinted in Berson 1996, 1, p. 414), a comment that seems more appropriate to the painting here than to the canvas that has previously been identified as that shown in 1882 (Berson 1996, 2, pp. 201 and 215).

After a brief stay at Les Petites Dalles in the summer of 1880, Monet returned to the Normandy coast for a longer spell in March 1881 – a stay made possible by the renewed purchases the dealer Paul Durand-Ruel was making from him, beginning in February that year. Durand-Ruel's continuing support was a vital factor in enabling Monet to spend extended periods travelling, on the Normandy coast and elsewhere, throughout the 1880s.

Apart from two canvases of boats in the port, Monet's views of Fécamp fall into two main groups: panoramic views from the cliff tops and canvases that engage directly with the sea and the shoreline. In a few of the views from the cliffs, we see the jetty extending out from the harbour, but, apart from this, there is no sign in these canvases of the significance of Fécamp as a fishing port or of its role as a holiday resort (he was there out of season). Monet's cliff scenes offer dramatic and unexpected juxtapositions of land and sea, presenting the painter as a solitary explorer seeking out remote and often precarious viewpoints.

His viewpoint for *The Sea at Fécamp* was close to the eastern entry to the harbour and close to Jongkind's standpoint in cat. 6. However, turning his back on the town, Monet was confronted by a scene that

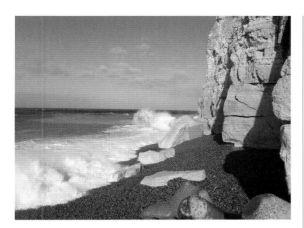

Fig. 42 The sea at Fécamp, photograph, 2005

had been eloquently described by the German traveller Jacob Venedey 40 years earlier: 'On the right of the pier, scarcely ten paces from it, the waves washed the foot of the perpendicular cliff, and blocks as high as a man, which lay scattered around, attested to the power of the billows that had rent them from their places' (Venedey 1841, 1, p. 305). Present-day photographs of the site testify to the continuing power of the waves in remodelling this cliff (fig. 42).

The canvas translates the force of the waves against the cliff into an extraordinary virtuosic display of brushwork. The colour is relatively subdued, dominated by greens, blues and beiges, but the surface of the picture is animated by the dynamic energy of the mark making – cursive strokes for the incoming waves, sharper accents and stabs of paint on the rocks, and a maze of filigree arcs where the waves crash against the shore.

For all its seeming immediacy, the changing tide levels and rough weather conditions cannot have permitted Monet to bring *The Sea at Fécamp* to its present state in front of the scene; we must assume that he reworked it over a more rapid initial notation (see e.g. the Etretat scenes reproduced in Herbert 1994, pp. 75 and 80). Its status is complicated by the existence of another version of the subject, closely similar but on a slightly smaller canvas (Wildenstein 1974, no. 659). Both canvases were bought from Monet by Durand-Ruel in May 1881.

A Stormy Sea cannot be firmly dated, but it seems very likely to have been painted during the same stay at Fécamp. The crisp, cursive strokes used to express the movement of the waves are comparable to the treatment of the open sea in *The Sea at Fécamp*, and especially characteristic of his work in 1881; another comparable canvas is dated 1881 (Wildenstein 1974, no. 661, reproduced in San Francisco 2006, p. 81). Here Monet was tackling a subject that would have immediately invoked associations with Courbet's many canvases of breaking waves (see cat. 26). However, the resulting effect is far from the density – solidity, even – of Courbet's waves. Monet's sea is light and airy, his touch lithe and energetic, and there is no single focus; the eye is drawn right across the canvas, and step by step out to sea from one bank of waves to the next, and across the clouds, uniting sea and sky in an overall sense of movement.

53
CLAUDE MONET (1840–1926)
The Cottage at Trouville, Low Tide,
1881
La Cabane à Trouville, marée basse
Oil on canvas, 60 x 73.5 cm
Carmen Thyssen-Bornemisza Collection.
On loan at the Thyssen-Bornemisza Museum,
Madrid
KEY REFERENCE: Wildenstein 1974, no. 686

Monet saw his stay on the Channel coast in the late summer of 1881 as futile, blaming the poor weather for his failure to complete much work (letter to Paul Durand-Ruel, 13 September 1881, in Wildenstein 1974, p. 443). However, *The Cottage at Trouville, Low Tide*, painted during this trip, is one of the most significant indications of the radical change in his approach to his subject matter in the early 1880s.

In 1870 he had focused on resort life in Trouville (cats 35–39), but now, revisiting the most celebrated resort of the entire coastline, he excluded any sign of this development. The single cottage is an old customs watch-house perched on an otherwise undisturbed cliff and looking out over the vast panorama of Trouville bay at low tide, with the tiny forms of fishing boats scattered across the distant sea. Although Monet was there during the holiday season, he presents the expanses of Trouville's sands in the foreground as wholly unpeopled. His viewpoint is even more isolated than Corot's view out over the bay at Trouville from the 1830s (fig. 13, p. 23) in which he gave a sense of the outsider discovering the place; the closest comparison is with Daubigny's view of nearby Villerville at sunset, shown at the 1873 Salon (cat. 43), though even there the figures of fisherfolk lend animation to the scene. This sense of the painter as a lone explorer is a keynote of Monet's coastal scenes of the 1880s (see p. 27).

The asymmetrical composition has clear, if generic, echoes of Japanese colour prints, with the viewer poised above the space without visible foothold, and the wedge of cliff jutting into the corner of the picture. Monet has used this format to emphasise the contrast between foreground and distance, and to give a vivid sense of the wide space of the bay. The recession into space is conveyed by means quite unlike the flat planes of the Japanese print – by subtle nuances of colour and touch that lead the eye out across the sands, through the clusters of boats, and to the dimly indicated far shoreline. Although the colour is relatively subdued – testimony, we assume, to the poor weather during his trip – the interplay between water and sand is effectively evoked by colour contrasts, between pale grey-blues and soft beige-orange hues. Monet returned to a very similar subject a year later in his long sequence of canvases of the customhouse-man's cottage on the cliffs to the west of Pourville.

54
CLAUDE MONET (1840–1926)
Sunset at Pourville, 1882
Coucher de soleil à Pourville
Oil on canvas, 60 x 81 cm
Courtesy of The Kreeger Museum,
Washington DC
KEY REFERENCE: Wildenstein 1979, no.781
(Exhibited in Washington only)

Monet spent over five months at Pourville, 5 kilometres west of Dieppe, during 1882. Staying initially in Dieppe itself, he felt himself to be 'too much in the town', and soon moved to Pourville where, he wrote, 'the countryside is very beautiful; one could not be closer to the sea than I am; the waves beat against the foundations of the house' (letters to Alice Hoschedé, 7 and 15 February 1882, in Wildenstein 1979, pp. 213–14). After a first visit of two months, he returned for more than three months the same summer, renting a villa with Alice Hoschedé and their children.

Pourville's rise to popularity was slow. In *L'Ancienne Normandie*, published in 1825 as one of the volumes of the *Voyages pittoresques et romantiques dans l'ancienne France* series, the author saw the place as a metaphor for the vanity of man's efforts to keep the sea at bay: 'A small number of earthen constructions, half destroyed by a recent flood, testify to the vanity of the efforts of the man who wants to set up barriers to the ocean, and made us sorrowfully aware of the lot that awaits the poor inhabitants of these places at the first tempest' (quoted in Rouillard 1984, p. 47). In 1866, Eugène d'Auriac described it as 'a place of solitude and melancholy', with 'scarcely fifteen cabins', but recommended it to 'lovers of calm and solitude' for its 'very acceptable small bathing establishment' (Auriac 1866, p. 128). The Conty guide in 1876 described it as a beach that was beginning to be frequented and had a great future, and noted that there were chalets that could be rented for the season (Conty 1876, p. 282). By the 1880s, Bertall was recommending it as 'a little beach favoured by those who, for one reason or another, flee the splendours of the bathing place at Dieppe' (Bertall 1880, pp. 254–5). By 1896, when Monet returned there to paint, the place was 'transformed and sprinkled with magnificent villas' (Conty 1896, p. 131); Monet, on this later visit, found it spoiled.

On his first visit in 1882, Monet lodged with the local innkeeper, Paul Graff (known as *père* Paul) reporting that he was 'staying with some fine people who are very happy to have a lodger' (letter to Alice Hoschedé, 15 February 1882, in Wildenstein 1979, p. 214). Graff would doubtless have had few potential clients out of season, but he personally played a significant role in the development of Pourville. The 1876 Conty guide warmly recommended Graff's restaurant (Conty 1876, pp. 82 and 282), and twenty years later he was described as a 'celebrated chef who has done more for Pourville with his sauces and his *galette* than all the Parisian speculators'; he was also, by then, owner of the resort's small casino (Conty 1896, p. 131). In 1882, Monet painted a still-life of Graff's galettes, a type of cake that was a Normandy speciality, as well as portraits of Graff and his wife.

Monet's canvases of the Pourville area fall into three broad groups: views from the place itself, looking westwards along the beach and cliffs; views from other sites on the adjacent beaches (cats 55–57); and views over the sea from the neighbouring cliff tops (cats 58 and 59). *Sunset at Pourville* is one of the first group, and exceptional among the Pourville paintings in that it includes two small, fashionably dressed female figures; the canvas seems likely to derive from his second visit, during the holiday season, and the figures may be a response to the presence of Alice Hoschedé and her daughters during this stay. However, the main subject of the painting is not the figures, but rather their, and our, experience of the sunset seen from the beach. It is represented by a remarkable array of colour, ranging from

the intense oranges around the sun and in its reflections to the greens in the upper part of the sky, with soft blue and mauve enlivening the more subdued areas of the canvas.

55

CLAUDE MONET (1840–1926)
Rocks at Low Tide, 1882
Rochers à marée basse
Oil on canvas, 63 x 77 cm
Memorial Art Gallery of the University
of Rochester, New York.
Gift of Emily Sibley Watson
KEY REFERENCE: Wildenstein 1979, no.767

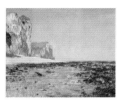

56

CLAUDE MONET (1840–1926)
*The Beach and Cliffs at Pourville,
Morning Effect*, 1882
*Plage et falaises de Pourville,
effet du matin*
Oil on canvas, 59 x 71 cm
Tokyo Fuji Art Museum, Tokyo
KEY REFERENCE: Wildenstein 1979, no. 787
(Exhibited in London and Washington only)

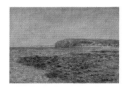

57

CLAUDE MONET (1840–1926)
Shadows on the Sea, Pourville, 1882
Ombres sur la mer, Pourville
Oil on canvas, 57 x 80 cm
Ny Carlsberg Glyptotek, Copenhagen
KEY REFERENCE: Wildenstein 1979, no. 792
(Exhibited in London and Washington only)

Many of the canvases Monet painted during his two spells working at Pourville in 1882 depict views from the wide beaches that extend for miles – to the east towards Dieppe, and to the west beneath the cliffs that are crowned by the church of Varengeville. Exploring the sands and the rocks that are exposed at low tide, Monet found a startling diversity of viewpoints that enabled him to create some of his most dramatic and unexpected pictorial compositions; in all of them, the viewer is positioned in ways that give a heightened sense of the immediacy of the scene.

In *Rocks at Low Tide* he placed himself far out across the beach, a little to the east of Pourville, and juxtaposed the distant cliffs with the fragmented forms of the rock shelves in the foreground (for a photograph of the site, see House 1986, p. 143). Thematically, this canvas is comparable with many pictures that appeared at the Salon in these years (see e.g. cat. 47) in its depiction of the open spaces of the beach with small figures collecting shellfish and tiny boats on the horizon. However, Monet differentiated his canvas from more conventional versions of the theme by the accentuated contrast of scale between foreground and background, and by the parade of calligraphic brushwork that conveys the energy of the waves breaking on the rocks.

Shadows on the Sea, Pourville views the coast from a position to the west of Pourville, including an indication of the little houses

of the village, but without any sign of its recent resort development; Dieppe itself lay beyond the central cliff mass, though the picture gives no sign of the town's presence. What gives the picture its distinctive character is the cast shadow of an unseen cliff across the foreground sea – part of the cliff mass seen in the background of *Rocks at Low Tide* – and the fact that there is no indication of the viewer's standpoint; we are presented with the wide expanse of open water that fills half of the picture, and are left to imagine that it is high tide, and that we are standing close beneath the massive cliff out of sight to our right.

The Beach and Cliffs of Pourville, Morning Effect places us directly below a cliff mass similar to that whose shadow we see in *Shadows on the Sea, Pourville*. Again our standpoint is insecure as we are placed on a zone of wet sand amid a scattering of broken rocks. The cliff towers above us, viewed at an angle that dramatises its height and its fragmented contours, accentuating the contrast between the rock faces and the stark horizontal of the rocky beach.

The asymmetry of *The Beach and Cliffs of Pourville, Morning Effect* and the contrasts of scale in *Rocks at Low Tide* testify to the lessons Monet had learned from Japanese landscape colour prints, of which he was an avid collector. He reapplied the lessons of their compositional conventions when formulating his own subjects on the beach, face to face with the natural subject.

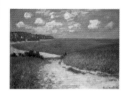

58

CLAUDE MONET (1840–1926)
Path in the Wheatfields, Pourville,
1882
Chemin dans les blés, Pourville
Oil on canvas, 58.2 x 78 cm
Collection of Frederic C. Hamilton
KEY REFERENCE: Wildenstein 1979, no. 753

59

CLAUDE MONET (1840–1926)
The Chemin de la Cavée, Pourville,
1882
Le Chemin de la Cavée, Pourville
Oil on canvas, 60.3 x 81.6 cm
Museum of Fine Arts, Boston.
Bequest of Mrs Susan Mason Loring
KEY REFERENCE: Wildenstein 1979, no. 762

These two canvases present the approach to the coast at Pourville in wholly different ways. Cat. 58 shows Pourville's long beach as seen from the road that leads there over the cliffs from Dieppe. It conveys the sense of discovery that can still be felt at the site, as the wide panorama of the beach and bay opens out in front of the traveller. In general terms it can be compared with Corot's view from the hills above Trouville from the 1830s (fig. 13, p. 23) and Monet's own panoramic view from above Trouville, painted the previous year (cat. 53). More immediately it evokes Monet's first discovery of Pourville in February 1882, as he left Dieppe, seeking a site to paint that was less developed (see cat. 54). However, the canvas cannot be an immediate response to this since the season depicted shows that it was executed on his return visit to Pourville the same summer.

By contrast, cat. 59 evokes a far more private, personal experience. On his painting trips away from home, Monet spent his first days at a new site prospecting for possible motifs. Before discovering the delights of Pourville in 1882, he wrote from Dieppe that he had 'gone through the whole area, followed every path that ends up beneath or on top of the cliffs' without finding suitable subjects to paint (letter to Alice Hoschedé, 7 February 1882, in Wildenstein 1979, p. 213). Cat. 59 can be seen as a celebration of the success of his explorations of the paths around Pourville; indeed, he painted the site three times. In contrast to the other canvases here, it does not depict the beach or the actual meeting point of sea and land, but the sandy path leading down towards the sea offers the anticipation of the wide expanses of the beach that will open out beyond the trees that flank the path.

Both canvases demonstrate the virtuosity and flexibility of Monet's technique. In cat. 58 the rapidly brushed clouds act as a keynote for the whole composition, suggesting the effects of a stiff breeze on this exposed point on the coastline. By contrast, the mood of cat. 59 is very still; here the keynote of the scene is the complex filigree weave of coloured touches that conveys the grasses and flowers on the banks that frame the path. A mesh of soft touches and more linear strokes, playing off warm against cool colours, coalesces in the viewer's eye to suggest the density and variety of the plants.

Both canvases were bought from Monet by the dealer Durand-Ruel soon after their execution.

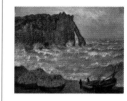

60

CLAUDE MONET (1840–1926)
Etretat, Rough Sea, 1883
Etretat, mer agitée
Oil on canvas, 81 x 100 cm
Musée des Beaux-Arts, Lyons
KEY REFERENCE: Wildenstein 1979, no. 821
(Exhibited in Washington only)

Monet had visited Etretat on a number of occasions during the 1860s, making the trip from his family home in nearby Le Havre. In winter 1868/69 he rented a house there, and first tackled the theme of stormy waves beating against the spectacular rock arches (fig. 43), a few months before Courbet in turn visited the place to paint (see cats 25 and 26). Returning early in 1883, Monet consciously saw himself as walking and painting in Courbet's footsteps, in the aftermath of Courbet's posthumous retrospective exhibition at the Ecole des Beaux-Arts in Paris in 1882. Soon after arriving, he wrote of his plans: 'I'm intending to do a big painting of the Etretat cliff, although it would be very audacious of me to do this after Courbet who did it admirably, but I shall try to do it differently' (letter to Alice Hoschedé, 1 February 1883, in Wildenstein 1979, p. 223). In the event he did not realise his initial plan to execute a large canvas in his studio based on studies made on the spot, but his paintings of Etretat were clearly a response to the challenge posed by Courbet, especially those depicting the Porte d'Aval and the Needle – subject of Courbet's most celebrated Etretat canvas, *The Cliff of Etretat after the Storm* from the 1870 Salon (fig. 36), and of cat. 25.

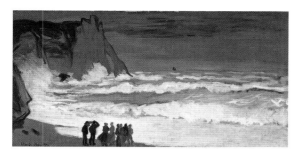

Fig. 43 Claude Monet, *Stormy Sea at Etretat*, 1868/9.
Oil on canvas, 66 x 131 cm. Musée d'Orsay, Paris (RF 1678)

Etretat, Rough Sea is the most ambitious and resolved of the canvases that are an obvious response to the challenge of Courbet's paintings. It views the cliffs from approximately the same angle as *The Cliff of Etretat after the Storm* and, like Courbet's painting, includes beached boats, emphasising the human dimension of the contrast between land and sea. In a sense Monet's picture, with its pounding waves, is a synthesis of this and Courbet's other 1870 Salon exhibit, *Stormy Sea* (fig. 37). The differences, which mattered so much to Monet, are also very evident. Whereas Courbet's cliffs give a vivid sense of the materiality of the rock, Monet emphasises pattern and texture, suggested by vigorous horizontal brushstrokes; and Monet's sea, quite unlike Courbet's palette-knife work, is conveyed by a virtuoso weave of cursive strokes that coalesce to evoke the dynamic shoreward movement of the successive bands of waves. Beyond this, despite the overcast weather and the relatively subdued palette of this particular canvas, Monet's forms are constantly variegated by subtle shifts of colour, which set up sequences of relationships and contrasts that run through the whole canvas.

Etretat, Rough Sea was presumably executed from a window in the Hôtel Blanquet, at the centre of Etretat's seafront, which allowed Monet to paint in hostile weather conditions (see also cat. 63).

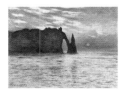

61
CLAUDE MONET (1840–1926)
The Cliff at Etretat, Sunset, 1883
La Falaise à Etretat, coucher de soleil
Oil on canvas, 60.5 x 81.8 cm
North Carolina Museum of Art, Raleigh, NC
KEY REFERENCE: Wildenstein 1979, no. 817
(Exhibited in Hartford only)

62
CLAUDE MONET (1840–1926)
Etretat, Rainy Weather, 1885
Etretat, la pluie
Oil on canvas, 60.5 x 73.5 cm
The National Museum of Art,
Architecture and Design, Oslo
KEY REFERENCE: Wildenstein 1979, no. 1044
(Exhibited in London only)

During his 1883 visit, Monet viewed the bay, and the Porte d'Aval, from many angles; for *The Cliff at Etretat, Sunset* his viewpoint was further to the northeast along the shore than in cat. 60, away from the Falaise d'Aval, so that the Needle, situated beyond the arch, can be clearly seen (compare Jongkind, cat. 7, and Courbet, cat. 25). In a sense, the canvas marks a return to previous preoccupations; richly coloured effects of sunrise and sunset had been one of Monet's trademarks since *Impression, Sunrise* (Musée Marmottan, Paris) was included in the first Impressionist group exhibition in Paris in 1874. However, the silhouette of the rock gives the theme quite different impact; despite the serenity of this particular sunset, the dramatic rock forms are an insistent reminder of the force of the sea that shaped them.

Painted on Monet's return visit to Etretat in the autumn of 1885, *Etretat, Rainy Weather* views the bay from a similar angle to *The Cliff at Etretat, Sunset*. It is rapidly worked and was not brought to the same degree of finish; the broad sweeps of paint effectively suggest the blurring of a landscape viewed through sheets of rain. This was a canvas in which Monet took great pride; he exhibited it at the gallery of the dealer Georges Petit in spring 1886 with the title *Temps de pluie (impression)*, thus linking it with the celebrated *Impression, Sunrise*, and presenting it as one of the sequence of canvases in which he was seeking to capture the most fleeting natural effects, as a display of his painterly virtuosity (see House 1986, p. 162).

The novelist Guy de Maupassant described Monet at work on this canvas:

> Last year, I often followed Claude Monet in pursuit of impressions. ... The painter, face to face with his subject, lay in wait for the sunlight and the shadows, grasped in a few strokes of the brush the falling ray or the passing cloud. ... I saw him grasp the dazzling light falling on the white cliff. ... On another occasion, he grasped with his open hands a rain shower falling on the sea, and threw it onto his canvas. And it was indeed the rain that he had painted, nothing but the rain veiling the waves, the rocks and the sky, scarcely visible through the deluge.
> (Maupassant 1886, in Riout 1989, pp. 375–6)

Doubt is cast on the literal accuracy of this account in a letter from Monet to Alice Hoschedé, describing Maupassant's visit to see his pictures in his hotel room: 'He claims that he really likes them, but I'm not convinced that he understands much about them. However, he didn't pick out the least good things, the rain effect absolutely amazed him' (letter to Alice Hoschedé, 31 October 1885, in Wildenstein 1979, p. 264); there is no mention in Monet's letters of Maupassant following in his tracks out of doors.

Etretat, Rainy Weather was the first canvas by Monet to be purchased by any museum; it was bought from the dealer Boussod & Valadon (managed at that date by Theo van Gogh) by the museum in Christiania (Oslo) in 1890. It seems likely that Monet added the incorrect date '1886' to the canvas on the occasion of this sale, or perhaps during his visit to Oslo in 1895.

63
CLAUDE MONET (1840–1926)
Boats on the Beach, Etretat, 1885
Bateaux sur la plage d'Etretat
Oil on canvas, 65.5 x 81.3 cm
The Art Institute of Chicago.
Charles H. and Mary F. S. Worcester
Collection, 1947.95
KEY REFERENCE: Wildenstein 1979, no. 1024

Monet stayed in Etretat from early October to mid-December 1885, timing his arrival to coincide with the departure of the summer holidaymakers. A journalist described him at work there:

> The true lovers of the sea who, when the Parisians have long since packed their bags, remain in deserted Etretat to see the equinoctial tides battering against the cliff, will tell you that, on the November mornings when the sea-spray was thicker than a rain shower, they saw Claude Monet on the beach, water streaming down under his cape, painting the tempest while spattered with salt water. (Le Roux 1889)

During this visit, alongside his canvases of the cliffs and rocks (e.g. cat. 62), Monet focused on the activities of the fishermen and the comings and goings of their boats in all weather conditions. Late in November he undertook a pair of paintings of the fishing boats seen from his window in the Hôtel Blanquet (see letters to Alice Hoschedé, 24 and 25 November 1885, in Wildenstein 1979, p. 268). In both canvases, we look across the former fishing boats that had been thatched and converted into storage spaces; in cat. 63, four fishing boats are poised at the edge of the stormy sea, while in *The Departure of the Fleet, Etretat* (fig. 44) the fishing fleet is out at sea in calm conditions (for a contemporary photograph of the beach, see Herbert 1994, p. 104). Monet's letters record his frustration when the changing weather led to the boats being moved from the position in which he had begun to paint them. *Boats on the Beach,*

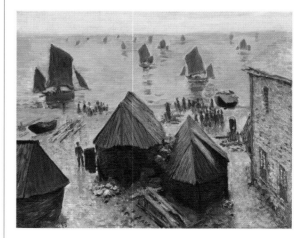

Fig. 44 Claude Monet, *The Departure of the Fleet, Etretat*, 1885.
Oil on canvas, 73 x 92 cm. Art Institute of Chicago

Etretat bears witness to these problems; the original positions of the masts of three of the boats can be clearly seen beneath the rapid reworking of the canvas. The fact that they were originally placed close to their final positions might indicate that Monet erased them when the boats unexpectedly went out to sea, and replaced them on their return.

This theme marked a return to a very traditional vision of the coast as a site of elemental conflict and the arena for the bravery of the fishermen and the dangers they faced (see Huet, fig. 7, p. 21). Moreover, this specific scene was part of the stock imagery of Etretat. Guidebooks repeatedly described the difficulties of fishing from here, where the boats needed to be hauled up the steep shingle beach since there was no natural harbour, and the thatched boats figured in many accounts and engravings of the place. However, *Boats on the Beach, Etretat* transforms its subject through its technique. Monet's bravura brushwork can be linked to the dramatic, animated paint handling of 'romantic' seascapes such as those of Paul Huet, but in *Boats on the Beach, Etretat* he cultivated a deliberate roughness and impromptu quality in his touch in order to convey with as much immediacy as possible the effects of the wild weather. *The Departure of the Fleet, Etretat*, the calm-weather pair to *Boats on the Beach, Etretat*, is far more delicately handled.

64
PIERRE AUGUSTE RENOIR
(1841–1919)
By the Seashore, 1883
Au bord de la mer
Oil on canvas, 92.1 x 72.4 cm
The Metropolitan Museum of Art, New York.
H. O. Havemeyer Collection. Bequest of Mrs
H. O. Havemeyer, 1929 (29.100.125)
KEY REFERENCE: Daulte 1971, no. 448

By the Seashore is evidently a synthesis of a figure posed in the studio and a landscape background based on study of an actual site. In this sense it is comparable to *Sailor Boy (Portrait of Robert Nunès)* (fig. 47), the background of which is based on cat. 65. However, there are two crucial differences between these two examples. First, in *By the Seashore* there is little or no attempt to create a credible spatial relationship between figure and background; we cannot tell where the figure is sitting, and there is no indication of her immediate surroundings – the view beyond the young woman acts merely as a backdrop. Secondly, the figure is not a portrait, but rather a generic type, though presumably it was studied from a live model.

The background bears some resemblance to a cliff scene Renoir had painted in 1879 while staying with his friend Paul Berard at Wargemont, to the east of Dieppe (fig. 45), and it is possible that, four years later, this canvas acted as documentation for the present picture; if this identification is correct, the distant sunlit cliffs represent the coastline to the west of Dieppe that Monet depicted, from closer to, in *Rocks at Low Tide* (cat. 55).

There is also a marked disjunction in treatment between foreground and background. The landscape is treated quite broadly and softly, with fluent coloured touches that blend into each other

Fig. 45 Pierre Auguste Renoir, *The Coast near Dieppe*, 1879.
Oil on canvas, 50 x 60 cm (Sotheby's sale, London, 3 May 1967, lot 65)

and do not define the forms depicted with any precision. By contrast, the figure and chair are more clearly defined. The figure's knitting, scarf and hat are treated with considerable delicacy, and her face, the focus of the picture, is smoothly modelled and stands out sharply from the loose brushwork beyond. The treatment of the face, in particular, is an early sign of the so-called crisis that Renoir underwent during the 1880s, when he returned to taut draughtsmanship and hard-edged modelling as a result of dissatisfaction with the looseness of his Impressionist paint handling. Here, though, there is no sign of this reaction in the treatment of the background; the two parts of the picture demand to be viewed in very different ways.

Since the canvas cannot be viewed in naturalistic terms, as an immediate response to the sight of a figure by the sea, we must ask what this figure, in this setting, might signify. Her fashionable clothes, relaxed pose and leisurely pursuit suggest that she should be viewed as the typical young female holidaymaker, with the coast behind her acting as a sort of attribute that defines the sphere of her activities.

By the Seashore is very probably the canvas that Renoir sold to the dealer Paul Durand-Ruel in January 1884 with the title *Young Woman Knitting by the Sea*.

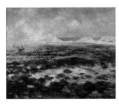

65
PIERRE AUGUSTE RENOIR
(1841–1919)
Low Tide, Yport, 1883
Marée basse, Yport
Oil on canvas, 54 x 65 cm
Sterling and Francine Clark Art Institute,
Williamstown, Massachusetts

Renoir visited Yport, a small town just to the west of Fécamp, during the summer of 1883. *Low Tide, Yport*, for many years identified as a view of Guernsey (see cat. 66), can be firmly identified as the view looking eastwards from Yport towards Fécamp (see fig. 46).

Fig. 46 The beach at Yport, photograph, 2005

The guidebooks of the period regularly denigrated Yport for its rocky and unpleasant beach (e.g. Conty 1877, p. 103), but its cliffs were highly praised. In 1866, d'Auriac described the view Renoir chose: 'To the right the cliffs and waves extend as far as the eye can see; … the whole scene forms a picture that is gracious, imposing and full of poetry' (Auriac 1866, p. 165). As late as 1887, Yport could still be recommended to painters: 'The outsiders who live in Yport, the painters who like to paint the many varied aspects of the bay of Fécamp, who find so many interesting motifs in the comings and goings of the fishermen and their boats, … praise the solitude of their retreat, and the beautiful appearance of the sea and the cliffs' (Joanne 1887, p. 144).

Renoir's canvas takes some note of the activities of the local fisherfolk, with the small boat and the summary indications of figures out on the rocks, but its primary focus is the rocks themselves, together with the sunlit panorama of the bay beyond. Although the motif is comparable to Monet's *Rocks at Low Tide* of 1882 (cat. 55), Renoir is far less concerned than Monet with finding distinctive types of brush mark to suggest the varied textures of the scene in front of him. Instead, the rocks and foreground sea alike are treated in relatively homogeneous, loosely parallel strokes running from upper

Fig. 47 Pierre Auguste Renoir,
*Sailor Boy (Portrait of
Robert Nunès)*, 1883.
Oil on canvas, 130.2 x 80 cm.
Barnes Foundation, Merion,
Pennsylvania

left to lower right; the rocks are indicated by tone and colour, rather than by texture, and enlivened by dappled patches of sunlight. Although the tonal contrasts in the foreground differentiate it clearly from the uniformly high-key tonality of the background, the continuation of the parallel brushstrokes through most of the sky lends an overall unity to the whole image.

This means of unifying a canvas through the direction of the brushstrokes can be compared with the system of parallel hatching (generally from lower left to upper right) that Cézanne was evolving in these years; over the next couple of years, Renoir's treatment of his landscape subjects became tighter and dryer, and seemingly more closely indebted to Cézanne's example (see cat. 67).

The present canvas is a fully finished picture, signed and dated; it is presumably the canvas Renoir sold to the dealer Durand-Ruel in December 1883 with the title *Low Tide, Yport*, but he also used it as the basis for the landscape in the background of the ambitious, commissioned portrait *Sailor Boy (Portrait of Robert Nunès)* (fig. 47).

66
PIERRE AUGUSTE RENOIR (1841–1919)
Children on the Seashore, Guernsey,
c. 1883
Enfants au bord de la mer à Guernesey
Oil on canvas, 91.4 x 66.4 cm
Museum of Fine Arts, Boston.
Bequest of John T. Spaulding
KEY REFERENCE: Daulte 1971, no. 451

In the late summer of 1883, Renoir spent about a month on the island of Guernsey, in the English Channel off the west coast of the Cotentin peninsula in northwestern Normandy. The rocks and background in *Children on the Seashore, Guernsey* are evidently based on the landscape of Moulin Huet Bay on Guernsey where Renoir painted most of his subjects when on the island. This bay, 3 kilometres south of the island's capital, St Peter Port, where Renoir was lodging, was widely considered to be the island's most beautiful natural site (see House 1988, pp. 5–6).

Writing of the scenes he witnessed on the beach on Guernsey, Renoir described the mood that he found there: 'Nothing is more attractive than the mixture of men and women crowded on these rocks. One would think oneself in a landscape by Watteau rather than in the real world,' and compared the experience of seeing women changing their clothes amid the rocks with ancient Athens (letter to Paul Durand-Ruel, 27 September 1883, in Venturi 1939, 1, pp. 125–6). It was this carefree and seemingly timeless mood that he tried to re-create in *Children on the Seashore* using the figures of girls and children on the beach to evoke notions of innocent pleasure.

However, in the same letter he wrote that he was painting 'documents for making pictures in Paris', and it is unlikely that the picture itself was painted on the island. The forms of the landscape are somewhat generalised, and the disjunction between figures and background (compare cat. 64), combined with the inexplicit lighting on the main figures, strongly suggest that the picture was executed in the studio. This marks Renoir's realisation that open-air painting was impracticable as a means of executing the ambitious figure

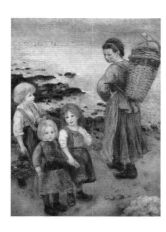

Fig. 48 Pierre Auguste Renoir, *Mussel Fishers at Berneval*, 1879. Oil on canvas, 175.3 x 130.2 cm. Barnes Foundation, Merion, Pennsylvania

subjects to which he was directing his attention in these years.

Renoir did not, though, succeed in transforming this subject into a finished composition. We do not know whether the present picture was conceived as a study for a larger and more ambitious one, such as *Mussel Fishers at Berneval* (fig. 48), shown at the 1880 Salon and based on studies made on the coast in 1879, or whether it is itself the beginnings of the planned figure subject. Its sketchy handling and the unresolved forms in parts of the picture, such as the legs of the girl on the right, show that it never reached completion; it remained in Renoir's studio until his death. A second version of the subject, in a horizontal format and with the figures seen from a greater distance, also remained unfinished at his death (fig. 49).

Beneath much of the present composition, colours can be made out which bear no relationship to the final picture; this is very visible in the red behind the head of the principal figure; Renoir was very probably reusing a discarded canvas.

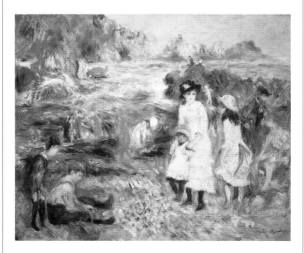

Fig. 49 Pierre Auguste Renoir, *Beach Scene, Guernsey*, 1883. Oil on canvas, 54 x 65 cm. Barnes Foundation, Merion, Pennsylvania

67
PIERRE AUGUSTE RENOIR
(1841–1919)
Sea and Cliffs, c. 1884/85
Mer et falaises
Oil on canvas, 51.4 x 63.5 cm
The Metropolitan Museum of Art, New York.
Robert Lehman Collection, 1975
(1975.1.200)
KEY REFERENCE: Vollard 1989, no. 1311
(Exhibited in Washington and Hartford only)

Little is known about *Sea and Cliffs*. It seems likely to represent the coast at Puys, just to the east of Dieppe, close to the house of Renoir's friend and patron Paul Berard at Wargemont (compare Guillemet, cat. 45, which views the coast at Puys from further to the west and nearer to Dieppe). Its date, too, is uncertain. However, its technique strongly suggests a date in the mid-1880s; presumably it was painted during Renoir's stay with Berard in summer 1884 or, perhaps more likely, during his return visit in autumn 1885.

Compared with *Low Tide, Yport*, painted in 1883 (cat. 65), *Sea and Cliffs* is more tightly and dryly executed with every zone – sky, cliffs, water and beach – treated with distinct, straight paint-strokes, generally running parallel to each other; in the sea, especially, the brushwork makes it hard to see the water surface as a horizontal plane. By contrast, the buildings seen at the far-right margin are delineated with some precision. The resulting effect is a wholesale rejection of the fluency of touch of Renoir's art of the 1870s. The beginnings of this tighter handling can be see in *Low Tide, Yport*, but there the whole canvas is still integrated into a harmonic unity by touch as well as by colour. Here, by contrast, the individual zones and forms stand out from each other. The use of sequences of parallel brushstrokes has clear parallels with Cézanne's work in these years, but the staccato effect that results in *Sea and Cliffs* is quite unlike the coherence of Cézanne's canvases.

The colour of the picture creates a greater sense of overall integration, with the orange hues of the cliff reflected in the water and echoed in the sky, and the blues of the sky and water picked up on the cliff. However, again in contrast to *Low Tide, Yport*, Renoir interrupted this by introducing the deep greens that suggest the grassy cliff top; these sharp accents act as tonal as well as colouristic contrasts, and prevent the eye from passing seamlessly from cliff face to sky.

Nothing is known of the early history of the picture. It is unsigned, but was, it seems, sold by Renoir, since it appears in Ambroise Vollard's volume of photographs of his work, published in 1918, and was not part of the contents of Renoir's studio at his death.

68
PAUL GAUGUIN (1848–1903)
The Beach, Dieppe, 1885
La Plage, Dieppe
Oil on canvas, 71.5 x 71.5 cm
Ny Carlsberg Glyptotek, Copenhagen
KEY REFERENCE: Wildenstein 2001,
no. 178
(Exhibited in London and Washington only)

Gauguin spent three months at Dieppe between July and early October 1885, but seems to have had little contact with the other painters who were there at the time. He wrote to Camille Pissarro that he had had a chance meeting with Degas, and that Degas had subsequently avoided seeing him when Gauguin called on him (letter to Pissarro, 2 October 1885, in Merlhès 1984, p. 113).

The Beach, Dieppe presents a highly unusual vision of the beach within the context of the art of the period. All of the motifs it includes are familiar – the juxtaposition of a white-sailed yacht with dark-sailed fishing boats, the nets hanging on posts in the shallows, the bathing women and boys, and the figures seated on the beach. But the tone of the canvas and the treatment of these elements are quite unlike the work of other artists. Despite the breaking waves, the effect depicted seems very still, with none of the dynamism that Monet brought to his treatment of comparable subjects. Comparable pyramidal shapes are repeated across the canvas – the boats, the nets on their posts, the figures on the beach – and the repetitive delicately flecked brushwork gives the whole canvas a surface coherence that works against the diversity of the motifs depicted. The square format of the canvas – most unusual for a landscape scene – further heightens the static quality of the picture. Moreover, the poses of the women on the beach have none of the elegance that Boudin sought in his depictions of female figures at Trouville; these seem to be local figures, concentrating on their sewing, rather than fashionable bourgeois holidaymakers.

Shortly before his stay in Dieppe, Gauguin wrote to Pissarro describing the technique in his recent works in terms that show that he was deliberately rejecting the technical bravura of painters such as Monet:

> I envisaged a very mat technique without evident contrasts, and I am not bothered about its dull tone, since I felt that this was necessary for me; ... since my art is more concerned with reflection than with developing my technical skill, I needed a starting point opposed to what I detest in painters who seek dramatic visual effects. ... More and more I am convinced that art should not be exaggerated and that there is no salvation in the extreme.
> (Letter to Pissarro, late May 1885, in Merlhès 1984, p. 107).

Declarations such as these were part of a larger realignment in his art and aesthetic, as he developed his ideas of 'synthesis' as a deliberate repudiation of the Impressionists' preoccupation with the immediate visual sensation.

It was very probably this canvas that was exhibited in the eighth and final Impressionist group exhibition in 1886 with the title *Les Baigneuses* (see Copenhagen 2005, p. 264 and note 6 on pp. 354–5). At this exhibition, Gauguin's paintings were little noticed, and were thoroughly upstaged by the attention paid to the work of Georges Seurat, notably his *Sunday on the Ile de la Grande-Jatte* (Art Institute of Chicago). Jean Ajalbert's verdict was particularly severe: 'The monotony of his subjects, treated with a hesitant technique, betray a sad indecisiveness. Our wish not to give any favours because of friendship makes us more severe than we should wish; for some of his canvases show good qualities and a latent force' (reprinted in Berson 1996, 1, p. 432).

69
MARY CASSATT (1844–1926)
Children at the Seashore, 1885
Enfants sur la plage
Oil on canvas, 97.5 x 73.7 cm
National Gallery of Art, Washington.
Ailsa Mellon Bruce Collection, 1970.17.19
KEY REFERENCE: Breeskin 1970, no. 131

Little is known about Mary Cassatt's trip to the coast in 1885, the result of 'a bad case of bronchitis' (Matthews 1994, p. 172), and *Children at the Seashore* is the only canvas that resulted from it. However, she valued the picture highly enough to include it among her exhibits at the eighth and final Impressionist group exhibition in Paris in 1886, where it received a number of revealing and perceptive reviews that highlighted her awareness of the distinctive quality of children's experience of the beach.

Paul Adam admired the finesse of the draughtsmanship but found the colour unsatisfactory (reprinted in Berson 1996, 1, p. 429). Other critics, though, felt that Cassatt had successfully captured the quality of coastal light and the effects of the sun on the children's flesh. Gustave Geffroy commented: 'The *Children at the Seashore* display the crisp contours that people and things assume on the sand, against the background of sea and sky; their short arms and rosy-cheeked faces display their flesh beneath a thick covering of sunburn' (reprinted in Berson 1996, 1, p. 451). Maurice Hermel praised the 'naturalness and truthfulness' of the figures, and noted: 'Their cheeks, their plump arms, their chubby legs have a pretty sunburnt colour, with the firm, fine texture of nectarines; these are real babies who play in the sand with conviction' (reprinted in Berson 1996, 1, p. 456). The comments about sunburn are especially interesting in the context here, since in the nineteenth century fashionable women carefully avoided exposing their skin to direct sunlight; sunburnt flesh marked a figure out as a peasant, forced to work under the sun. The sunburn on Cassatt's children was a marker of their childish unselfconsciousness. Jean Ajalbert noted a different form of childish unawareness: 'Two chubby babies digging holes in the sand that are soon filled with water; two babies with cherry-red cheeks (*joues de confitures*), concentrating on their play and inattentive to the booming waves' (reprinted in Berson 1996, 1, p. 432).

Uninterested in the spectacle of the ocean and unconcerned with the effects of the sun, Cassatt's bourgeois children, absorbed in their task, mimic the position of the peasant workers on the beach or in the fields. Their poses carry an echo of the stock imagery of resting fieldworkers so popular at the Salon, and the posture of the foreground figure is a witty reprise of the female figure in Jules Bastien-Lepage's celebrated *Haymaking* (Musée d'Orsay, Paris), exhibited at the 1878 Salon and thereafter on display in the Musée du Luxembourg in Paris.

EUGÈNE LOUIS BOUDIN, detail of cat. 14

Overleaf: PIERRE AUGUSTE RENOIR, detail of cat. 65

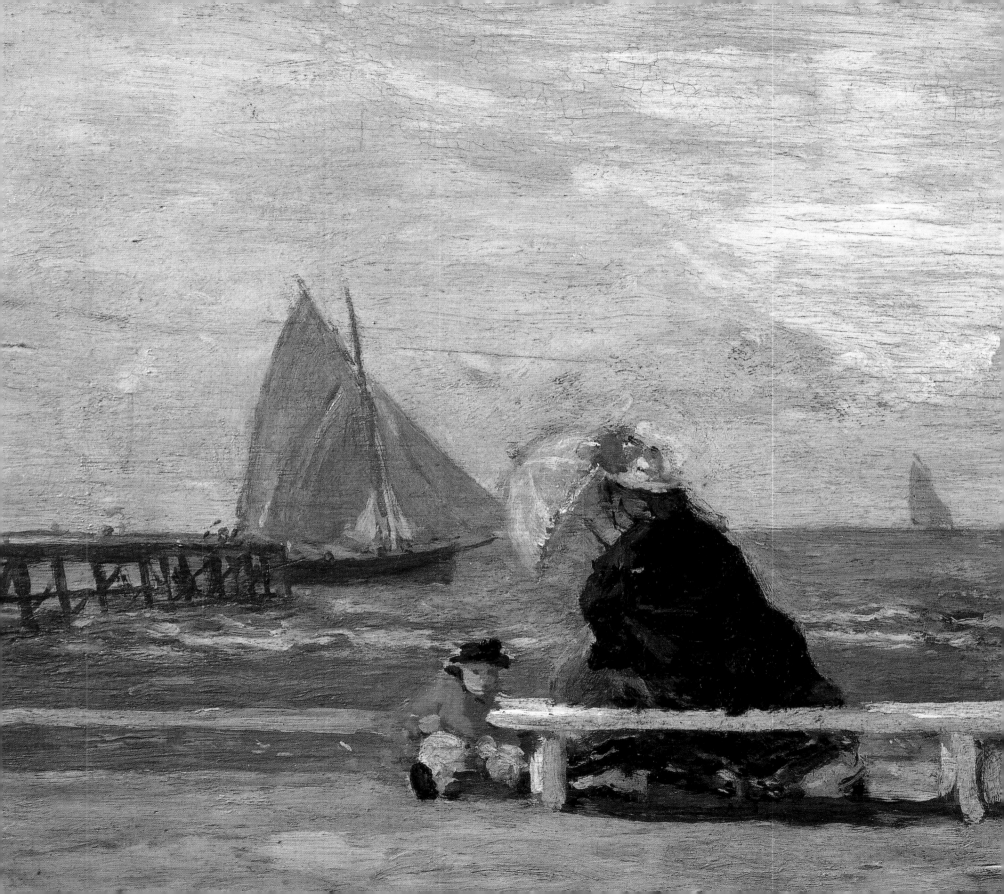

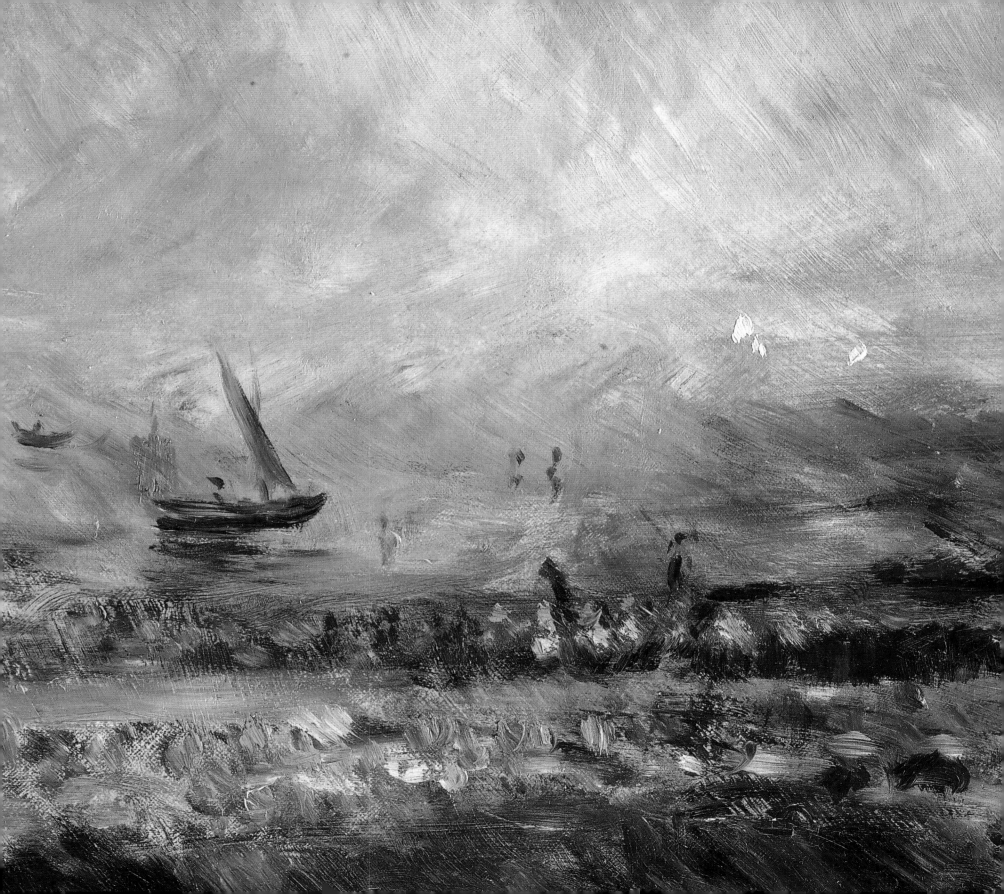

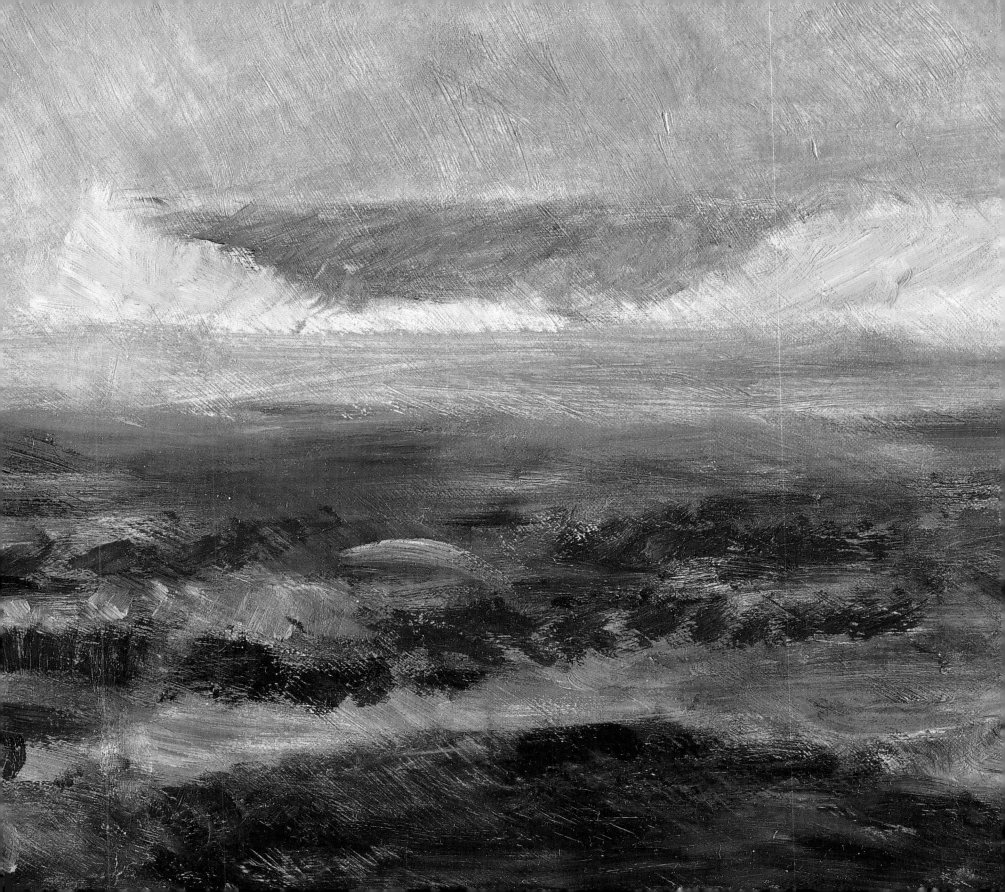

Chronology

1847
Railway line from Paris to Le Havre completed

1848
February: Revolution, overthrow of
King Louis Philippe

Railway line from Paris to Dieppe completed

December: Election of Louis Napoleon
(nephew of Napoleon I) as president

1850–51
Jongkind painting on the Normandy coast

1851
December: Louis Napoleon seizes power
in coup d'état

1852
December: Louis Napoleon declares himself Emperor
Napoleon III, and institutes the Second Empire

1855
Exposition Universelle in Paris

Railway line from Paris to Lisieux and Caen
completed

1860
Beginning of construction of resort at Deauville

1861
Whistler working in Brittany, at Perros-Guirec

Publication of Jules Michelet, *La Mer*

1862
Jongkind painting at Sainte-Adresse; meets Monet

Boudin paints his first fashionable beach scenes at
Trouville

1863
Opening of Trouville–Deauville railway station,
on branch line from Lisieux

1864
Boudin exhibits Trouville beach scenes for the first
time at the Salon

Monet painting at Sainte-Adresse

1865
Monet's first beach scenes shown at the Paris Salon
(see fig. 32)

Late summer: Jules Breton's first visit to Brittany,
to Douarnenez

Autumn: Courbet and Whistler painting together
at Trouville

1866
Publication of Victor Hugo, *Les Travailleurs
de la mer*

Early autumn: Courbet painting at Deauville

1867
Exposition Universelle in Paris

Courbet includes a group of *paysages de mer*
at his one-artist exhibition in Paris

Summer: Monet painting at Sainte-Adresse

1868
Summer: Manet painting at Boulogne

Winter 1868–69: Monet living and painting
at Etretat

1869
Late summer: Courbet painting at Etretat

1870
Courbet exhibits two Etretat seascapes at the Salon
(figs 36 and 37)

Summer: Monet painting at Trouville

July: Outbreak of Franco-Prussian War

September: Fall of Napoleon III;
creation of Third Republic

1871
January: Fall of Paris to Prussians

March–May: Paris Commune

1872
September: Corot painting at Etretat

1873
May: MacMahon becomes President,
and institutes 'moral order' regime

July: Manet painting at Berck-sur-Mer

1874
April–May: First Impressionist group exhibition

1877
December: Death of Courbet, in exile in
Switzerland

1878
Exposition Universelle in Paris

1879
January: Fall of MacMahon's 'moral order' government

Summer: Renoir's first visit to Wargemont,
near Dieppe, home of his patron Paul Berard;
visits him regularly until 1885

1880
Monet returns to the coast, paints briefly
at Les Petites Dalles

Caillebotte painting at Villers

1881
March: Monet painting at Fécamp

Late summer: Monet briefly painting at Trouville

1882
February–April: Monet painting at Pourville

May: Courbet retrospective exhibition
at the Ecole des Beaux-Arts

June–October: Monet painting at Pourville

1883
January–February: Monet painting at Etretat

January–March: Durand-Ruel mounts one-artist
shows of Boudin, Renoir and Monet

April: Death of Manet; Monet moves his base to
Giverny

Summer: Renoir painting at Yport

September–October: Renoir painting on Guernsey

1884
January: Manet retrospective exhibition
at the Ecole des Beaux-Arts

1885
July–October: Gauguin painting at Dieppe

October–December: Monet painting at Etretat

1886
Spring: Eighth and last Impressionist group exhibition

Bibliography

Arras 2002
Annette Bourrut Lacouture, *Jules Breton: La Chanson des blés*, exh. cat., Musée des Beaux-Arts, Arras, 2002.

Aubert 1883
Ch. F. Aubert (Valentine Vattier d'Ambroyse), *Le Littoral de la France*, 1: 'De Dunkerque au Mont-Saint-Michel', Paris, [1883].

Aubrun 1974
Marie-Madeleine Aubrun, *Jules Dupré: Catalogue raisonné de l'oeuvre*, Paris, 1974.

Aubrun 1980
Marie-Madeleine Aubrun, *Jules Dupré: Catalogue raisonné de l'oeuvre: supplément*, Nantes, [1980].

Auriac 1866
Eugène d'Auriac, *Guide pratique, historique et descriptif aux bains de mer de la Manche et de l'Océan*, Paris, 1866.

Berhaut 1994
Marie Berhaut, *Gustave Caillebotte: catalogue raisonné des peintures et pastels*, new edition, Paris, 1994.

Berson 1996
Ruth Berson (ed.), *The New Painting: Impressionism 1874–1886, Documentation*, San Francisco and Seattle, 2 vols, 1996.

Bertall 1876
Bertall (Albert d'Arnoux), *La Vie hors de chez soi*, Paris, 1876.

Bertall 1880
Bertall (Albert d'Arnoux), *Les Plages de France*, Paris, [1880].

Blackburn 1869
Henry Blackburn, *Normandy Picturesque*, London, 1869.

Blackburn 1880
Henry Blackburn and Randolph Caldecott, *Breton Folk: An Artistic Tour in Brittany*, London, 1880.

Boston 1984
Alexandra R. Murphy, *Jean-François Millet*, exh. cat., Museum of Fine Arts, Boston, 1984.

Bourrut Lacouture 1987
Annette Bourrut Lacouture, 'Jules Breton; Une Source au bord de la mer', in Denise Delouche (ed.), *Arts de l'Ouest: Bretagne: Images et mythes*, Rennes, 1987.

Breeskin 1970
Adelyn Dohme Breeskin, *Mary Cassatt: A Catalogue Raisonné of the Oils, Pastels, Watercolors, and Drawings*, Washington DC, 1970.

Breton 1890
Jules Breton, *La Vie d'un artiste*, Paris, 1890.

Bruce-Gardner 1987
Robert Bruce-Gardner, Gerry Hedley and Caroline Villers, 'Impressions of Change', in *Impressionist and Post-Impressionist Masterpieces: The Courtauld Collection*, exh. cat., International Exhibitions Foundation, Washington DC, 1987–88.

Buzard 1993
James Buzard, *The Beaten Track: European Tourism, Literature, and the Ways to Culture, 1800–1918*, Oxford, 1993.

Cabantous 1993
Alain Cabantous, *Les Côtes barbares: Pilleurs d'épaves et sociétés littorales en France 1680–1830*, Paris, 1993.

Cabantous and Hildesheimer 1987
Alain Cabantous and Françoise Hildesheimer (eds), *Foi chrétienne et milieux maritimes (XVᵉ–XXᵉ siècles)*, Paris, 1987.

Caen 1994
Alain Tapié, *Désir de rivage de Granville à Dieppe: Le Littoral normand vu par les peintres entre 1820 et 1945*, exh. cat., Musée des Beaux-Arts, Caen, 1994.

Cahen 1900
Gustave Cahen, *Eugène Boudin: sa vie et son oeuvre*, Paris, 1900.

Cassell 1870
Cassell's Topographical Guides, *Normandy: Its History, Antiquities and Topography*, London, n.d. [1870].

Castagnary 1861
Jules Castagnary, *Les Artistes au XIXᵉ siècle: Salon de 1861*, Paris, 1861.

Castagnary 1892
Jules Castagnary, *Salons (1857–1879)*, 2 vols, Paris, 1892.

Chappé 1990
François Chappé, *L'Epopée islandaise, 1880–1914. Paimpol, la République et la mer*, Thonon-les-Bains, 1990.

Chapus 1862
Eugène Chapus, *De Paris à Rouen et au Havre*, Paris, 1855; Paris, 1862.

Chesneau 1864
Ernest Chesneau, *L'Art et les artistes modernes en France et en Angleterre*, Paris, 1864.

Chesneau 1868
Ernest Chesneau, *Les Nations rivales dans l'art*, Paris, 1868.

Chicago 1995
Anne Distel and others, *Gustave Caillebotte: Urban Impressionist*, exh. cat., Art Institute of Chicago, Los Angeles County Museum of Art, 1995.

Chicago 2003
Juliet Wilson-Bareau, David Degener and others, *Manet and the Sea*, exh. cat., Art Institute of Chicago, Philadelphia Museum of Art, Van Gogh Museum, Amsterdam, 2003–04.

Chu 1992
Petra ten-Doesschate Chu (ed.), *Letters of Gustave Courbet*, Chicago and London, 1992.

Conty 1876
H. A. de Conty, *Guide Conty: Les Côtes de Normandie*, third edition, Paris, 1876.

Conty 1877
H. A. de Conty, *Guide Conty: Les Côtes de Bretagne*, second edition, Paris, 1877.

Conty 1896
H. A. de Conty, *Guide Conty: Les Côtes de Normandie*, new edition, Paris, 1896.

Conway 1867
Moncure D. Conway, 'Trouville: A New French Paradise', *Harper's New Monthly Magazine*, 36 (1867), pp. 25–30.

Copenhagen 2005
Richard R. Brettell and Anne-Birgitte Fonsmark, *Gauguin and Impressionism*, exh. cat., Ordrupgaard, Copenhagen, and Kimbell Art Museum, Fort Worth, 2005–06.

Corbin 1995
Alain Corbin, *Le Territoire du vide*, Paris, 1988; *The Lure of the Sea: The Discovery of the Seaside in the Western World, 1750–1840*, London, 1995.

Culler 1988
Jonathan Culler, 'The Semiotics of Tourism', in *Framing the Sign: Criticism and Its Institutions*, Oxford, 1988.

Cuny 1904
Henri Cuny, *Essai sur les conditions des marins-pêcheurs*, Thèse pour le doctorat en droit, Université de Rennes, Paris, 1904.

Darrieus 1990
Henri Darrieus, *L'oeuf des mers: Histoire de la Société des oeuvres de mer*, Saint-Malo, 1990.

Daulte 1971
François Daulte, *Auguste Renoir: Catalogue raisonné de l'oeuvre peint, 1: Figures 1860–1890*, Lausanne, 1971.

Dayot 1884
Armand Dayot, *Salon de 1884*, Paris, 1884.

Deldrève 2004
Valérie Deldrève, 'L'acquisition et la reconnaissance des savoirs halieutiques: L'accès aux ressources marines comme enjeu social', in *Savoirs, travail et organisation*, Université de Versailles-St-Quentin-en-Yvelines, 2004.

Désert 1983
Gabriel Désert, *La Vie quotidienne sur les plages normandes du Second Empire aux années folles*, Paris, 1983.

Du Camp 1861
Maxime du Camp, *Le Salon de 1861*, Paris, 1861.

Duigou 1985
Serge Duigou, *Les premiers touristes chez les Bigoudens*, Quimper, 1985.

Dumas 1989
Alexandre Dumas (père), *Mes Mémoires, 2, 1830–1833*, Paris, 1989.

Durand-Ruel 1873–75
Galerie Durand-Ruel, *Recueil d'estampes*, Paris, 1873–75.

Duranty 1877
Emile Duranty, 'Réflexions d'un bourgeois au Salon de peinture (1er article)', *Gazette des Beaux-Arts*, 1 June 1877.

Du Seigneur 1880
Maurice du Seigneur, *L'Art et les artistes au Salon de 1880*, Paris, 1880.

Fernier 1977, 1978
Robert Fernier, *La Vie et l'oeuvre de Gustave Courbet: Catalogue raisonné*, 1, Lausanne and Paris, 1977; 2, Lausanne and Paris, 1978.

Flaubert 1910
Gustave Flaubert, 'Mémoires d'un fou' (1838), in *Oeuvres de jeunesse*, 1, Paris, 1910.

Fowle and Thomson 2003
Frances Fowle and Richard Thomson, *Soil and Stone: Impressionism, Urbanism, Environment*, Aldershot, 2003.

Garner 2005
Alice Garner, *A Shifting Shore: Locals, Outsiders, and the Transformation of a French Fishing Town, 1823–2000*, Ithaca, 2005.

Gautier 1856
Théophile Gautier, *Les Beaux-arts en Europe*, 2, Paris, 1856.

Gautier 1992
Théophile Gautier, *Exposition de 1859*, Wolfgang Drost and Ulrike Henninges (eds), Heidelberg, 1992.

Giron 1887
Alfred Giron, *De Cancale à Terre-Neuve: L'odyssée d'un petit mousse*, Limoges, 1887.

Glasgow 1992
Vivien Hamilton, *Boudin at Trouville*, exh. cat., Burrell Collection, Glasgow, Courtauld Institute Galleries, London, 1992–93.

Goncourt 1867
Edmond and Jules de Goncourt, *Manette Salomon*, 2 vols, Paris, 1867.

Goncourt 1989
Edmond and Jules de Goncourt, *Journal: Mémoires de la vie littéraire*, 3 vols, Paris, 1989.

Grate and Hedström 2006
Pontus Grate and Per Hedström, *French Paintings III: Nineteenth Century*, Nationalmuseum Stockholm, 2006.

Grossetête 1988
Jean Marie Grossetête, *La Grande Pêche de Terre-Neuve et d'Islande*, Saint-Malo, 1988.

Guichard-Claudic 1998
Yvonne Guichard-Claudic, *Eloignement conjugal et construction identitaire: Le cas des femmes de marins*, Paris, 1998.

Hareux 1891–93
Ernest Hareux, *Manuel pratique de la peinture à l'huile, 2: Paysages, marines*, Paris, 1888–89; *Practical Manual of Painting in Oil Colours, 2: Landscape and Marine*, London, n.d. [1891–93].

Haskell and Penny 1981
Francis Haskell and Nicholas Penny, *Taste and the Antique*, New Haven and London, 1981.

Hefting 1969
Victorine Hefting (ed.), *Jongkind d'après sa correspondance*, Utrecht, 1969.

Hefting 1975
Victorine Hefting, *Jongkind: sa vie, son oeuvre, son époque*, Paris, 1975.

Hellebranth 1976
Robert Hellebranth, *Charles-François Daubigny, 1817–1878*, Morges, 1976.

Herbert 1988
Robert L. Herbert, *Impressionism: Art, Leisure, and Parisian Society*, New Haven and London, 1988.

Herbert 1994
Robert L. Herbert, *Monet on the Normandy Coast: Tourism and Painting, 1867–1886*, New Haven and London, 1994.

Herbert 1995
Robert L. Herbert, 'Courbet's Lost Laundresses', *Art in America*, February 1995.

Herding 1991
Klaus Herding, *Courbet: To Venture Independence*, New Haven and London, 1991.

Hopkin 2003
David Hopkin, 'Legendary Places: Oral History and Folk Geography in Nineteenth-Century Brittany', in Fowle and Thomson 2003.

Hopkin 2005
David Hopkin, 'Storytelling and Networking in a Breton Fishing Village, 1879–1882', *International Journal of Maritime History*, 17 (2005), pp. 113–40.

House 1986
John House, *Monet: Nature into Art*, New Haven and London, 1986.

House 1988
John House, 'Renoir in Guernsey', in *Artists in Guernsey: Renoir*, Guernsey, [1988].

House 1992
John House, 'Boudin's Modernity', in Glasgow 1992.

House 2003
John House, 'The Viewer on the Beach', in Fowle and Thomson 2003.

House 2004
John House, *Impressionism: Paint and Politics*, New Haven and London, 2004.

Huet 1911
René Paul Huet, *Paul Huet (1803–1869)*, Paris, 1911.

Humphreys 1884
Mary Gay Humphreys, 'Trouville', *Harper's New Monthly Magazine*, 69, 1884.

James 1869
Constantin James, *Guide pratique aux eaux minerals, aux bains de mer et aux stations thermales*, Paris, 1869.

Jean-Aubry 1922
G. Jean-Aubry, *Eugène Boudin d'après des documents inédits*, Paris, 1922.

Joanne 1886
Adolphe Joanne, *Itinéraire général de la France: Normandie*, Paris, 1866.

Joanne 1887
Paul Joanne, *Itinéraire général de la France: Normandie*, Paris, 1887.

Johnston 1982
William R. Johnston, *The Nineteenth-Century Paintings in the Walters Art Gallery*, Baltimore, 1982.

Karr 1860
Alphonse Karr, *Le Chemin le plus court*, Paris, 1836; new edition, Paris, 1860.

Lafenestre 1873
Georges Lafenestre, 'Salon de 1873, 2', *Gazette des Beaux-Arts*, 8, July 1873.

Lagrange 1867
Léon Lagrange, 'Les Beaux-arts en 1867: L'Exposition universelle: Le Salon', *Le Correspondant*, 55, 1867.

L'Autographe 1865
L'Autographe au Salon, Paris, 1865.

Le Bouëdec 2004
Gérard Le Bouëdec, François Ploux, Christophe Cérino and Aliette Geistdoerfer (eds), *Entre terre et mer: sociétés littorales et pluriactivités (XVe–XXe siècles)*, Rennes, 2004.

Lepoittevin 2000
Lucien Lepoittevin and others, *Jean-François Millet: au-delà de l'Angelus*, Paris, 2000.

Le Roux 1889
Hugues le Roux, 'Silhouettes parisiennes: L'Exposition de Claude Monet', *Gil blas*, 3 March 1889.

Le Roy 1865
Raoul Le Roy, *Bains de mer de Houlgate-Beuzeval*, Paris, 1865.

Letellier 1999
Ascribed to L. Letellier, *Sur le Grand-Banc. Pêcheurs de Terre-Neuve. Récit d'un ancien pêcheur*, Saint-Malo, 1999.

Leys 2003
Simon Leys (ed.), *La Mer dans la littérature française*, 2 vols, Paris, 2003.

L'Illustration 1884
Anon., 'Les Bains de mer de Trouville', *L'Illustration*, 7 September 1844.

Lognone 1985
Maryse Lognone, 'L'Evolution du recrutement et des salaires des Terres-Neuvas malouins au XIXe siècle', masters dissertation, Université de Rennes II, 1985.

London 1990
David Bomford, Jo Kirby, John Leighton and Ashok Roy, *Art in the Making: Impressionism*, exh. cat., National Gallery, London, 1990–91.

London 1995
John House and others, *Landscapes of France*, exh. cat., Hayward Gallery, London, 1995; shown as *Impressions of France*, Museum of Fine Arts, Boston, 1995–96.

London 2003
James Cuno, Joachim Kaak and John House, *Manet Face to Face*, exh. cat., Courtauld Institute Gallery, London, 2003–04.

Loti 1886
Pierre Loti, *Pêcheur d'islande*, Paris, 1886.

Lyons 2002
Vincent Pomarède and others, *L'Ecole de Barbizon: peindre en plein air avant l'impressionnisme*, exh. cat., Musée des Beaux-Arts, Lyons, 2002.

Macquoid 1874
Katharine S. Macquoid, *Through Normandy*, London, 1874.

Macquoid 1877
Katharine S. Macquoid, *Through Brittany*, London, 1877.

Marshall 1871
[Frederic Marshall], 'Trouville and the Calvados Shore', *Blackwood's Edinburgh Magazine*, 110 (1871), pp. 481–99.

Matthews 1994
Nancy Mowll Matthews, *Mary Cassatt: A Life*, New York, 1994.

Maupassant 1883
Guy de Maupassant, *Une Vie*, Paris, 1883.

Maupassant 1886
Guy de Maupassant, 'La Vie d'un paysagiste', *Gil blas*, 28 September 1886, reprinted in Riout 1989.

Merlhès 1984
Victor Merlhès (ed.), *Correspondance de Paul Gauguin*, 1, Paris, 1984.

Merson 1861
Olivier Merson, *La Peinture en France: Exposition de 1861*, Paris, 1861.

Michel 1900
André Michel, 'Les Arts à l'Exposition universelle de 1900: L'Exposition centennale: la peinture française, 5', *Gazette des Beaux-Arts*, 24, November 1900.

Michelet 1983
Jules Michelet, *La Mer*, Paris, 1861; Jean Borie (ed.), Paris, 1983.

Middleton 1993
Richard Middleton, 'The British Coastal Expeditions to France, 1757–1758', *Journal of the Society for Army Historical Research*, 71 (1993), pp. 74–92.

Miquel 1980
Pierre Miquel, *Eugène Isabey 1803–1886: La Marine au XIX͏e siècle*, 2 vols, Maurs-la-Jolie, 1980.

Morlent 1862
J. Morlent, *Le Havre: Guide du touriste au Havre et dans ses environs*, Le Havre, [1862].

Nadel-Klein 2003
Jane Nadel-Klein, *Fishing for Heritage: Modernity and Loss Along the Scottish Coast*, Oxford, 2003.

Nochlin 2006
Linda Nochlin, *Bathers, Bodies, Beauty: The Visceral Eye*, Cambridge (Mass.), 2006.

Pakenham 1967
Simona Pakenham, *60 Miles from England: The English at Dieppe, 1814–1914*, London, 1967.

Paris 1975
Robert L. Herbert, *Jean-François Millet*, exh. cat., Grand Palais, Paris, 1975–76.

Paris 1997
Hélène Toussaint and others, *Gustave Courbet*, exh. cat., Grand Palais, Paris, 1977–78.

Paris 1996
Vincent Pomarède and others, *Corot*, exh. cat., Grand Palais, Paris, 1996.

Pénel 1866
Eugène Pénel, *De Paris à Boulogne*, Paris, 1866.

Pludermacher 2000
Isolde Pludermacher, *Eugène Boudin, Lettres à Ferdinand Martin*, Mémoire de D.E.A., Paris, 2000.

Richard 1856
J. B. Richard, *Conducteur du voyageur en France*, Paris, 1856.

Richard 1866
J. B. Richard, *Guide du voyageur en France*, Paris, 1866.

Riat 1906
Georges Riat, *Gustave Courbet, peintre*, Paris, 1906.

Riout 1979
Denys Riout (ed.), *Les Ecrivains devant l'impressionnisme*, Paris, 1979.

Robaut 1905
Alfred Robaut, *L'Oeuvre de Corot: catalogue raisonné et illustré*, 4 vols, Paris, 1905.

Rouart and Wildenstein 1975
Denis Rouart and Daniel Wildenstein, *Edouard Manet: Catalogue raisonné*, 2 vols, Lausanne and Paris, 1975.

Rouillard 1984
Dominique Rouillard, *Le Site balnéaire*, Liège and Brussels, 1984.

San Francisco 2006
Heather Lemonedes and others, *Monet in Normandy*, exh. cat., Fine Arts Museums of San Francisco, North Carolina Museum of Art, Cleveland Museum of Art, 2006–07.

Schmit 1973
Robert Schmit, *Eugène Boudin: catalogue raisonné de l'oeuvre peint*, 3 vols, Paris, 1973.

Sébillot 1997
Paul Sébillot, *Le Folklore des pêcheurs*, Saint-Malo, 1997.

Sébillot 1998–2000
Paul Sébillot, *Contes populaires de la Haute-Bretagne*, Dominique Besançon (ed.), Rennes, vol. 1, 1998; vol. 2, 1999; vol. 3, 2000.

Sensier 1870
Alfred Sensier, 'Les Peintres de la nature: Salon de 1870', *Revue internationale de l'art et de la curiosité*, 3, 15 May 1870.

Shaw 1991
Jennifer L. Shaw, 'The Figure of Venus: Rhetoric of the Ideal and the Salon of 1863', *Art History*, 14, December 1991.

Shiff 1984
Richard Shiff, *Cézanne and the End of Impressionism*, Chicago, 1984.

Sinsoilliez 1994
Robert Sinsoilliez, *La Bataille des pêcheries*, Saint-Malo, 1994.

Stechow 1966
Wolfgang Stechow, *Dutch Landscape Painting of the Seventeenth Century*, London, 1966.

Stevens 1859
Mathilde Stevens, *Impressions d'une femme au Salon de 1859*, Paris, 1859.

Thiébault-Sisson 1998
François Thiébault-Sisson, 'Claude Monet: Les années des épreuves', *Le Temps*, 26 November 1900, reprinted as Claude Monet, *Mon histoire*, Paris, 1998.

Thoré 1870
Théophile Thoré, *Salons de W. Bürger, 1861 à 1868*, 2 vols, Paris, 1870.

Toulier 1998
Bernard Toulier, 'L'influence des guides touristiques dans la représentation et la construction de l'espace balnéaire (1850–1950)', in E. Cohen, G. Chabaud, N. Coquery and J. Penez (eds), *Guides imprimés du XVIe au XXe siècle. Les villes, paysages, voyages*, Paris, 2001.

Tryon 1896
D. W. Tryon, 'Charles-François Daubigny', in J. C. Van Dyke (ed.), *Modern French Masters*, New York, 1896.

Urbain 2003
Jean Didier Urbain, *Sur la plage*, Paris, 1994; *At the Beach*, Minneapolis and London, 2003.

Venedey 1841
[Jacob Venedey], *Excursions in Normandy*, 2 vols, London, 1841.

Venturi 1939
Lionello Venturi, *Les Archives de l'impressionnisme*, 2 vols, Paris, 1939.

Vollard 1989
Ambroise Vollard, *Pierre-Auguste Renoir, Tableaux, pastels et dessins*, Paris, 1918; new edition, San Francisco, 1989.

Wagner 1981
Anne M. Wagner, 'Courbet's Landscapes and Their Market', *Art History*, 4, December 1981, pp. 410–31.

Wildenstein 1974, 1979
Daniel Wildenstein, *Monet, biographie et catalogue raisonné*, 1, Lausanne and Paris, 1974; 2, Lausanne and Paris, 1979.

Wildenstein 2001
Daniel Wildenstein, with Sylvie Crussard and Martine Heudron, *Gauguin: Catalogue raisonné de l'oeuvre peint (1873–1888)*, Paris, 2001.

Williamstown 1997
Marc Simpson, *Uncanny Spectacle: The Public Career of the Young John Singer Sargent*, exh. cat., Sterling and Francine Clark Art Institute, Williamstown, 1997.

Young 1980
Andrew McLaren Young, Margaret MacDonald, Robin Spencer and Hamish Miles, *The Paintings of James McNeill Whistler*, 2 vols, New Haven and London, 1980.

Zola 1970
Emile Zola, *Mon Salon, Manet, Ecrits sur l'art*, A. Ehrard (ed.), Paris, 1970.

Lenders to the Exhibition

ANN ARBOR
University of Michigan Museum of Art

BALTIMORE
Walters Art Museum

BERWICK-UPON-TWEED
Berwick Borough Museum and Art Gallery

BIRMINGHAM
Barber Institute of Fine Arts,
 The University of Birmingham
Birmingham Museums and Art Gallery

BOSTON
Museum of Fine Arts

BRISTOL
Bristol's Museums, Galleries and Archives

CARCASSONNE
Musée des Beaux-Arts de Carcassonne

CHICAGO
The Art Institute of Chicago

COPENHAGEN
Ny Carlsberg Glyptotek

DETROIT
The Detroit Institute of Arts

DIEPPE
Château-Musée de Dieppe

GLASGOW
Glasgow City Council (Museums)

THE HAGUE
Ivo Bouwman Gallery

Frederic C. Hamilton

HARTFORD
Wadsworth Atheneum Museum of Art

HONFLEUR
Musée Eugène Boudin

LAVAL
Musée du Vieux-Château

LE HAVRE
Musée Malraux

LONDON
Courtauld Institute of Art Gallery
Matthiesen Gallery
National Gallery

LYONS
Musée des Beaux-Arts

MADRID
Carmen Thyssen-Bornemisza Collection

MINNEAPOLIS
Minneapolis Institute of Arts

MONTCLAIR, NJ
Montclair Art Museum

NEW HAVEN
Yale University Art Gallery

NEW YORK
The Metropolitan Museum of Art

NORFOLK, VA
Chrysler Museum of Art

OSLO
National Museum of Art, Architecture and Design

OTTAWA
National Gallery of Canada

PARIS
Musée d'Orsay

PHILADELPHIA
Philadelphia Museum of Art

PHOENIX
Phoenix Art Museum

PRINCETON
Princeton University Art Museum

RALEIGH
North Carolina Museum of Art

RICHMOND
Virginia Museum of Fine Arts

ROCHESTER, NY
Memorial Art Gallery of the University of Rochester

ROUEN
Musée des Beaux-Arts de Rouen

SAINT LOUIS
Saint Louis Art Museum

SAN FRANCISCO
Fine Art Museums of San Francisco

STOCKHOLM
Nationalmuseum

STUTTGART
Staatsgalerie

TOKYO
Tokyo Fuji Art Museum

TORONTO
Art Gallery of Ontario

WASHINGTON DC
Corcoran Gallery of Art
The Kreeger Museum
National Gallery of Art
The Phillips Collection

WILLIAMSTOWN
Sterling and Francine Clark Art Institute

and others who wish to remain anonymous

Photographic Acknowledgements

All works of art are reproduced by kind permission of the owners.

Specific acknowledgements are as follows:

Ann Arbor, © The University of Michigan Museum of Art/Patrick Young, cat. 23
Baltimore, The Walters Art Museum, cat. 8
Birmingham, The Barber Institute of Fine Arts, The University of Birmingham, cat. 25
Birmingham Museums & Art Gallery, cat. 7
Boston, © 2007 Museum of Fine Arts, cats 59, 66
Boston, Museum of Fine Arts. Gift of Miss Mary Appleton, 1935. 35.708, page 135 (fig. 39)
Bristol, © By Permission of Bristol Museums & Art Gallery, cat. 18
Caen, Musée des Beaux-Arts – Martine Seyve Photographe, page 136 (fig. 41)
Carcassonne, © Musée des Beaux-Arts de Carcassonne/Hervé Samzun, cat. 47
Chicago, © The Art Institute of Chicago, cats 32, 63
Chicago (Illinois), reproduction © The Art Institute of Chicago, page 139 (fig. 44)
Copenhagen, © Ny Carlsberg Glyptotek/Ole Haupt, cats 57, 68
Detroit, © 2000 The Detroit Institute of Arts, cat. 41
Dieppe, © Château-musée de Dieppe/Bertrand Legros, cat. 45
Glasgow, © Glasgow City Council (Museums), cat. 17
Honfleur, Musée Eugène Boudin, pages 23 (fig. 14), 25 (fig. 18)
Japan, © Tokyo Fuji Art Museum, Tokyo, Japan/The Bridgeman Art Library, cat. 56
Kópavogi, National Museum of Iceland, page 33 (fig. 22)
Laurent Lecat, page 128 (figs 36, 37)
Hervé Lewandowski, page 139 (fig. 43)
Lisieux, Musées de Lisieux, page 23 (fig. 15)
London, © AKG Images: Erich Lessing, pages 21 (fig. 7), 125 (fig. 32), 127 (fig. 35);
London, © The National Gallery, London, cats 11, 38
London, Copyright © 2007 The National Gallery, London, All Rights Reserved, page 20 (figs 5, 6)
London, Prudence Cuming Associates Ltd, cat. 22

London, The Samuel Courtauld Trust, Courtauld Institute of Art Gallery, cat. 49
London, © 2007 Sotheby's, page 123 (fig. 31)
Lyons, Musée des Beaux-Arts de Lyons/© Studio Basset, cat. 60
Madison (Wisconsin), Chazen Museum of Art, University of Wisconsin, page 135 (fig. 40)
Madrid, Copyright © Carmen Thyssen-Bornemisza Collection. On loan at the Museo Thyssen-Bornemisza, cats 48, 53
Merion (Pennsylvania), © Reproduced with permission of The Barnes Foundation. All Rights Reserved, page 140 (fig. 47), page 141 (figs 48, 49)
New York, © 1980 The Metropolitan Museum of Art, cats 33, 64, 67
Oslo © The National Museum, J. Lathion, cat. 62
Ottawa, © National Gallery of Canada, cat. 52
Paris, © Photo RMN: A. Danvers, page 122 (fig. 28); Christian Jean, page 127 (fig. 34)
Paris, RMN/Hervé Lewandowski, cats 35, 40; Jean Schormans, cat. 44
Paris, © www.notrefamille.com, page 35 (fig. 24)
Princeton, © 2003 Trustees of Princeton University/Bruce M. White, cat. 15
Raleigh, North Carolina Museum of Art, cat. 61
Richmond, © Virginia Museum of Fine Arts/Katherine Wetzel, cat. 34
Rouen, © Musées de la ville de Rouen, page 24 (fig. 16)
Rouen, © Musées de la Ville de Rouen/Catherine Lancien, Carole Loisel, cat. 27
Saint-Brieuc, © Musée d'art et d'histoire des Côtes-d'Armor, page 37 (fig. 27)
Saint-Cast Le Guildo, © Photo-Raph, page 36 (fig. 25)
Saint Louis, Saint Louis Art Museum, cat. 28
Greg Staley, 2006, cat. 50
Stockholm, The National Museum of Fine Arts, cat. 31
Toronto, © 2007 Art Gallery of Ontario, cat. 5
Troyes, Cliché des Musées de Troyes – Photo: Jean-Marie Protte, page 25 (fig. 19)
James Via, cat. 55
Washington, © Board of Trustees, National Gallery of Art, Washington, cats 16, 20, 69

Washington, National Gallery of Art (partial and promised gift), page 125 (fig. 33)
Washington, DC, courtesy of The Corcoran Gallery of Art, Washington, DC, cat. 46
Washington, DC, courtesy, The Kreeger Museum, cat. 54
Williamstown © Sterling and Francine Clark Art Institute, Williamstown, Mass., cat. 65
Winterthur (Switzerland), Collection Oskar Reinhart 'Am Römerholz', page 23 (fig. 13)

Index

Names of artists whose works appear in the exhibition are set in **red** type; their birth and death dates are given in parentheses. All references are to page numbers; those in **red** type indicate catalogue plates, and those in *italic* indicate other illustrations.

Benefactors of the Royal Academy of Arts

Carl Stewart
John and Sheila Stoller
Mrs Betty Thayer
Mr and Mrs Julian Treger
Michael and Yvonne Uva
Mary Wolridge
Sir Robert Worcester
and others who wish to remain anonymous

SCHOOLS PATRONS GROUP
Chairman
John Entwistle OBE DL

Gold Patrons
The Brown Foundation, Inc, Houston
The Ernest Cook Trust
D'Oyly Carte Charitable Trust
The Gilbert & Eileen Edgar Foundation
The Eranda Foundation
Mr and Mrs Jack Goldhill
The David Lean Foundation
The Leverhulme Trust
Paul and Alison Myners
Newby Trust Limited
Edith and Ferdinand Porjes Charitable Trust
Paul Smith and Pauline Denyer-Smith
Oliver Stanley Charitable Trust
The Starr Foundation
Sir Siegmund Warburg's Voluntary Settlement
The Harold Hyam Wingate Foundation

Silver Patrons
Lord and Lady Aldington
The Celia Walker Art Foundation
Mr and Mrs Ian Ferguson
Philip Marsden Family Trust
The Radcliffe Trust
The Stanley Picker Trust

Bronze Patrons
Mrs Elizabeth Alston
Lee Bakirgian Family Trust
Mark and Lucy Blair
The Charlotte Bonham-Carter Charitable
 Trust
The Selina Chenevière Foundation
May Cristea Award
The Delfont Foundation
John Entwistle OBE DL
Mr and Mrs John A Gardiner
Professor and Mrs Ken Howard RA
The Lark Trust
Mr Colin Lees-Millais FRICS
Mrs Diana Morgenthau
Pickett
Peter Rice Esq
Anthony and Sally Salz
Mr and Mrs Robert Lee Sterling, Jr
Roger Taylor
Mr and Mrs Denis Tinsley
Mr Ray Treen
The Worshipful Company of Painter-Stainers
and others who wish to remain anonymous

CONTEMPORARY PATRONS GROUP
Chairman
Susie Allen

Mrs Alan Artus
Susan and John Burns
Dr Elaine C Buck
Debbie Carslaw
Dania Debs-Sakka
Chris and Angie Drake
Mr John Eldridge
Lawton Wehle Fitt
Melanie C Gerlis
Marcia and Michael Green
Mrs Robin Hambro
Miss Pauline Karpidas
Mrs Mireille Masri
Sharon Maurice
Marion and Guy Naggar
Angela Nikolakopoulou
Libby Paskin and Daniel Goldring
Maria N Peacock

Ramzy and Maya Rasamny
Mr Andres Recoder and Mrs Isabelle Schiavi
John Tackaberry and Kate Jones
Britt Tidelius
Mr and Mrs John D Winter
Mary Wolridge
and others who wish to remain anonymous

AMERICAN ASSOCIATES OF
THE ROYAL ACADEMY TRUST
Burlington House Trust
Mr and Mrs Donald P Kahn
Mrs Nancy B Negley
Mr and Mrs James C Slaughter

Benjamin West Society
Mrs Walter H Annenberg
Mr Francis Finlay

Benefactors
Ms Susan Baker and Mr Michael Lynch
Mrs Deborah Loeb Brice
Mrs Edmond J Safra
The Honorable John C Whitehead
Mr and Mrs Frederick B Whittemore

Sponsors
Ms Britt Allcroft
Mrs Katherine D Findlay
Mrs Henry J Heinz II
Mr David Hockney RA
Mr Arthur L Loeb
Mr Hamish Maxwell
Mrs Lucy F McGrath
Mr Arthur O Sulzberger and Ms Allison
 S Cowles
Mr and Mrs Vernon Taylor Jr

Patrons
Ms Helen H Abell
Mrs Russell B Aitken
Mr and Mrs Steven Ausnit
Mr and Mrs E William Aylward
Mr Donald A Best
Mrs Edgar H Brenner
Mr and Mrs Henry W Breyer III
Mrs Mildred C Brinn
Mrs Benjamin Coates
Mrs Mary Sharp Cronson
Mrs Catherine G Curran
Anne S Davidson
Ms Zita Davisson
Mr and Mrs Beverley Duer
Mrs Frances Dulaney
Mrs June Dyson
Mr Jonathan Farkas
Mr and Mrs John Fiorilla
Mr Richard E Ford
Ms Barbara Fox-Bordiga
Mr and Mrs Lawrence S Friedland
Mr John Gleiber
Mr and Mrs Eugene Goldberg
Mr O Delton Harrison, Jr
Dr Bruce C Horten
Ms Betty Wold Johnson and Mr Douglas F
 Bushnell
The Honorable and Mrs W Eugene Johnston
Mr William W Karatz
Mr and Mrs Gary Kraut
The Honorable and Mrs Philip Lader
Mrs Katherine K Lawrence
Mr and Mrs William Little
Dr Jean McCusker
Ms Marcia V Mayo
Ms Barbara T Missett
The Honorable and Mrs William A Nitze
Ms Diane A Nixon
Mr and Mrs William O'Boyle
Mr and Mrs Chips Page
Mrs Evelyn Peterson
Mr and Mrs Jeffrey Pettit
Ms Barbara Pine
Lady Annie Renwick
Mr and Mrs Peter Sacerdote
Ms Louisa Stude Sarofim
Mrs Frances G Scaife
Dr and Mrs Myron Scholes
Mr and Mrs Stanley De Forest Scott

Mr and Mrs Morton I Sosland
Mrs Frederick M Stafford
Mr and Mrs Stephen Stamas
Ms Joan Stern
Ms Brenda Neubauer Straus
Ms Elizabeth F Stribling and Mr Guy Robinson
Mr Martin J Sullivan
Ms Britt Tidelius
Mr and Mrs Lewis Townsend
Mr and Mrs Stanford Warshawsky
Mr and Mrs George White
Dr and Mrs Robert D Wickham
Mr Robert W Wilson

Corporate and Foundation Support
AIG
American Express
The Brown Foundation
General Atlantic
General Motors
GlaxoSmithKline
The Horace W Goldsmith Foundation
Henry Luce Foundation
Sony

CORPORATE MEMBERS OF
THE ROYAL ACADEMY OF ARTS
Launched in 1988, the Royal Academy's
Corporate Membership Scheme has proved
highly successful. Corporate Membership
offers benefits for staff, clients and
community partners and access to the
Academy's facilities and resources. The
outstanding support we receive from
companies via the scheme is vital to the
continuing success of the Academy and we
thank all Members for their valuable support
and continued enthusiasm.

Premier Level Members
CB Richard Ellis
Deutsche Bank AG
Ernst & Young LLP
GlaxoSmithKline plc
Goldman Sachs International
Hay Group
HSBC plc
Intercontinental London Park Lane
King Sturge
Rio Tinto plc
Smith and Williamson
Standard Chartered

Corporate Members
All Nippon Airways
Aon
Arcadia Group plc
A. T. Kearney
Bank of America
Bear, Stearns International Ltd
Bibendum Wine Limited
BNP Paribas
The Boston Consulting Group
Bovis Lend Lease Limited
Bridgewell Securities
British American Business Inc.
British American Tobacco
The British Land Company PLC
Calyon
Cantor Fitzgerald
Capital International Limited
Christie's
Citigroup
Clifford Chance
Concordia Advisors
De Beers
Diageo plc
EADS Space
Epson (UK) Ltd
F & C Management plc
Gallery 88
GAM
H & M
Heidrick & Struggles
Insight Investment
ITV plc
Ivy Production Ltd

John Lewis Partnership
JPMorgan
KPMG
Lazard
LECG
Lehman Brothers
Linklaters
London College of Fashion
L'Oréal UK
Man Group plc
Mizuho International
Momart Limited
Morgan Stanley
The National Magazine Company Ltd
Nedrailways
Norton Rose
Novo Nordisk
Pentland Group plc
The Royal Bank of Scotland
The Royal Society of Chemistry
Schroders & Co
SG
Slaughter & May
Timothy Sammons
Troika
Trowers & Hamlins
Unilever UK Limited
Veredus Executive Resourcing
Weil, Gotschal & Manges

SPONSORS OF PAST EXHIBITIONS
The President and Council of the Royal
Academy would like to thank the following
sponsors and benefactors for their generous
support of major exhibitions during the last
ten years:

2007
239th Summer Exhibition
 Insight Investment
The Unknown Monet
 Bank of America

2006
238th Summer Exhibition
 Insight Investment
Chola: Sacred Bronzes of Southern India
 Travel Partner: Cox & Kings
Premiums and *RA Schools Show*
 Mizuho International plc
RA Outreach Programme
 Deutsche Bank AG
Rodin
 Ernst & Young

2005
China: The Three Emperors, 1662–1795
 Goldman Sachs International
Impressionism Abroad:
 Boston and French Painting
 Fidelity Foundation
Matisse, His Art and His Textiles:
 The Fabric of Dreams
 Farrow & Ball
Premiums and *RA Schools Show*
 The Guardian
 Mizuho International plc
Turks: A Journey of a Thousand Years,
 600–1600
 Akkök Group of Companies
 Aygaz
 Corus
 Garanti Bank
 Lassa Tyres

2004
236th Summer Exhibition
 A. T. Kearney
Ancient Art to Post-Impressionism:
 Masterpieces from the Ny Carlsberg
 Glyptotek, Copenhagen
 Carlsberg UK Ltd
 Danske Bank
 Novo Nordisk
The Art of Philip Guston (1913–1980)
 American Associates of the
 Royal Academy Trust

The Art of William Nicholson
 RA Exhibition Patrons Group
Vuillard: From Post-Impressionist
 to Modern Master
 RA Exhibition Patrons Group

2003
235th Summer Exhibition
 A. T. Kearney
Ernst Ludwig Kirchner:
 The Dresden and Berlin Years
 RA Exhibition Patrons Group
Giorgio Armani: A Retrospective
 American Express
 Mercedes-Benz
Illuminating the Renaissance:
 The Triumph of Flemish Manuscript
 Painting in Europe
 American Associates of the
 Royal Academy Trust
 Virginia and Simon Robertson
Masterpieces from Dresden
 ABN AMRO
 Classic FM
Premiums and *RA Schools Show*
 Walker Morris
Pre-Raphaelite and Other Masters:
 The Andrew Lloyd Webber Collection
 Christie's
 Classic FM
 UBS Wealth Management

2002
234th Summer Exhibition
 A. T. Kearney
Aztecs
 British American Tobacco
 Mexico Tourism Board
 Pemex
 Virginia and Simon Robertson
Masters of Colour: Derain to Kandinsky.
 Masterpieces from The Merzbacher
 Collection
 Classic FM
Premiums and *RA Schools Show*
 Debenhams Retail plc
*RA Outreach Programme**
 Yakult UK Ltd
Return of the Buddha:
 The Qingzhou Discoveries
 RA Exhibition Patrons Group

2001
233rd Summer Exhibition
 A. T. Kearney
Botticelli's Dante: The Drawings
 for Dante's Divine Comedy
 RA Exhibition Patrons Group
The Dawn of the Floating World
 (1650–1765). Early Ukiyo-e Treasures
 from the Museum of Fine Arts, Boston
 Fidelity Foundation
Forty Years in Print: The Curwen Studio
 and Royal Academicians
 Game International Limited
Frank Auerbach, Paintings and Drawings
 1954–2001
 International Asset Management
Ingres to Matisse:
 Masterpieces of French Painting
 Barclays
Paris: Capital of the Arts 1900–1968
 BBC Radio 3
 Merrill Lynch
Premiums and *RA Schools Show*
 Debenhams Retail plc
*RA Outreach Programme**
 Yakult UK Ltd
Rembrandt's Women
 Reed Elsevier plc

2000
1900: Art at the Crossroads
 Cantor Fitzgerald
 The Daily Telegraph
232nd Summer Exhibition
 A. T. Kearney

Apocalypse: Beauty and Horror
 in Contemporary Art
 Eyestorm
 The Independent
 Time Out
Chardin 1699–1779
 RA Exhibition Patrons Group
The Genius of Rome 1592–1623
 Credit Suisse First Boston
Premiums and RA Schools Show
 Debenhams Retail plc
*RA Outreach Programme**
 Yakult UK Ltd
The Scottish Colourists 1900–1930
 Chase Fleming Asset Management

1999
231st Summer Exhibition
 A. T. Kearney
John Hoyland
 Donald and Jeanne Kahn
John Soane, Architect:
 Master of Space and Light
 Country Life
 Ibstock Building Products Ltd
Kandinsky
 RA Exhibition Patrons Group
LIFE? or THEATRE?
 The Work of Charlotte Salomon
 The Jacqueline and Michael Gee
 Charitable Trust
Monet in the Twentieth Century
 Ernst & Young
Premiums
 Debenhams Retail plc
 The Royal Bank of Scotland
RA Schools Show
 Debenhams Retail plc
*RA Outreach Programme**
 Yakult UK Ltd
Van Dyck 1599–1641
 Reed Elsevier plc

1998
230th Summer Exhibition
 Diageo plc
Chagall: Love and the Stage
 RA Exhibition Patrons Group
Picasso: Painter and Sculptor in Clay
 Goldman Sachs International
Premiums and *RA Schools Show*
 The Royal Bank of Scotland
*RA Outreach Programme**
 Yakult UK Ltd
Tadao Ando: Master of Minimalism
 The Drue Heinz Trust

* Recipients of a Pairing Scheme Award,
managed by Arts + Business. Arts + Business
is funded by the Arts Council of England and
the Department for Culture, Media and Sport

OTHER SPONSORS
Sponsors of events, publications and other
items in the past five years:
Carlisle Group plc
Country Life
Derwent Valley Holdings plc
Dresdner Kleinwort Wasserstein
Foster and Partners
Goldman Sachs International
Gome International
Gucci Group
Rob van Helden
IBJ International plc
John Doyle Construction
Martin Krajewski
Marks & Spencer
Michael Hopkins & Partners
Morgan Stanley Dean Witter
Prada
Radisson Edwardian Hotels
Richard and Ruth Rogers
Strutt & Parker